A FIREFLY BOOK

Published by Firefly Books Ltd. 2005

First printing

Publisher Cataloging-in-Publication Data (U.S.)

Mittermeier, Russell A.
 Pantanal : South America's wetland jewel / text [by[Russell A. Mittermeier ... [et al.] ; photographs by Theo Allofs ; foreword [by] Gordon Moore.
[176] p. : col. ill. , col. photos. ; cm.
Includes bibliographical references and index.
Summary: An examination of the Pantanal, including the geography, geology, vegetation and animal life of the world's largest wetland, as well as recent conservation efforts to preserve the unique habitat.
ISBN 1-55407-090-2
1. Pantanal. 2. Wetlands--Brazil. I. Title.
981.72 dc22 F2585.M588 2005

Published in the United States by
Firefly Books (U.S.) Inc.
P.O. Box 1338, Ellicott Station
Buffalo, New York 14205

Book design by Red Design, Auckland
Map by Black Ant Productions

Front cover: A Pantanal caiman (*Caiman yacare*) swimming in the Rio Claro, northern Pantanal.

Back cover: The giant Amazon waterlily (*Victoria amazonica*), Acurizal Reserve.

Contents page (from top): *Pantaneiro*; giant river otter (*Pteronura brasiliensis*); coati (*Nasua nasua*); male black howler monkey (*Alouatta caraya*); Pantanal caiman (*Caiman yacare*).

Page 4: Female black howler monkey (*Alouatta caraya*).

Library and Archives Canada Cataloguing in Publication

 Pantanal : South America's wetland jewel / Russell A. Mittermeier ... [et al.] ; photographer, Theo Allofs; foreword by Gordon Moore.
Includes bibliographical references and index.
ISBN 1-55407-090-2
 1. Pantanal. 2. Natural history--Pantanal. 3. Wetland conservation--Pantanal. I. Mittermeier, Russell A. II. Allofs, Theo, 1956-

QH117.M43 2005 508.81'71 C2005-901511-X

Published in Canada by
Firefly Books Ltd.
66 Leek Crescent
Richmond Hill, Ontario L4B 1H1

Printed in China by Everbest Printing Co., Ltd.

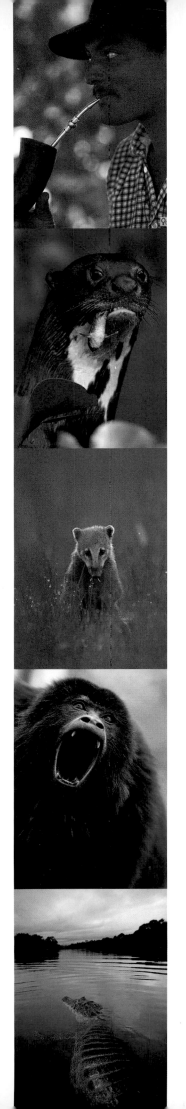

Contents

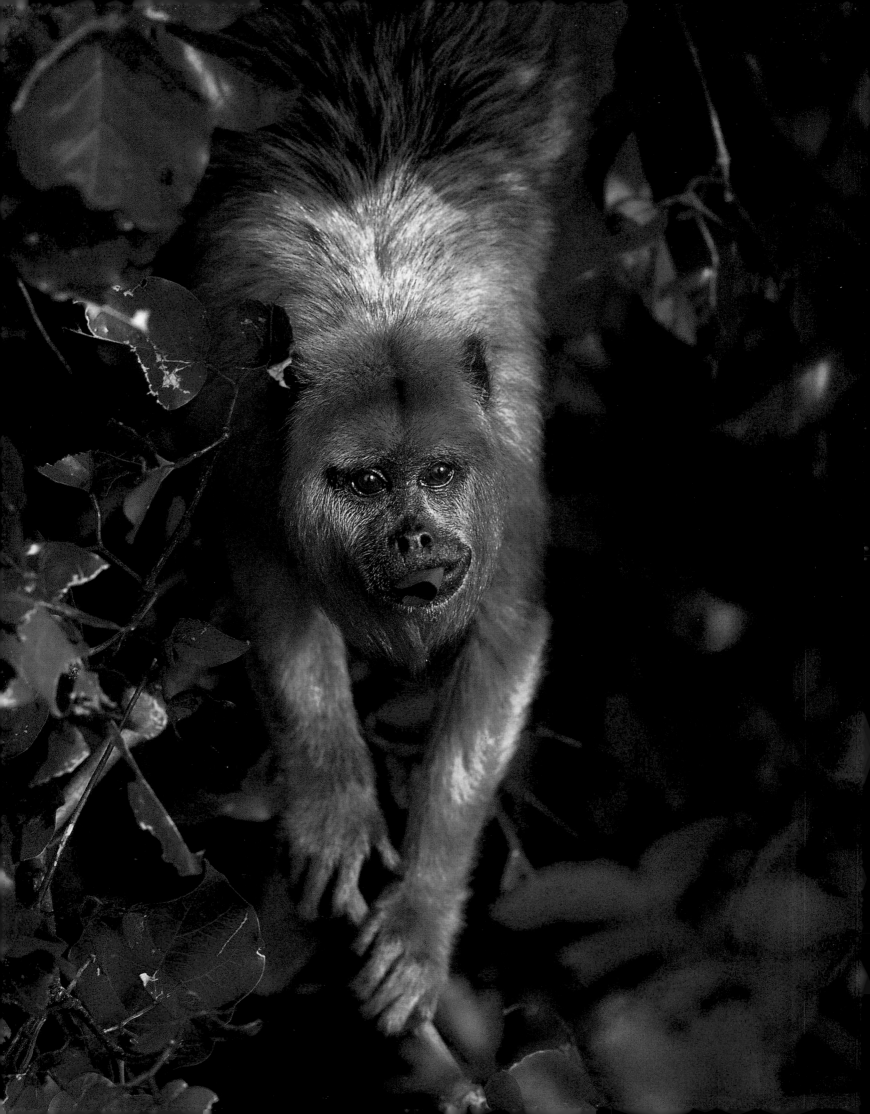

Acknowledgements

To be able to photograph the Pantanal, a vast region of rich biodiversity with a poorly developed infrastructure, I was dependent on the support and cooperation of many people during six long visits over the past four years. Strangers at first, some individuals soon were not only involved in my project, but also became friends.

It is difficult to imagine how my photographic work would have started without the very supportive staff at Conservation International in Campo Grande, who helped me with my first steps in an unknown land among a people whose language I did not speak. I am especially indebted to Reinaldo Lourival, Monica Harris, Mariza da Silva and Susana Coelho Lima.

When photographing on the Conservation International-owned Fazenda Rio Negro, other farmers approached me and invited me to work on their *fazendas*. I accepted their generous offers and had the chance to see some of the most magnificent private lands in the Southern Pantanal. Joáo and Vania Ildefonso let me stay at their Pousada Aguapé and allowed me to roam freely on the ranch. A very enthusiastic Joáo and his cowboys provided great help with images of the cattle drive. Through Fernando Luiz Lima de Barros I discovered Pousada Mangabal on Fazenda Pouso Alto, a ranch so rich in wildlife that it reminded me of the African savannah. Refúgio Ecológico Caiman, the first ecotourism-oriented farm in the Pantanal, is one of the best places to see a large variety of animals. Owner Roberto Klabin and his manager Marcia Reed gave me the opportunity to capture some very special moments. It was at Refúgio Ecológico Caiman that my wish to photograph a giant anteater with a baby on its back was finally fulfilled. Thanks also to Wolf-Dieter Eberhard for helping me with the organization needed to visit the remote Acurizal Reserve near the Bolivian border.

I am greatly indebted to my guides, who not only tried hard to understand my broken Portuguese but also helped me obtain the images I needed. Their knowledge, good eyes and enthusiasm were the foundation of my photography in the Pantanal: Tasso Madeirus, Helio Antonio Martins ("Picolé"), Ezidio Arruda ("Baiano"), Jurandir Ferreira Leite, Paulo Rogério da Silva, Marcos Violanta and Carlos Alves de Arruda — dear friends, thank you very much!

Conservation International has sponsored my photography in the Pantanal from the beginning. Without the support of its president, Dr. Russell A. Mittermeier, this book would not have been possible. I would also like to thank my publisher Paul Bateman for his trust in this book. Associate publisher Tracey Borgfeldt quickly responded to my numerous e-mails and also coordinated the project; her constructive criticism and ideas helped shape the book to a large extent. I am also thankful to graphic designer Richard Wheatley for the beautiful layout.

And what would I do without my wife Sabine; without her support, love and all the patience she needs being married to a nature photographer. The Pantanal project was her idea.

Theo Allofs

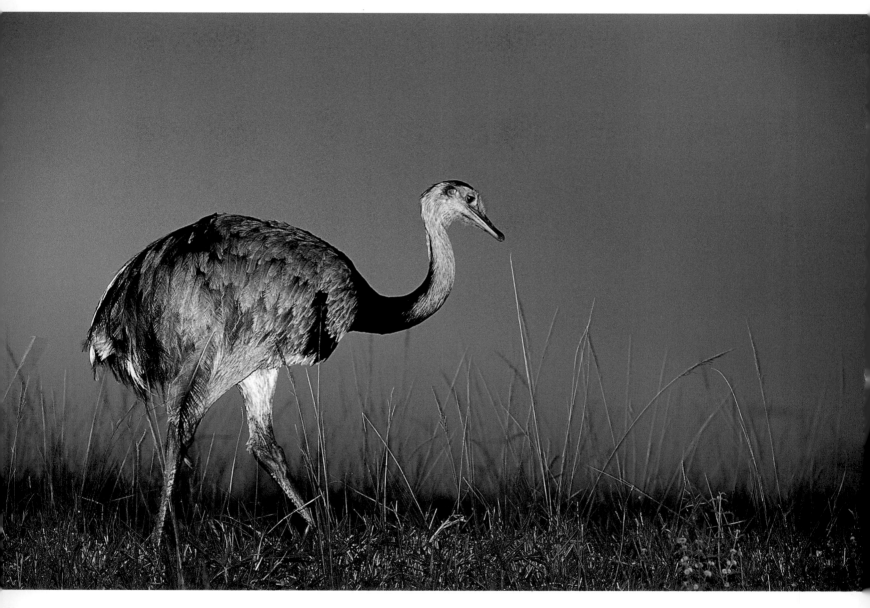

The greater rhea (*Rhea americana*).

Photographer's Note
Nature is reality and truth. My goal in photography is a true and honest documentation of nature.
Accordingly none of my images, including the pictures in this book, have been digitally altered
or in any other way manipulated. With very few exceptions all depicted animals are wild
and were photographed in their natural habitat. The exceptions are a toco toucan
and a blue-and-yellow macaw that were rescued from the illegal pet trade
and released on farms where I photographed them.

MAP OF THE PANTANAL

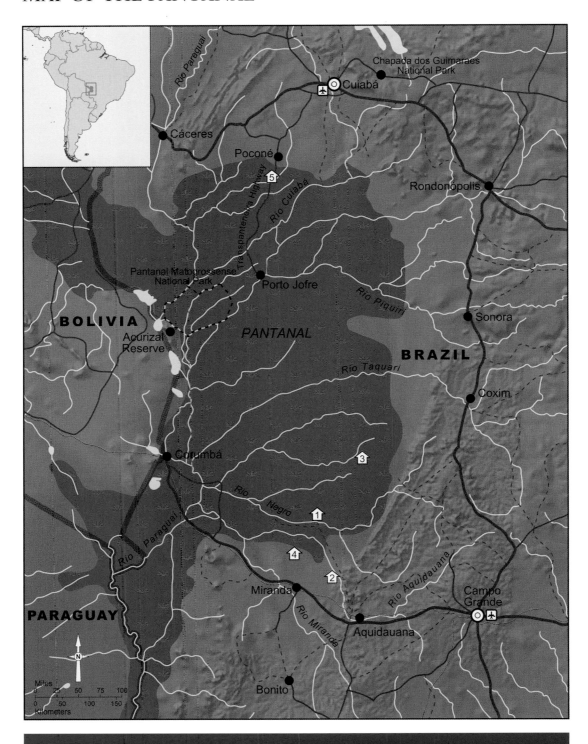

KEY

1 FAZENDA RIO NEGRO 2 FAZENDA SAO JOSE 3 FAZENDA POUSO ALTO

4 REFUGIO ECOLOGICO CAIMAN 5 POUSO ALEGRE

FOREWORD

Gordon Moore, Intel

The Pantanal is a special place. This huge wetland teems with birds, fish and other wildlife nurtured by the annual cycles of inundation and drought. Capybara and caiman cover the riverbanks during the low-water period, while during the flood they disperse into the forest patches and grasslands. The periodic flooding leaves little area for livestock that prefers dry land, so the region was divided into large ranches, often several hundred thousand acres, each with some "high ground" to sustain the cattle during the floods. During the past 150 years these *fazendas* have been divided and re-divided until the remnants are no longer financially viable. The future of the Pantanal lies somewhere other than in raising cattle.

The climate varies considerably with the seasons. During my first trip to the Pantanal in February, the middle of the flood, I nearly cooked. Coming in from the river for lunch it had turned so hot that all we could do for the first several hours of the afternoon was sit quietly in the shade moving as little as possible while watching the dozens of bird species arriving at a small feeding station baited with various fruits. Of course the humidity from all the water added to our discomfort. But as the sun settled in the west, our energy returned and we were off again to observe the wonders of nature. On a single evening ride our group was able to count a hundred bird species.

Another visit in the dry season in July happened to coincide with a cold snap blowing up from Antarctica. There was actually frost in the morning, a rare occurrence here. Not being prepared, we shivered in the morning air. Soon, however, the chatter of the wildlife and warming sun revived our interest in learning more about this special place and its inhabitants. The birds are everywhere and spectacular. Seeing a group of the magnificent and endangered hyacinth macaws sitting on fence posts or noisily eating in a palm tree is only the beginning. A wide range of birds from the ostrich-like rhea to a variety of thrushes and cardinals make this their home. The large open spaces between forest patches allow them to be observed, unlike in deep rainforests, where birds are often heard, but not seen by the casual observer. Screamers, ibis, macaws of several varieties and many others make their presence known. While cleaning fish on the river bank, it is not uncommon to have a jabiru stork, nearly as tall as I am, come close for a possible handout.

The rivers are also spectacular and contain an assortment of fish that are unusual, at least to the North American visitor. As in nearly all tropical waters of South America, piranha are plentiful. While it might seem incongruous to swim in rivers full of these toothy critters, as well as a healthy population of caiman, that is a common way to cool off. There are catfish of many species, ranging from tiny to huge, and the rivers contain the *dourado*, a great game fish common to the rivers of the general area that makes delicious table fare as well as great sport.

We have seen giant river otter on nearly every boat trip I have taken. Again, this is an animal in danger of extinction. The largest jaguars anywhere populate the area. My son had the rare experience of seeing two jaguars in a single day. On the Rio Negro, he was lucky enough to catch one in the act of swimming from one bank to the other. Later, as we flew out in a light plane, we had a great view of another one in an open area below. While attacks on humans are rare, ranchers have hunted the large cats for most of the last two centuries. Even today it is common for them to carry pistols "just in case". Certainly the frequency with which jaguar tracks appear along the river banks attests to their presence.

While I have not seen one, residents tell me that there is also a large population of anacondas. The best time to observe them is in the period when the water level is dropping in the transition from flooded to dry. The snakes have to migrate from the drying ponds to the rivers, so they are exposed on the land areas during transit.

At flood the high land and water level nearly match. Much of the grassland has a few inches of standing water under the blades. It is sloppy walking for a human, but for a horse it does not present a problem. Horseback through the flooded land is a good way to observe. Wildlife does not react to people on horseback the same way as when they are on foot. As a result, it is often easier to get close to the various birds and animals. Even during the dry season, horseback is a preferred way to see much of the region, since there are few tracks suitable for vehicles.

The Pantanal is like no other place I have ever been. Its rich biodiversity and uniqueness deserve to be preserved. This task will not be easy, for the hydrology that drives the wet cycle depends critically on the large river systems that border the Pantanal, particularly the Paraguay. Plans to deepen the river channel to allow for better navigation could destroy the flood portion of the cycle in the Pantanal, reducing it to rolling dry grassland or worse. This would destroy the largest and one of the most productive wetlands in the world.

Given the great global importance of this unique region, I am pleased to see the publication of this book, which will do much to increase awareness of its beauty and its diversity and to attract tourists from around the world. The truly outstanding photos by Theo Allofs and the very readable text by some of the world's leading authorities on the region combine to make this one of the best publications ever produced on this important ecosystem. I hope it will encourage you, the reader, to visit the Pantanal, as I myself have done several times, and to appreciate its many natural wonders firsthand.

Introduction

Home to some of the most spectacular concentrations of wildlife on Earth, the Pantanal region of Brazil, Bolivia and Paraguay is the world's largest contiguous wetland on the planet. Located between 16° and 22° South, and 55° and 58° West (see map page 7), it covers some 210,000 sq km. This area, about half the size of California, consists mainly of the low-altitude (average 80–180 m) floodplain of the Rio Paraguay and its tributaries, which drop off the Brazilian Cerrado, or *planalto* (central plateau). This huge, seasonally-flooded swampland is far more impressive and beautiful than any comparable region found elsewhere in the world.

The Pantanal covers a vast expanse in the middle of South America. With an average width of 500 km, it stretches in a north–south direction some 950 km along the upper Rio Paraguay basin.[1] It is bordered to the east by the savannahs and woodlands of the Brazilian Cerrado, extending as far as the Chapada dos Parecis; to the northwest by the semideciduous forests of the transition zone between Amazonia and the Cerrado; to the southwest by the Chaco formations (a wetland ecosystem of open vegetation and temperate climate) of Paraguay and Bolivia; and to the south by low-lying mountains, the Serras da Bodoquena and Maracajú.[2,3,4] To the west, it gently undergoes a transition into the dry forests of extreme eastern Bolivia along the Serra do Amolar. Some 70 percent of the Pantanal lies within the Brazilian states of Mato Grosso and Mato Grosso do Sul (which account for 40 percent and 60 percent, respectively, of the Brazilian side), with the remaining land lying within Bolivia (20 percent) and Paraguay (10 percent).

This enormous floodplain has been traditionally divided into subregions, based on history, soil type, vegetation, and its main rivers. Cáceres, Poconé, Barão de Melgaço, Paiaguás, Paraguai, Nhecolândia, Abobral, Aquidauana, Miranda, and Nabileque are some of the main Brazilian subregions.[5]

Rainfall

The Pantanal receives most of its rainfall, which amounts to 1,000–1,700 mm per year, during the rainy season between November and March.[6] With the area's average inclination of only 1.5 to 3.0 cm/km from north to south and 30 to 50 cm/km from east to west, water flows slowly on the flat land. The rain regime of more rain when the weather is hot (wet season) and less when the weather is cold (dry season) starts a flooding pulse that gradually affects different areas, depending on the amount of water they receive during the season. Large, permanently flooded areas, including lakes of up to 100 sq km, are found mainly in the northwest, in the state of Mato Grosso.[7,8]

Flood patterns

In the Pantanal region, the greatest area with the potential to be flooded in any calendar year is 130,920 sq km, but the mean flooded area in the last 100 years has been only 34,880 sq km. Among the major South American floodplains, the Pantanal has the highest variability

Giant water lilies (*Victoria amazonica*) in the Acurizal Reserve, Rio Paraguay. This magnificent species is only found in parts of the western Pantanal.

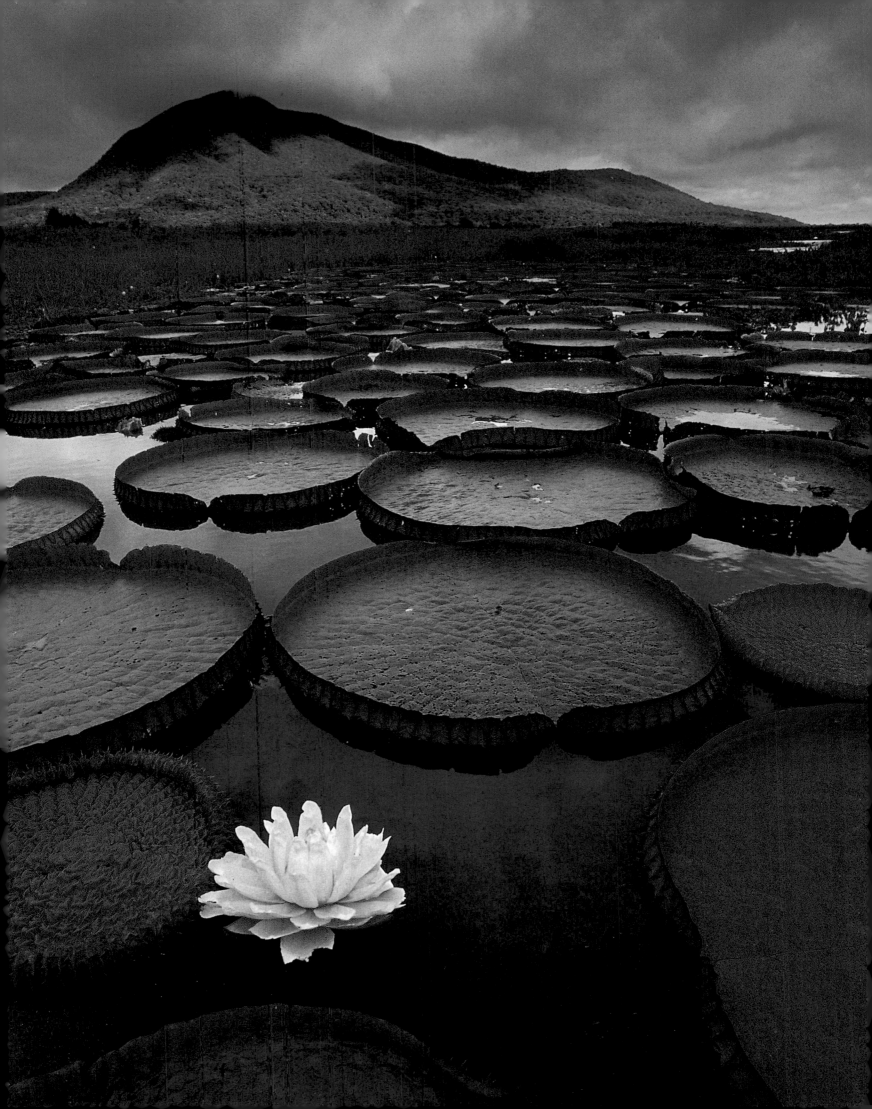

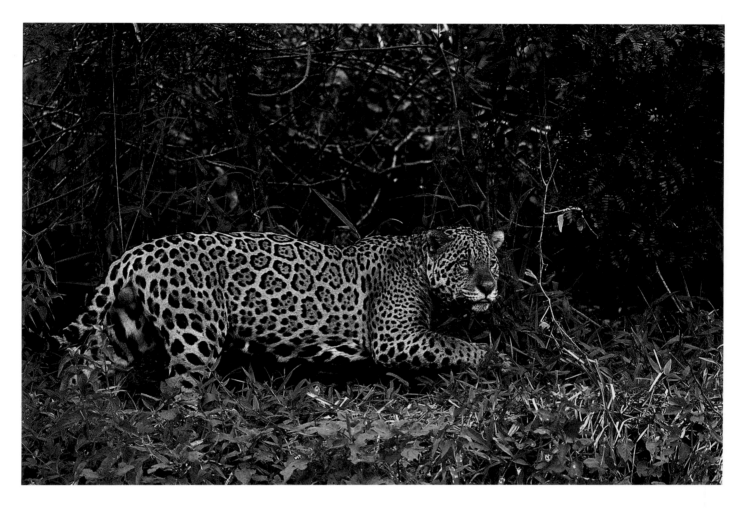

A Pantanal jaguar (*Panthera onca palustris*) stalking a capybara family on the banks of Rio Cuiabá. A favorite prey for America's biggest cat, the capybaras (*Hydrochaeris hydrochaeris*) jumped into the river to escape when they noticed the predator.

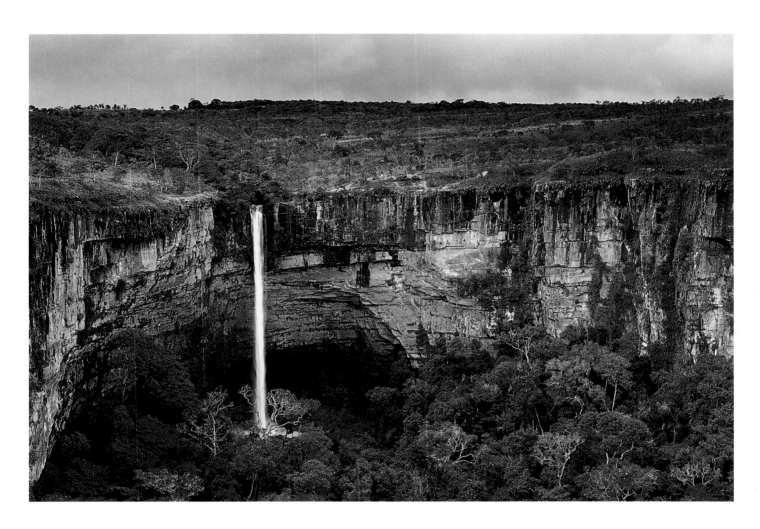

A waterfall plunges off the sandstone cliffs of the Chapada dos Guimarães. Much of the water flowing into the Pantanal comes from the rivers and streams of the Cerrado, Brazil's central plateau.

Water birds

Herons, egrets, bitterns, and many other water birds abound in the swamplands and reach amazing densities, the most impressive of which can be seen at the rookeries (*ninhais*). Among the many species found in the Pantanal are the roseate spoonbill (*Platalea ajaja*), the cocoi heron (*maguari; Ardea cocoi*), the wood stork (*Mycteria americana*), the great egret (*Ardea alba*), the rufescent tiger-heron (*Tigrisoma lineatum*), the black-crowned night heron (*Nycticorax nycticorax)*, the anhinga (*Anhinga anhinga*), the neotropical cormorant (*biguá; Phalacrocorax brasilianus*), and the southern screamer (*Chauna torquata*).

Reptiles

The most visible reptile species in the Pantanal is without doubt the Pantanal caiman or *jacaré* (*Caiman yacare*). An amazingly abundant crocodilian, this animal still numbers in the millions, and can be seen in almost any area of water. It occurs arguably at the highest densities of any crocodilian species. The writer and two companions once counted nearly 3,000 adults in a dry-season pool some 500 m long and averaging about 20 m in width. Although caiman were once heavily poached for the skin trade, with an estimated annual take of over one million skins in the 1980s,[29] hunting is now largely under control.

Comparable to the caiman in terms of flagship importance, but more difficult to see in its land and aquatic habitats, is the yellow anaconda (*sucuri amarela; Eunectes notaeus*). Even though it does not reach the length of its Amazonian relative, *Eunectes murinus*, at 4 m it is nonetheless among the largest snakes on earth.

Another very important reptile species is the caiman lizard (*víbora-do-pantanal; Dracaena paraguayensis*). The largest member of the family Teiidae, this giant, olive-brown lizard has a massive head, swims well, and eats mainly freshwater mollusks, which it crushes with its flattened teeth and powerful jaws. Its English name derives from the fact that it looks rather like a small crocodilian, while the local people call it *víbora* (viper) because it is considered poisonous and very aggressive. In spite of its fearsome reputation, it is not venomous and is quite shy in the wild.

Other reptiles in the region include the boa constrictor (*Boa constrictor*), the green iguana (*Iguana iguana*), the tegu lizard (*Tupinambis teguixin*), and a few turtle species, at least one of which, the Pantanal swamp turtle (*Acanthochelys macrocephala*), is among the few near endemic reptile species in the region, preferring the brackish water of the lakes in Nhecolândia.

Threats to the Pantanal wilderness

One of the first articles on threats to the Pantanal ecosystem was published by the writer and three associates in 1990, based on a trip to the region made in 1986.[30] This paper identified a series of environmental problems facing the area, some of which are still valid today, whereas others have been dealt with effectively in the past 18 years. Still others, unexpected at that time, have emerged in the interim. For example, large-scale poaching, a major issue in the 1980s, is now no longer a threat to caiman. On the other hand, major infrastructure projects like the Hidrovia (aquatic freeway) on the Rio Paraguay had not yet been conceived of in the 1980s, but began to emerge in the mid 1990s. What follows here is a review of the most important current threats to the region.

Deforestation and grasslands conversion

As always, habitat destruction is a major concern, and in the Pantanal it includes both deforestation and conversion of grassland habitats. Until recently, deforestation took place mainly to create more grazing areas for cattle on the higher land at the edge of the floodplain. After 1974, during the present multi-year wet cycle (10-year cycles of wet and dry occur in conjunction with the annual wet and dry seasons), the total area of native pasture decreased because of greater flooding, which in turn caused more intensive deforestation on the plain.

Cattle drive on the Transpantaneira Highway in the rainy season. As the water begins to rise towards the end of the rainy season, cattle are moved to higher ground.

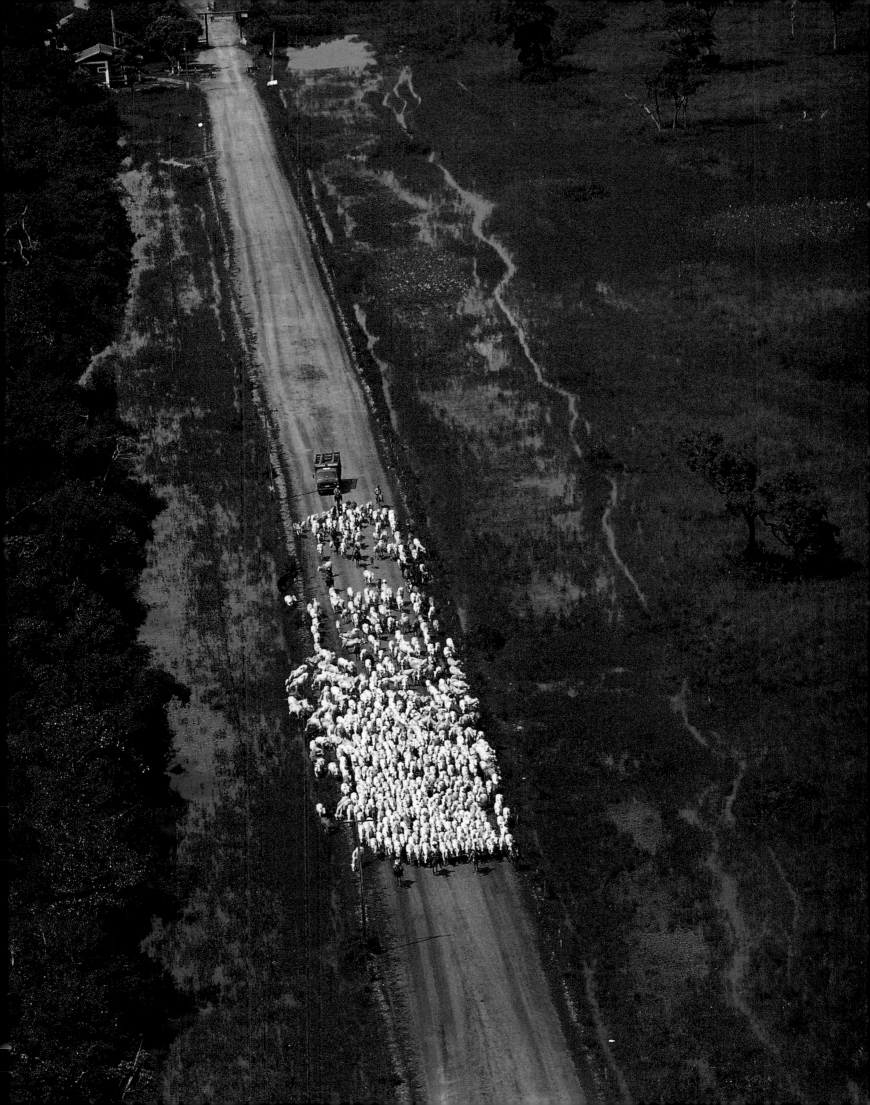

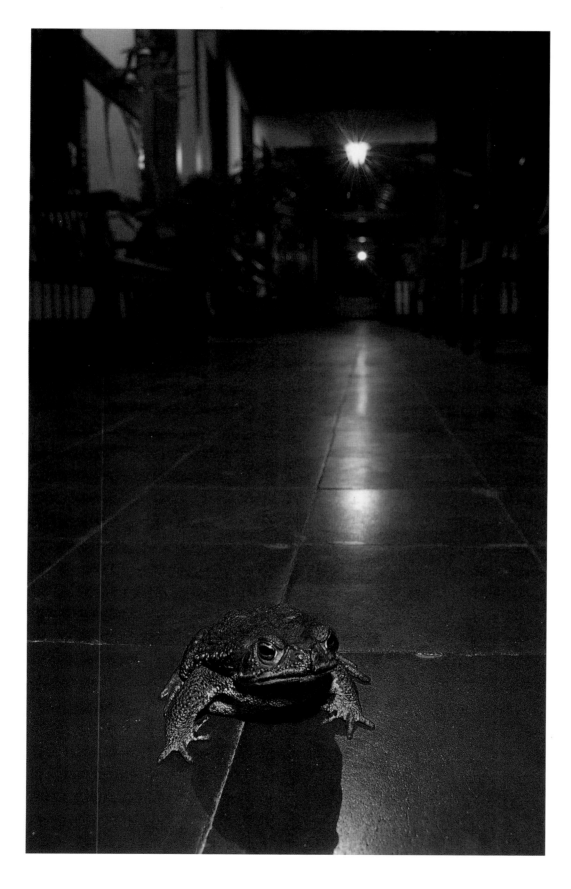

Cane toads (*Bufo paracnemis*) are a common sight around *fazendas*, in this case Fazenda Rio Negro. This South American native was introduced to Australia to control insect pests that threaten sugarcane crops. It quickly became a serious pest and in only a few years spread to other parts of the country, including Kakadu National Park.

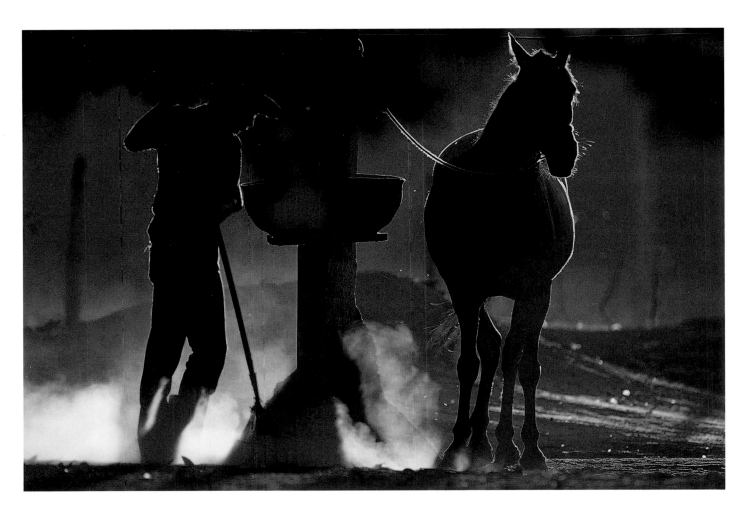

A young farm worker raking the yard at sunrise, a daily activity on many *fazendas*.

Nowadays, deforestation constitutes a major problem in the Pantanal, with 4.5 percent of the original 30 percent forested areas already destroyed and cultivated pastures increasing in size up to four-fold in just one year in subregions such as Miranda and Nhecolândia.[31] In addition, native grasslands such as the *caronais* have been cleared and tougher African species such as *Brachiaria humidicola* introduced. This highly invasive species spreads beyond its original plantings, reducing overall diversity. Such grasses also lead to more intense, uncontrolled fires. Ranchers tend not to burn these introduced grasses, which increases the fuel load. As a result, fires that begin spontaneously burn hotter and create more damage.

The breakup of larger properties over the course of generations has increased the demand for hardwood to create more fences. Replacement of fences occurs at a rate of about 10 percent per year, and burning also destroys fences and creates a demand for more wood to replace them. Combined with the negative effects of more intense burning, which destroys seedlings of valuable timber species, this kind of logging can have detrimental effects.

Hunting

Hunting of wildlife has always taken place in the Pantanal, but large-scale commercial exploitation did not begin until the early part of the 20th century. Certain old references, such as the 1914 *Album Graphico do Estado de Mato Grosso*,[32] give a good indication of the number of skins and feathers that were exported to Europe, and export of skins continued legally until 1967. After that year, when Brazilian legislation prohibited such hunting, large-scale poaching of caiman continued, with millions of skins being exported through Paraguay and Bolivia. This continued until the 1980s, when enforcement finally became effective, thanks to the participation of ranch-owners. However, some export for the pet trade, focused mainly on birds, continues to this day.

Traditional hunting of game species like peccary, tapir and deer has had little impact, but the continued hunting of big cats remains an issue.[34] Although it is less serious than it was in the past, it still occurs — mainly because of the inevitable conflicts between cattle-ranchers and these large predators.

Overfishing

Overfishing is more of a problem in the Pantanal than overhunting. Long a traditional activity in the region, fishing was the first Pantanal tourist attraction. However, as the popularity of the area increased among fishermen from the developed states of southern Brazil, demand for the most desirable species — the "Big Five" of *pintado* (*Pseudoplatystoma corruscans*), *cachara* (*Pseudoplatystoma fasciatum*), *jaú* (*Paulicea lutkeni*), *dourado* (*Salminus maxillosus*) and *pacú* (*Piaractus mesopotamicus*) — grew rapidly, creating an external market, especially in the state of São Paulo. In 2004 it has been estimated that illegal catches match the amount taken by legal fishing (170 tonnes/year).[35] The result is that some watersheds have been severely depleted, and stocks of *pacú* and *jaú* in particular have become threatened. [36]

Introduction of exotic species

Introduction of exotic species is also a cause for concern. In addition to the ranchers' adoption of African grasses, introduced animals like feral pigs (*monteiros*), European wild pigs (*javali*), Amazonian peacock bass (*tucanaré*) and golden mussels (*Limnoperna* sp.) are a problem in different areas of the region. Dogs, cats, water buffalo and other domestic species can also have an impact on local fauna and flora if not properly controlled. Fortunately, the Pantanal ecosystem is extensive and very resilient, and the large population of predators at least partly helps to control some of the introduced animals, such as the pigs. All things considered, exotic species are much less of a problem in the Pantanal than, for example, in many more fragile island ecosystems.

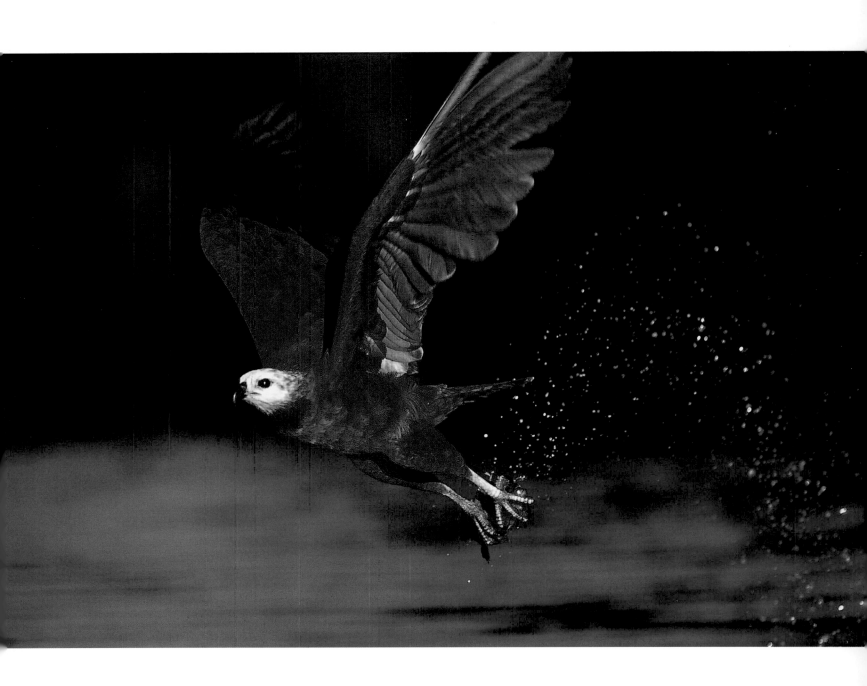

A black-collared hawk (*Busarellus nigricollis*) with a fish in its claws. These birds can be seen perched on trees along the waterways searching the surface for possible prey.

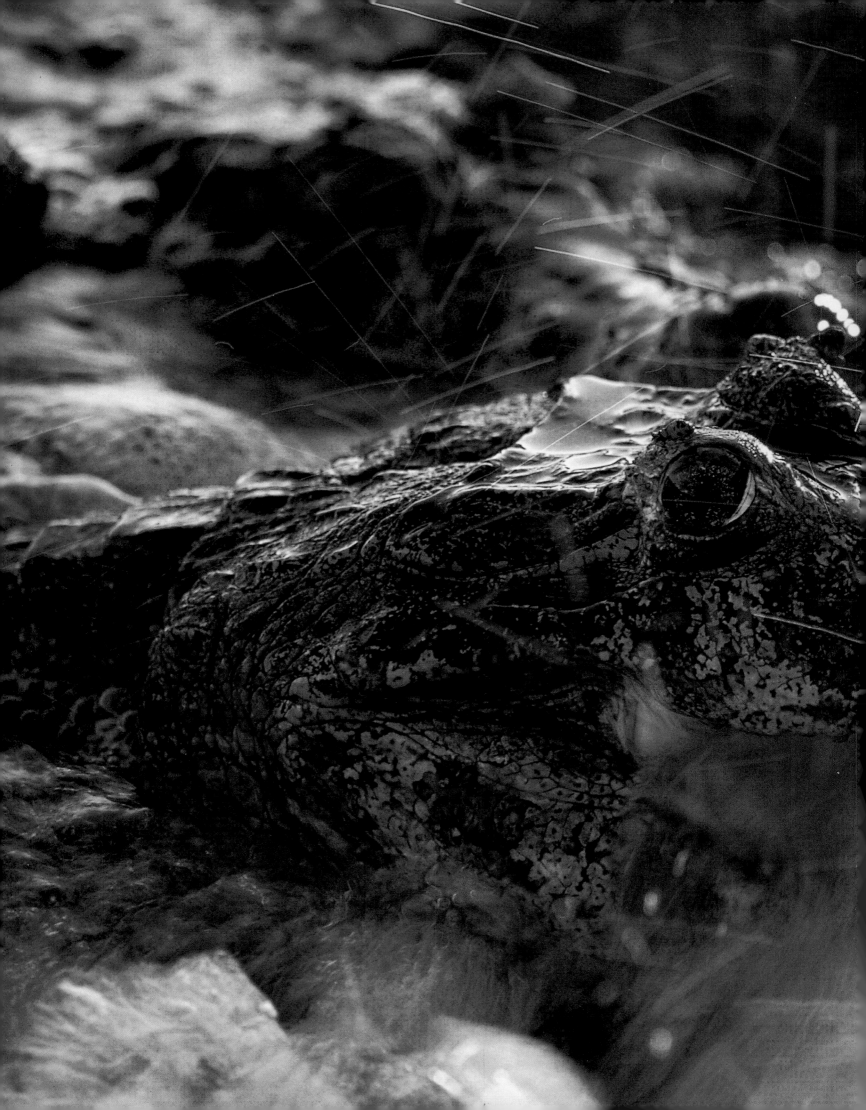

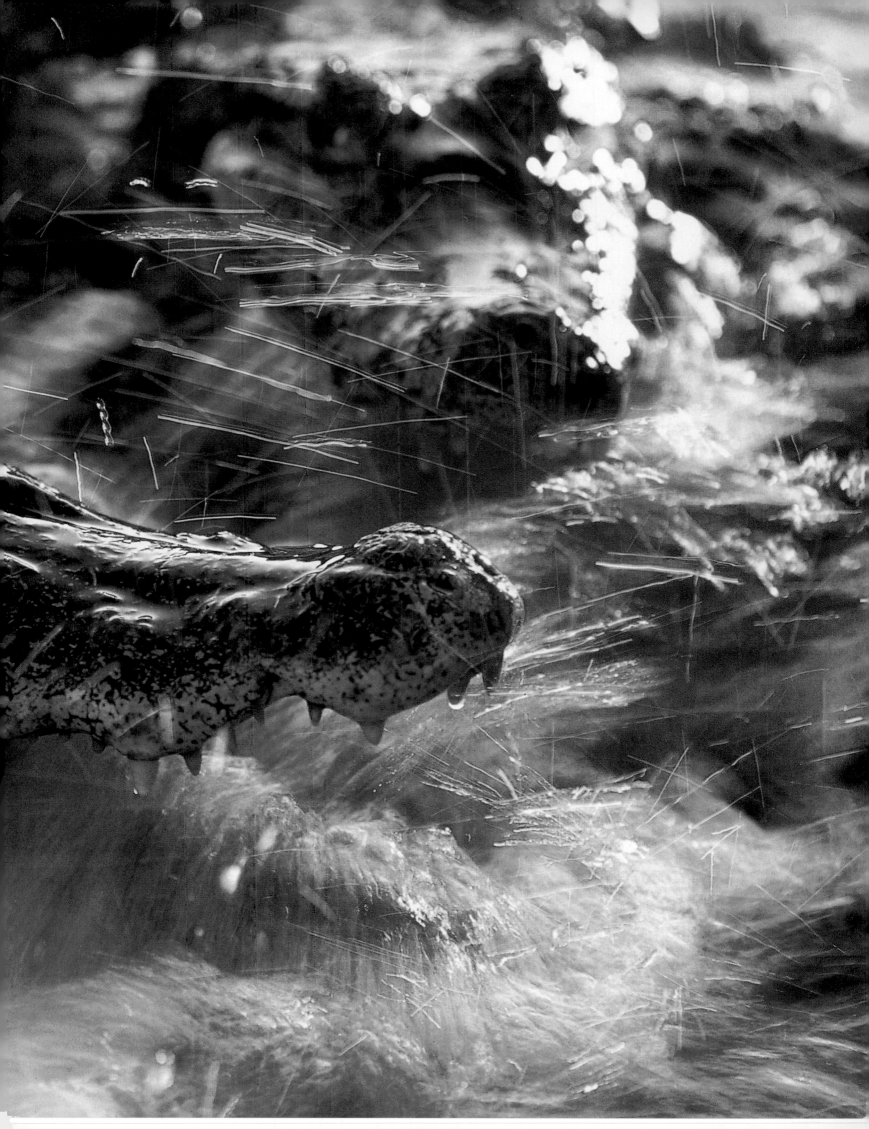

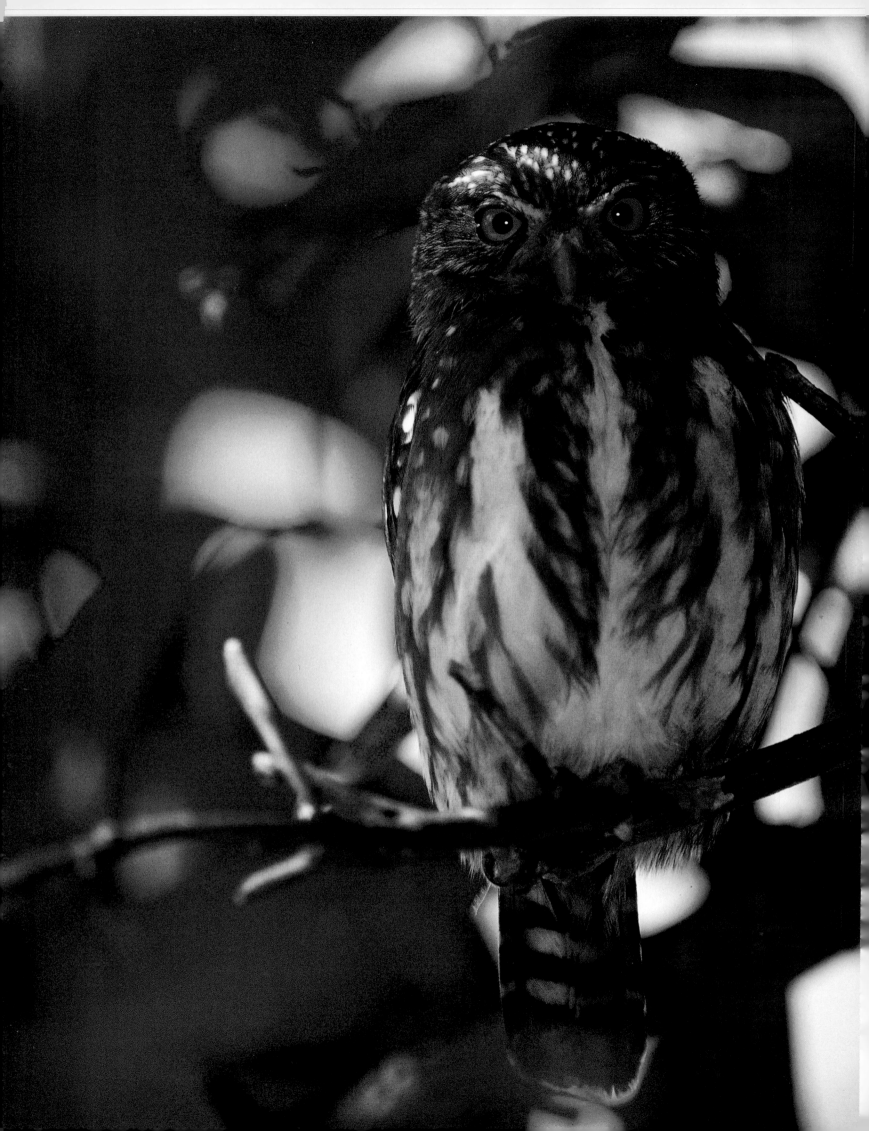

A cocoi heron (*Ardea cocoi*), RIGHT, with a huge fish in its bill. These herons stand motionless in or near water for long periods waiting for suitable fish or small vertebrates to come within range.

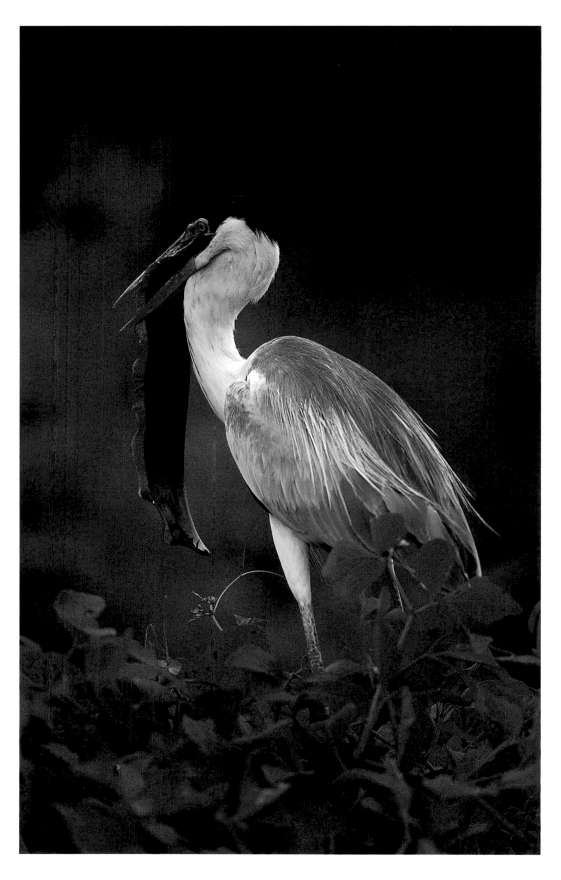

The ferruginous pygmy owl (*Glaucidium brasilianum*), OPPOSITE, is only 16 cm in length and is active day and night around forest edges and fazenda gardens.

The Pantaneiro

People of the Pantanal

Although cattle-ranching has defined human activities in the Pantanal for the past two centuries, people have been part of the scene here from much earlier times. Pre-Columbian records indicate that the occupation of the floodplain was initiated 5500 years ago. Peoples with a ceramic culture appeared around 2000–2500 years later. Determined by archeologists as belonging to the indigenous groups of the Pantanal tradition, they left archeological sites known as "mounds".[1,2] These mounds, abandoned 1000 years ago, were later re-occupied by indigenous groups historically known as Payaguá, Mbayá-Guaicurú, Guató and others. Rock art in different areas are a record of their presence. The Payaguá , Mbayá-Guaicurú and Guató were excellent canoeists and well adapted to life on the floodplain, where their descendants remain to this day.

Some of the indigenous groups lived permanently along the rivers, building on islands of dry land in the great freshwater sea. Others became better adapted to the nearby Cerrado, but still used the wetlands as hunting grounds during the dry season. Their warriors were a nightmare for the first expeditions of the *bandeirantes*, the famous Brazilian pioneers searching for El Dorado, the fabled gold-rich land of the Conquistadores. Today, only a few Guató remain, living around the Pantanal National Park in the north. The Mbayá-Guaicurú, on the other hand, were granted a 500,000 ha reserve in the southern Pantanal by the Portuguese in appreciation for their help in fighting the Spanish. This land, located between the Serra da Bodoquena and Porto Murtinho in the region called Nabileque, is now occupied by their descendants, the Kadiwéu.

In the early colonial period there was much activity in the La Plata watershed, which was considered the gateway to South America's heartland and a route to El Dorado. When explorers began arriving looking for gold and precious gems, the spread of devastating diseases and the conflicts that emerged had the same negative impacts on indigenous people here as in the rest of the Americas.

European exploration

When the first Spanish explorers arrived in the area known as the Mar dos Xaraés (Sea of Xaraes), or more properly the Laguna de Xarayes, they found a tropical paradise, albeit full of biting insects. It remains so today, and those who visit it right after the first rains might experience the same amazingly rich environment, full of wildlife and lush vegetation.

Pantanal farm worker, Rogério Alves, drinking *tereré*, a tea taken cold from a horn. *Tereré* is traditionally shared among the *peões* (Pantanal cowboys) to cool down in the heat.

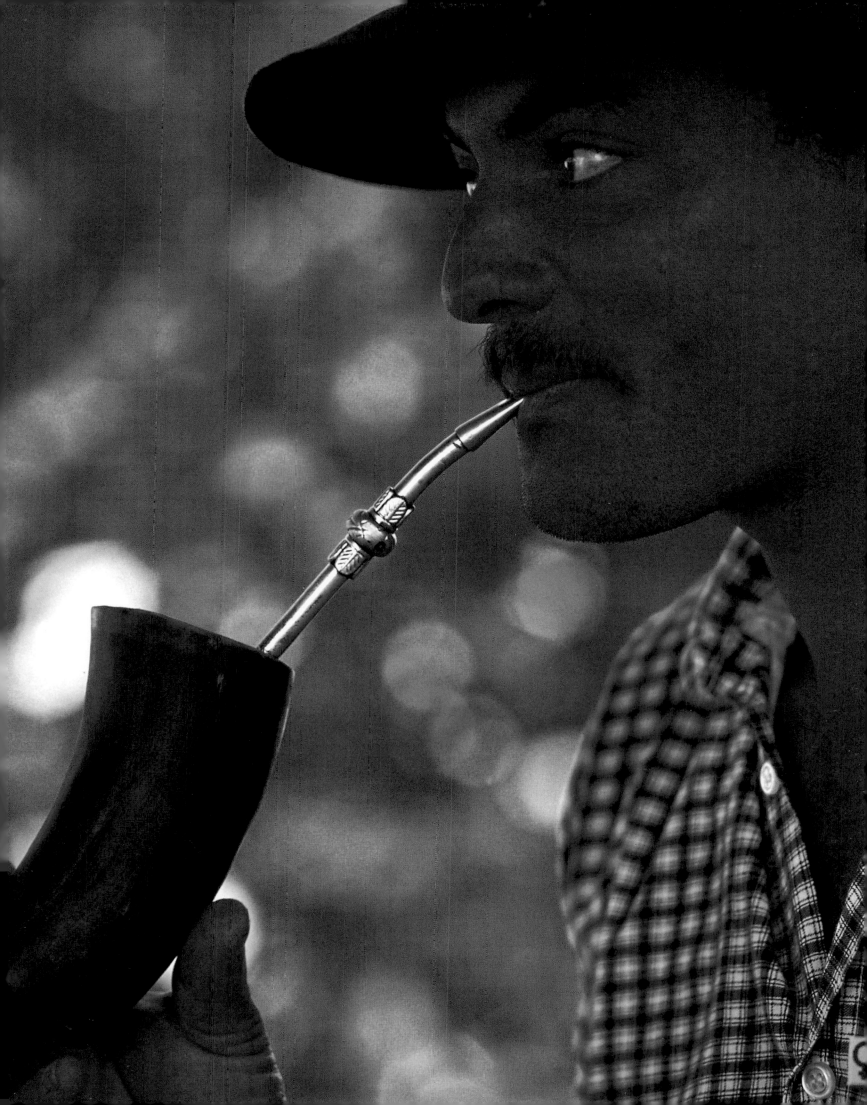

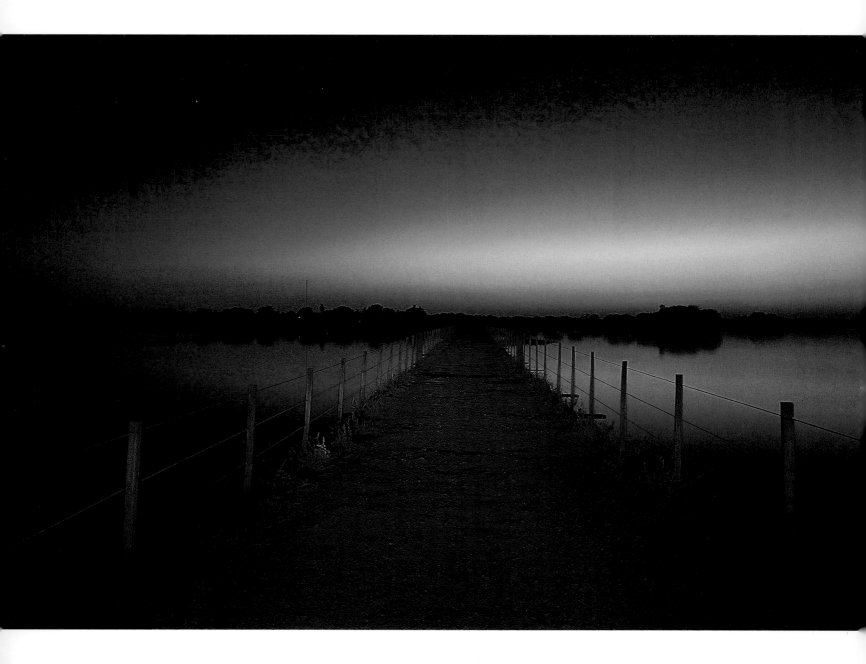

A bridge over a lagoon at sunrise, Refúgio Ecológico Caiman.
This fully operational *fazenda*, owned by Roberto Klabin, was
one of the pioneering ecotourism operations in the Pantanal.

45

A cowboy with his horse, still the most important means of transport for ranch workers, in a dusty yard early in the morning, Fazenda São José.

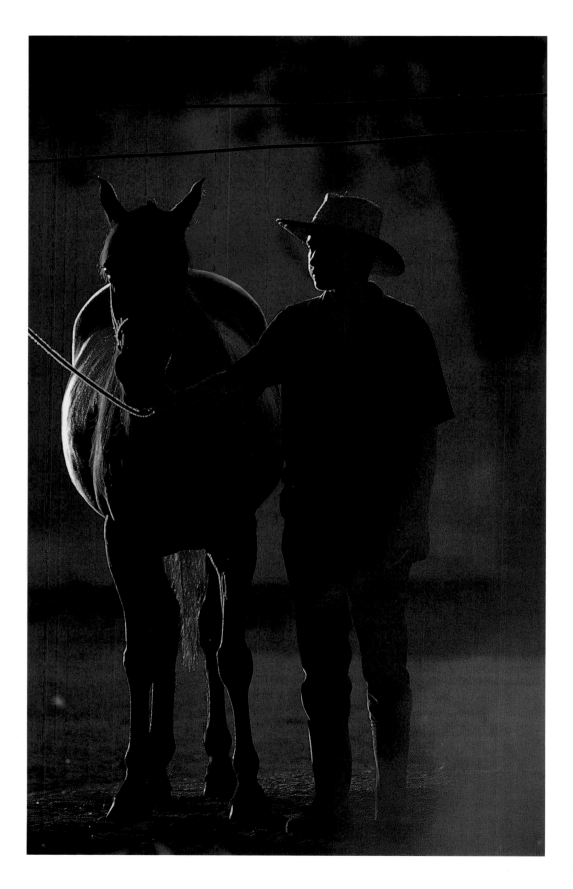

However, carving out a living in the Pantanal was a real challenge. Around 1540, during the time that the Spanish ruled over this region, the first European explorer in the Pantanal, Álvar Nuñes Cabeza de Vaca, was able to move upstream along the Rio Paraguay, with help from various indigenous groups, and he started several settlements.

Later, Portuguese settlers moved in and began to push the borders of Brazil deep into the heart of South America, ignoring treaties and agreements, or at least using royal contracts and marriages back in Portugal and Spain to justify their activities.

Early colonial settlements

Trade between the lowland tribes and those of the Andes involved precious metals, which soon led the explorers to the silver mines of the Bolivian Andes and the alluvial goldfields of places like Cuiabá, today the capital of the state of Mato Grosso. With the discovery of gold, colonization of the Pantanal region began in earnest. The first colonial settlements in the area were in Corumbá, Livramento, Cáceres and Coimbra, where fortifications and trade posts were established. Some indigenous groups made peace with either the Spanish or the Portuguese and fought under their flags to conquer others, eventually resulting in a negative situation for all the indigenous people of the region.

In Cuiabá, several other commercial activities developed at the time of the gold rush, with the result that the interests of the Portuguese crown increased and demanded more local control. This in turn attracted more settlers and at the same time lead to increased cattle-ranching to support the growing population. The cattle brought by the Portuguese were mixed with breeds introduced by the Spanish and became well adapted to the native grasslands. Ranching soon became a very worthwhile business, and meat and other goods from the region began to be traded for European products brought in by boat to Corumbá via the Rio Paraguay.

Cattle ranches prosper

The end of the 19th century and the first half of the 20th century were the most prosperous eras for cattle raising and also for the wildlife trade in the Pantanal. The need for beef to feed soldiers in World Wars I and II was strong enough to encourage English beef companies to build a railroad and develop huge ranches. Traditional families who had established themselves during the gold rush era started to develop farms to produce beef, at first dried and later corned. European interests also created a demand for wildlife products, including egret feathers, spotted cat and otter fur for the fashion trade, and peccary leather to make gloves. The hard work of the early settlers began to pay off, with the readily available but difficult to settle land producing enormous prosperity for those who accepted the challenges.

The natural grazing lands of the region required minimal investment, so profits were extremely high. Entire generations of descendents from the original farmers were sent to the cities of Rio de Janeiro and São Paulo to get good educations, in the hope that they would return and take over the family businesses. Many returned to help their parents, but for others life in the city proved to be much more exciting than living in the wilds of the Pantanal. Entire families moved to local urban areas, leaving their employees to care for their properties, which they visited only once or twice a year. The beautiful houses that had been built at the beginning of the 20th century became unused and very expensive to maintain. New houses were built in the major urban centers and fortunes were spent there, draining the wealth of even the most productive farms.

The expansion experienced by the Brazilian economy during the 1960s pushed the local economy to produce and sell enormous numbers of cattle to markets in São Paulo. The need to increase production led to the introduction of Indian cattle (Zebu), which added new blood to the traditional and well adapted Tucura breed brought in by colonists during and after the gold rush.

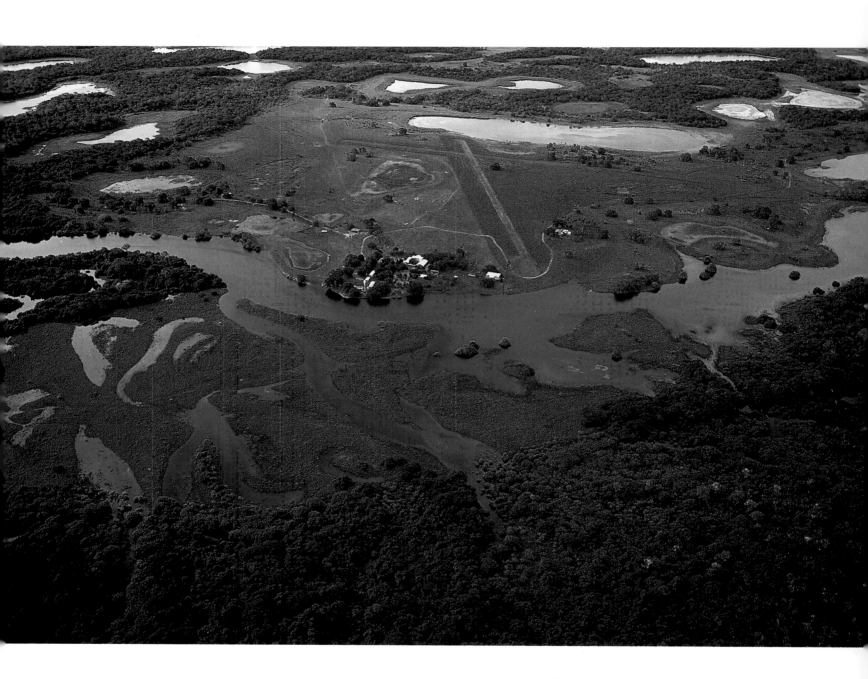

An aerial view of Fazenda Rio Negro in April, at the end of the rainy season. Famous in the late 1980s as a location for the well-known Brazilian soap opera *Pantanal*, it is now owned by Conservação Internacional (CI–Brasil). Fazenda Rio Negro was recognized as a private protected area in 2001 as part of a strategy to link with neighboring *fazendas* and a State Park to create a biodiversity corridor.

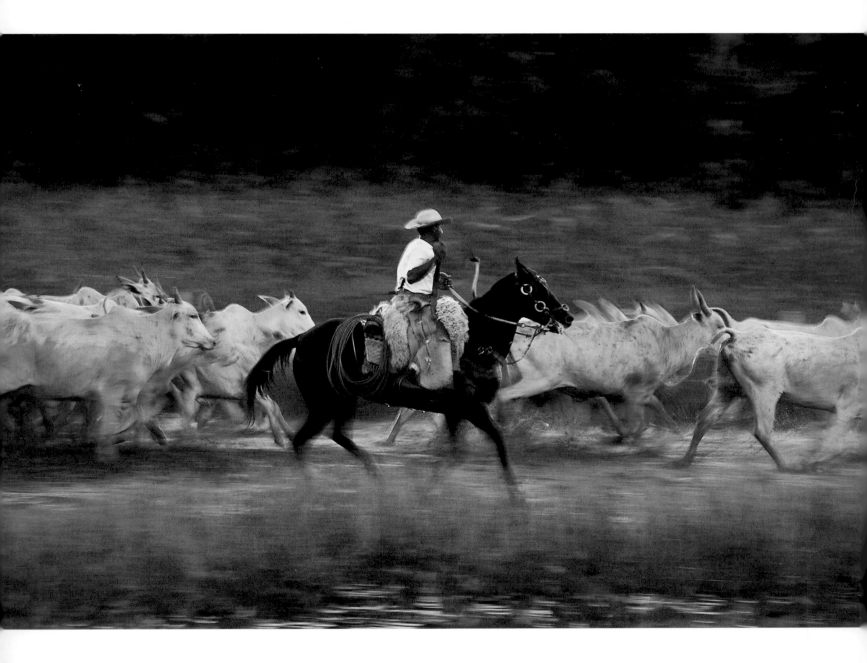

A cattle drive on Fazenda São José. In many parts of the region,
cattle are still farmed in much the same manner as 200 years ago.

49

A Pantanal cowboy, LEFT, with his traditional knife and knife sharpener. These two pieces of equipment, used by every cowboy in the region, are carried in a leather case known as *bainha*.

Pantaneiro Luiz Carlos Fernandes dos Santos, RIGHT, barbecuing beef at Fazenda Rio Negro. Under Conservation International's ownership the number of cattle on the ranch has been reduced from several thousand to 120. The few animals left are for supplying staff and tourists with milk and meat.

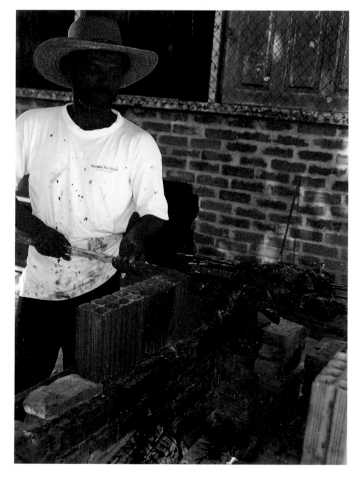

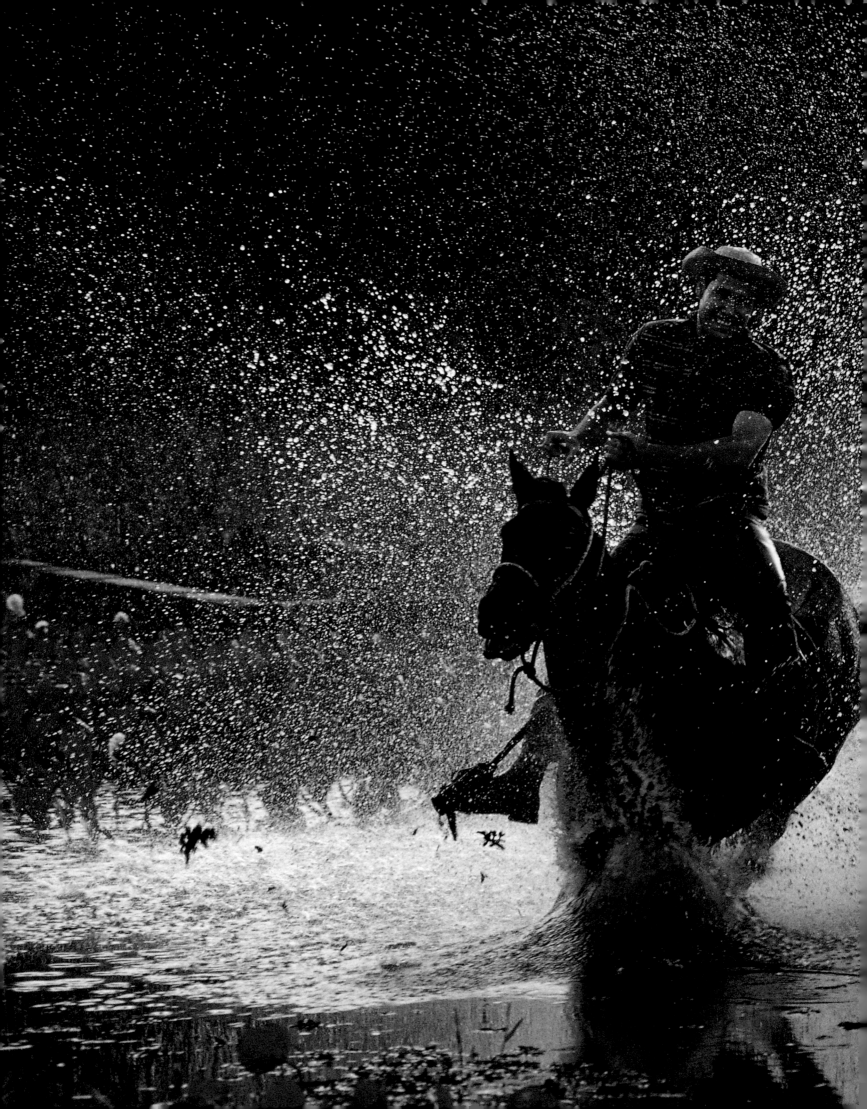

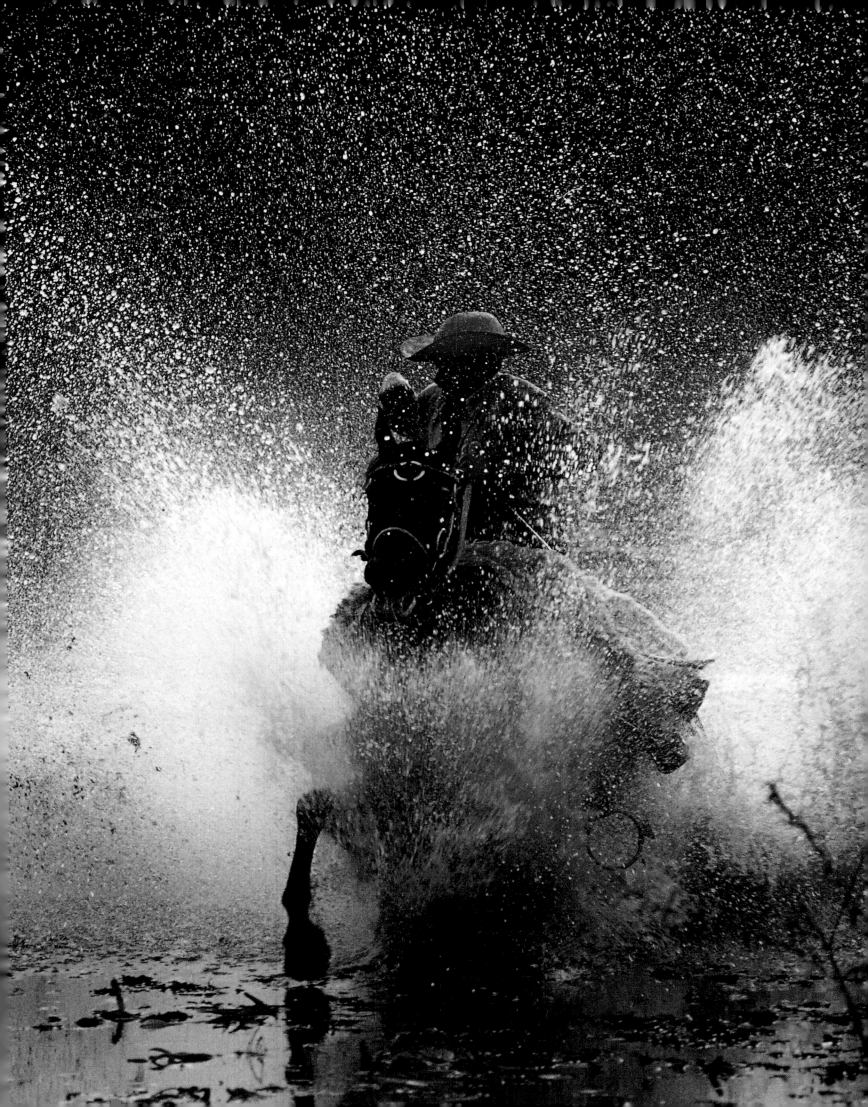

Deteriorating fortunes

In the sixties and early seventies, several damaging events held back the development of the cattle industry. First, an infectious anemia, a disease similar to HIV, almost destroyed the entire horse population, which was critical for taking care of the cattle herds. This was followed by a prolonged drought which left many ranches too isolated from permanent water sources to be able to survive.

Cattle-ranching changed forever during the late seventies and eighties, and local people who had followed *gaucho* cattle traditions for centuries experienced new pressures. The social structure, based on family partnerships and villages built around each farm to manage and care for the herds, started to break up. With the advent of increased technology fewer people were needed to carry out the traditional duties and more were attracted to the city life. More imported goods were consumed in place of those produced locally. Cattle buyers, known as *boiadeiros*, came on airplanes and sent their cattle drivers to move the animals to fattening facilities outside the Pantanal. These changes took place over a two-decade period and were heavily influenced by the expansion of the Cerrado region, which was being increasingly opened to agriculture and cattle-ranching. The Cerrado was closer to the major markets, and, since it was not subject to seasonal flooding, it was easier to clear the land here for pastures and plant aggressive African grass varieties, which provide more productive pastureland for cattle.

Modern developments

With the many changes that took place in the second half of the 20th century, the life of the *Pantaneiro* began to change dramatically. Traditional ranching balanced the interests of people and nature, but the changes that have come in recent years have begun to upset this delicate balance. New pressures have forced families to divide up large traditional landholdings, which are often sold off because of lack of interest or the skills to manage them properly. Outsiders have moved into the region, bringing land-use practices and interests that conflict with traditional patterns. New economic activities have been introduced, including various kinds of agriculture, wildlife management and unregulated tourism. Some of these have had a negative impact, including those that have attempted to create permanent dry land for agriculture by using dikes to prevent waterflow into certain areas.

As outlined in the introduction, some of these developments and new farming practices have also created a series of problems for conservation and for the long-term survival of this region, including sugarcane plantations, alcohol distilleries, commercial soybean production on the surrounding plateaus, and major infrastructure projects such as the proposed Hidrovia to improve access to major markets, the Bolivia-Brazil gas pipeline, and the various hydroelectric power plants. Some local farmers, seeking development and being poorly informed about the consequences of such projects, have supported these initiatives. Others, more conscious of the natural riches of their homeland, are searching for alternatives such as ecotourism, organic agriculture and other low-impact economic activities.

It is hoped that these new directions will help to ensure the survival of this unique wilderness area, while at the same time preserving the traditional lifestyle of the *Pantaneiro* that has in many ways been responsible for this unique ecosystem so far remaining largely intact. Building from the traditional knowledge of the local people and incorporating the latest approaches in conservation-based development, it should be possible to protect the rich wildlife resources of the region and also guarantee a worthwhile and enduring quality of life for its human inhabitants.

RUSSELL A. MITTERMEIER, MÔNICA BARCELLOS HARRIS, CRISTINA G. MITTERMEIER, JOSÉ MARIA CARDOSO DA SILVA, REINALDO LOURIVAL, GUSTAVO A. B. DA FONSECA

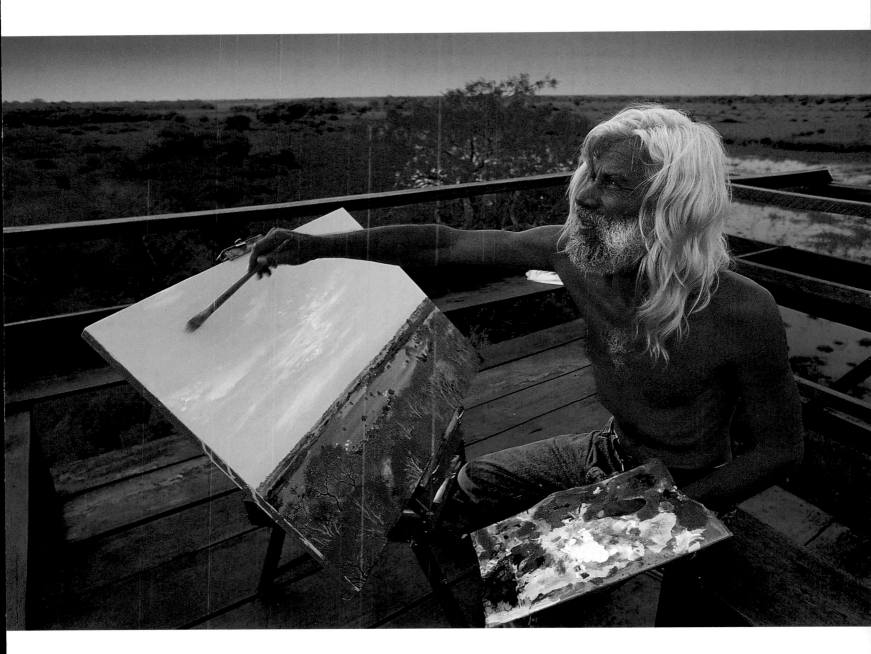

Artist Renato Campello painting a landscape from an observation tower south of Poconé, northern Pantanal.

PREVIOUS PAGES: Cowboys Joelci Albuquerque (left) and José Moreira ride full gallop through a swamp in pursuit of a herd of Pantanal horses. The *Panteneiro* horse was introduced by the Spanish, and later the Portuguese, from the late 16th century onward. In more recent times, it interbred with other introduced horses and the breed almost disappeared. Project Cabellero Pantanal has been attempting to save the Pantanal horse as it is smaller and better able to handle the wet conditions and hot weather of the region than other horses.

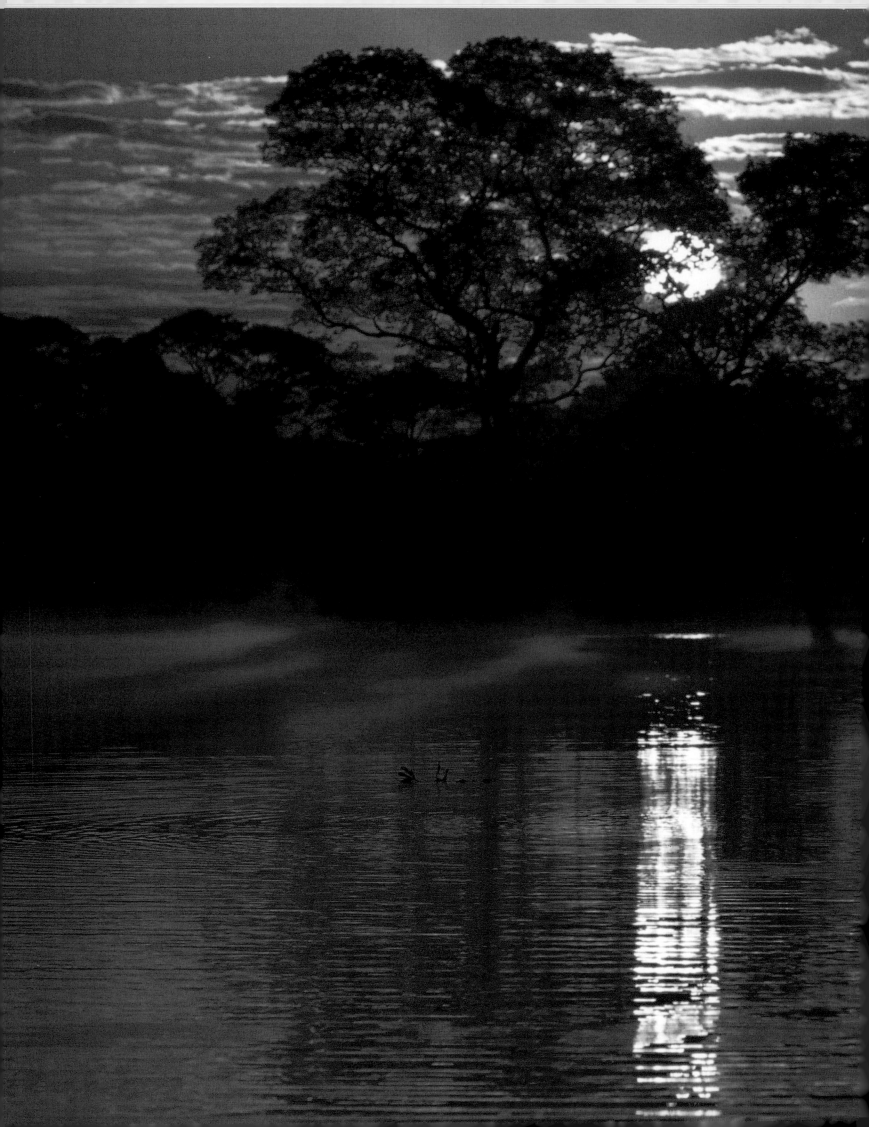

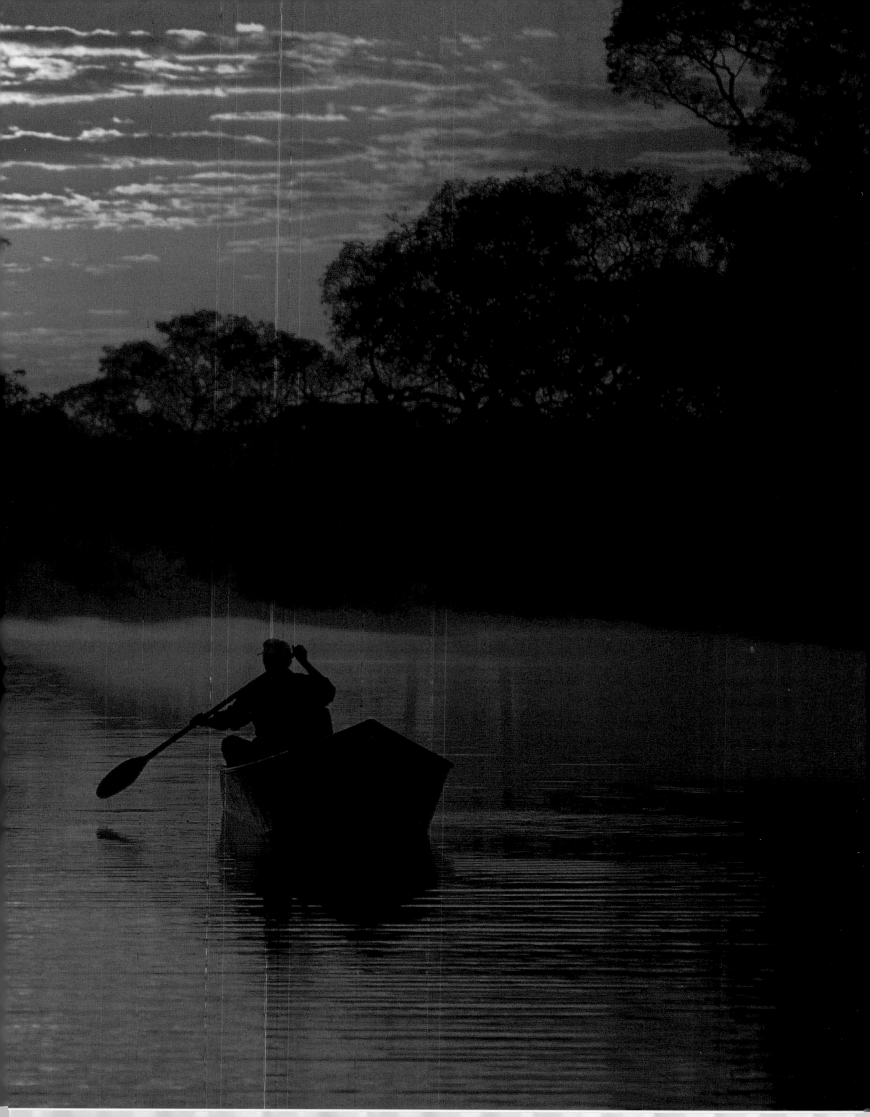

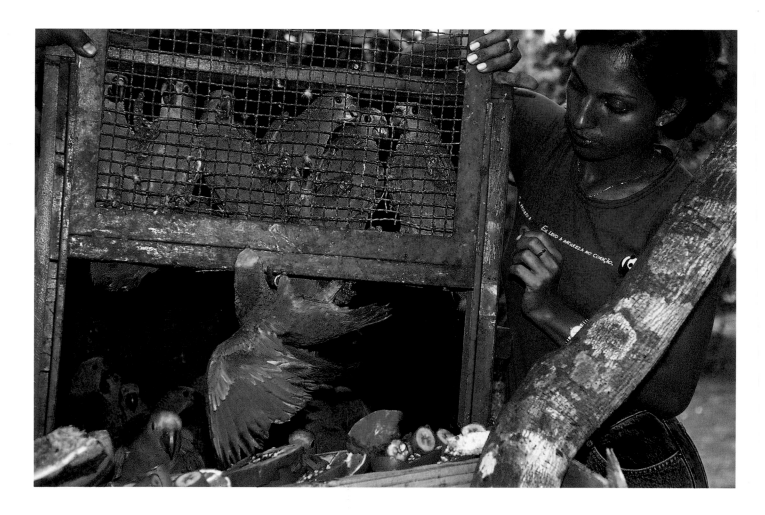

Biologist Alessandra Firmino releasing turquoise-fronted parrots
(*Amazona aestiva*), victims of the illegal pet trade, on a farm near
Aquidauana in the southern Pantanal.

Blue-and-yellow macaw (*Ara ararauna*), OPPOSITE, confiscated from
bird smugglers and released on a farm. The illegal trade in macaws
and parrots continues to be an issue in the region.

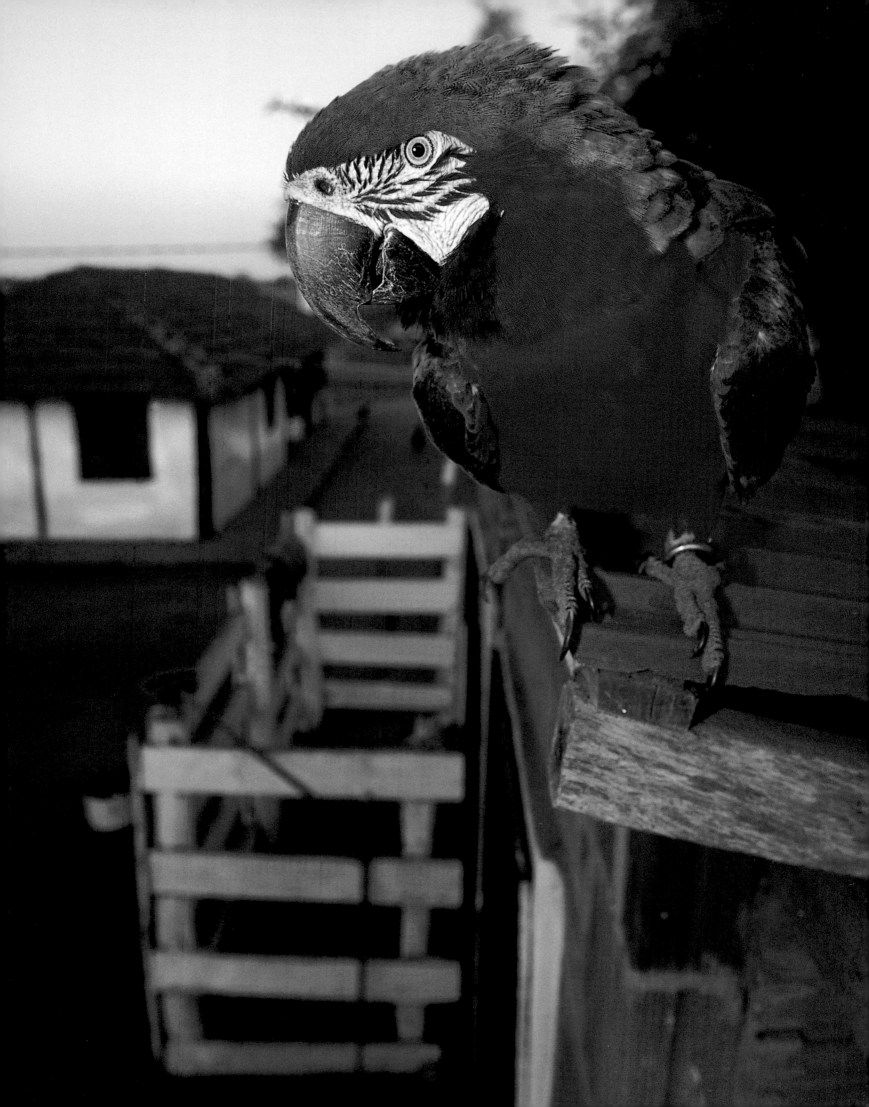

Wetlands

Life at the water's edge

Life at the water's edge on the planet's largest floodplain is one of seasonal spectacle. The pulse that drives it is the Pantanal's somewhat predictable annual cycle of floods and droughts. The diversity of aquatic systems found here — from large rivers, lakes and marshes to the unusual *salinas* and *baias* — forms an immense mosaic of land and water harboring great densities of animals and plants. Both wet and dry seasons, while strikingly different, provide feeding and reproductive opportunities for many aquatic and terrestrial species.

The wet season

In the wet season (October to March) astonishing populations of frogs and toads are encountered and their deafening choruses are just one indication of the vast numbers of smaller creatures lurking in waters here. Not surprisingly, the reproductive period of many species is synchronized with the annual flooding cycle, with the start of the major rainy months signalling them to begin their mating rituals to maximize survival for their offspring. The season of flooding is also a time when predators such as caimans follow their ancient routes into the most remote areas of the Pantanal where they can nest and reproduce.

As if sensing the commencement of the rainy season, many of the 325 local fish species begin the *piracema*, the migration process that will take them to protected breeding sites. Fish larvae find safety from predators in the tangled masses of vegetation in the permanently flooded shallows of the *baias* and *corixos*, as well as the newly inundated, low-lying *vazantes*. Here refuge is offered by such aquatic species as water hyacinth and water lettuce, also plants of the shallows like *Salvinia* and *Nymphae*, including the Pantanal species of the giant Amazon waterlily (*Victoria amazonica*).

A giant otter or *ariranha* (*Pteronura brasiliensis*) with a freshly caught catfish, Rio Pixaim, northern Pantanal.

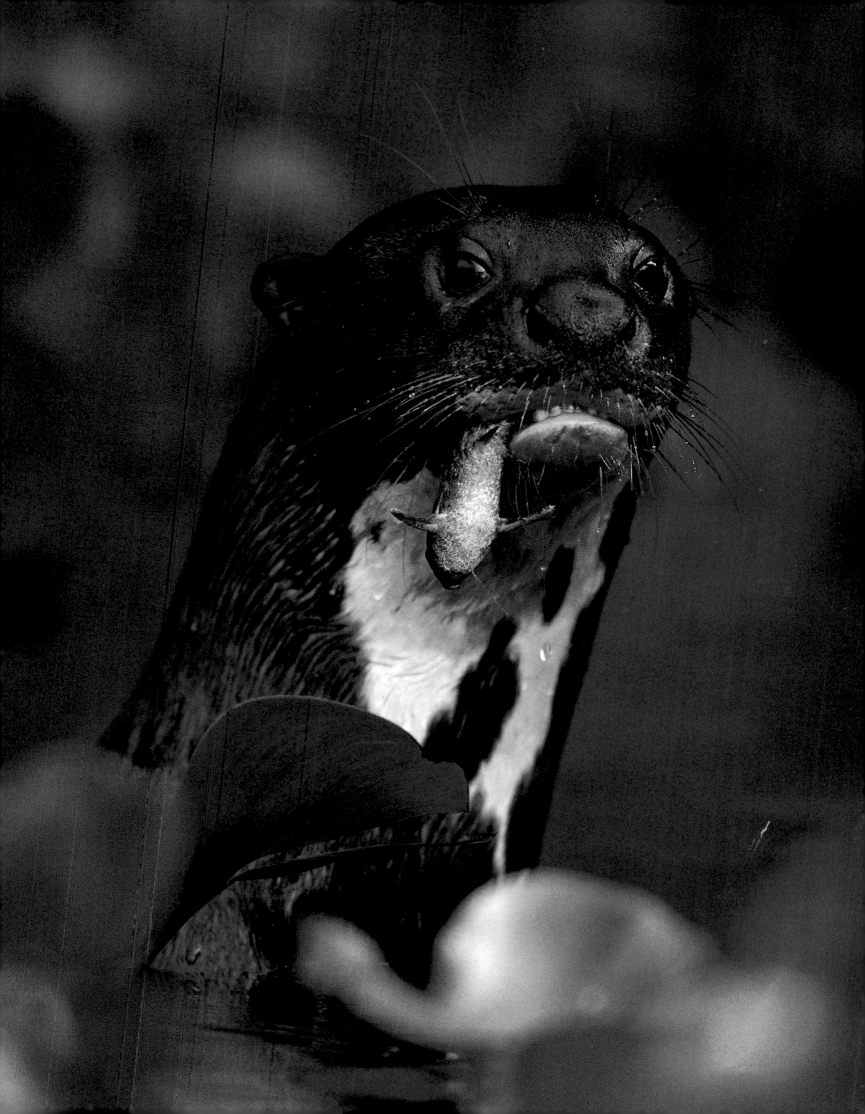

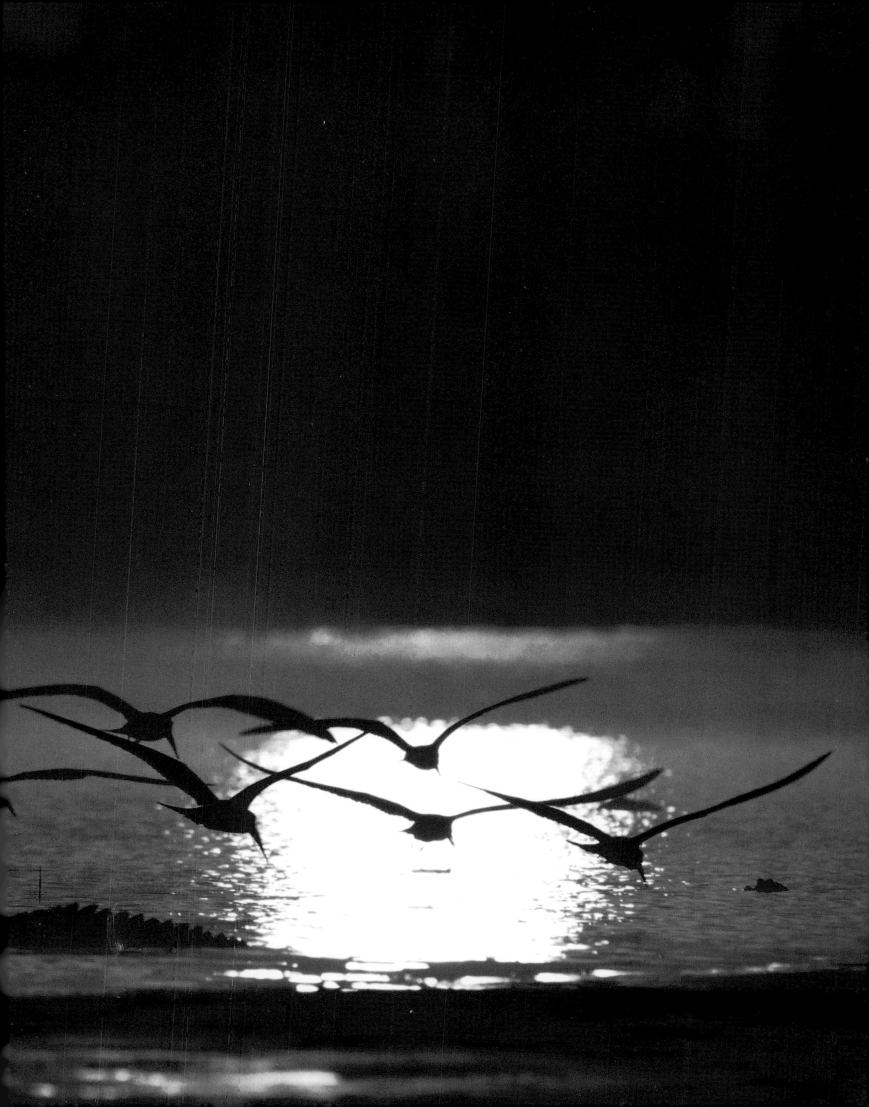

The giant Amazon waterlily

This waterlily, the largest aquatic plant in the world, grows in depths of a meter or so (the deeper the water, the larger the leaves) and is sometimes found alongside *Wolffia*, the smallest known flowering plant. The blossom of the giant waterlily, considered the largest flower in the Americas and the second largest in the world, grows up to 30 cm in diameter and blooms only over a period of two nights. When it first opens, the flower is milky-white and exudes a strong odor that attracts *Cyclocephala* beetles. The bloom then closes with the first light of day, trapping the beetles inside. It opens again the following night now a blush-colored flower, and releases the beetles loaded with pollen.[1]

Plants of the swamplands are all highly affected by the seasonal wet and dry cycles. Trees and shrubs invariably occupy the areas just above the high-water mark, while the floodplain itself is covered mainly by herbaceous species.[2] Many of the terrestrial and aquatic plants produce fruits during the wet season, making the most of the high waters to disperse their seeds.[3,4]

The dry season

The arrival of the dry season creates real constraints to most of the basic components of this ecosystem but opens opportunities for others. The drying ponds filled with fish provide abundant food for wading birds such as *jabiru* storks and roseate spoonbills as well as for the widespread caimans, ensuring the health and viability of next season's offspring for many species.

Two kinds of rookeries (*ninhais*) occur within the Pantanal. The so-called "white rookeries" are formed during the dry season and are composed mainly of wood storks, spoonbills and white egrets. The "black rookeries", with species like herons and cormorants, are usually linked to the floods and have their distribution always connected to the areas rich in fish close to swamplands, lakes and productive oxbow lakes (meander loops that have been cut off from the main flow of the river). In both instances, regardless of their foraging or reproductive strategies, the various bird species rely on the productivity of the ecosystem to provide food sources for their offspring.

If visiting the Pantanal from June to September, the driest months of the year, one can gain a unique perspective of the importance of water to all living creatures. Even tree-dwelling animals like howler monkeys can be seen walking on the ground in search of waterholes. Large congregations of animals gather around the few remaining water pools, both natural and man-made, creating a major tourist attraction and making the dry season the prime time to visit.

Animals of the water's edge

The seasonal gatherings can be misleading. For example, visitors could well assume that the Pantanal has an overpopulation of caimans. One of the smaller crocodilian species, the Pantanal caiman (*Caiman yacare*) reaches about 2.5–3 m in length and 55 kg in weight. It is basically harmless to humans, can be approached to a distance of less than a meter in its habitats and is unquestionably one of the great tourist attractions of the region, with night-spotting an amazing experience. The estimated population of non-hatching caimans is a staggering 35 million, and densities can reach 150 individuals per square kilometer.[5]

In the dry season hundreds of caiman can be observed clumped together in oxbows and small cattle waterholes, as they would die of dehydration if they dared to venture into the grasslands looking for larger pools. Crocodilians are very sensitive to temperature; so much so that even their sex is determined by it, with hotter temperatures hatching more males and cooler ones more females. When traveling from one drying pond to another, caimans can easily miscalculate the distance and get trapped under the scorching sun, paying with their lives for this mistake.

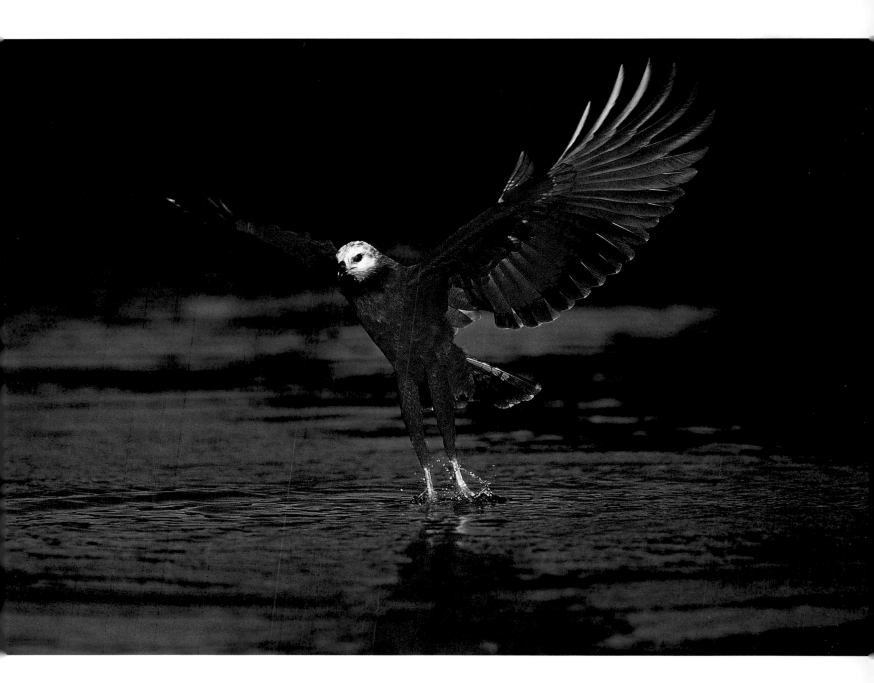

A black-collared hawk (*Busarellus nigricollis*) catching a fish in the Rio Claro, northern Pantanal. This species is one of the most common raptors in South American wetlands and mangroves. It hunts by jumping feet first into floating vegetation or shallow open water, mostly preying on fish, but also occasionally on frogs, tadpoles and other aquatic animals.

PREVIOUS PAGES: Black skimmers (*Rynchops niger*) at sunrise, flying low above a lagoon in search of fish, Rio Negro region, southern Pantanal.

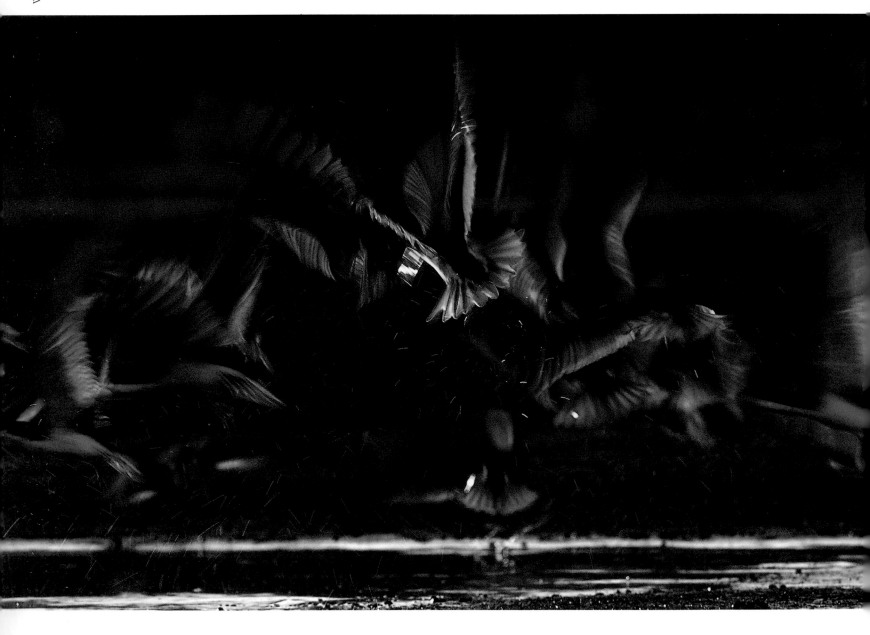

Black skimmers (*Rynchops niger*) taking off from the shore of a
lagoon in the early morning during the dry season, Rio Negro.
Although closely related to gulls and terns, black skimmers are
placed in their own genera, with only three species.

Santa Clara County Library District
1-800-286-1991
www.sccld.org

Terminal: CU-SELFCK3
Date: 07/08/2023 12:27:17 PM

Member: B. H**********
Membership Number: **********69

Current Fine: $0.00
On Loan:1 (0 Overdue)
On Hold:0 (0 Available to pickup)

Today's Borrowed Items: (1)

33305209450737
Pantanal : South America's wetland j
Due Date: 07/29/2023

24/7 Telecirc: 1-800-471-0991
Thank you for visiting our library

The Rio Negro is one of the major rivers of the southern Pantanal. Towards the end of the dry season in August, water levels drop dramatically, exposing many sandbars along and across the river. These are popular roosts for the black skimmer.

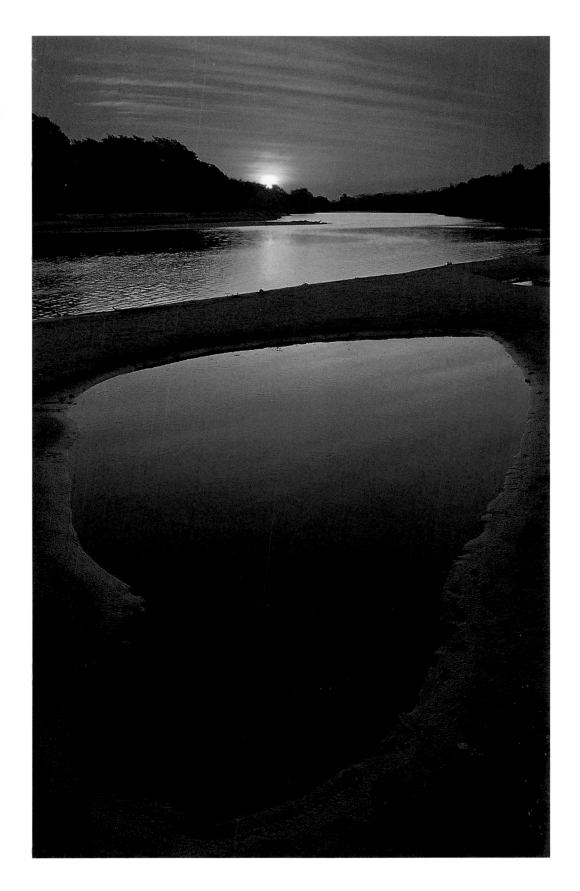

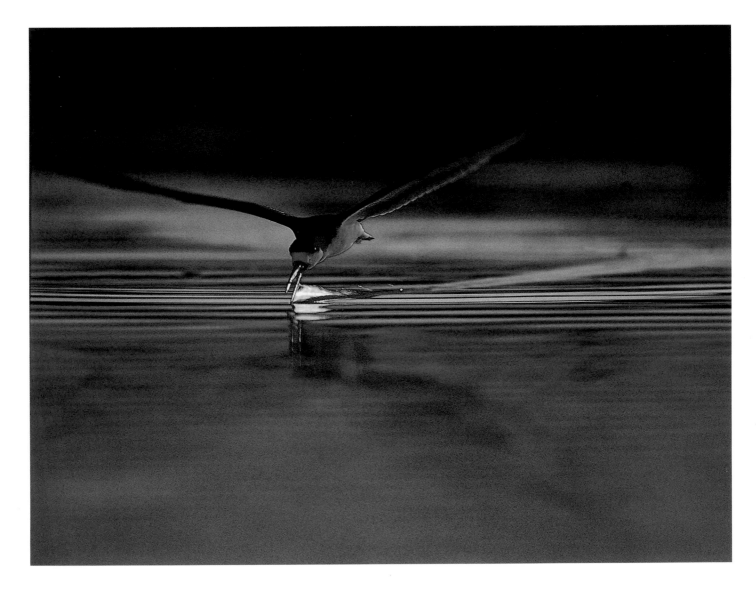

A black skimmer (*Rynchops niger*) fishing in a dry-season lagoon near the Rio Negro. The bill is unusual in that the lower part extends past the upper part, making it ideal to skim across the surface. When foraging, the bird flies low, slicing the surface of the water with its bill as it courses back and forth, snapping up small fish and invertebrates the instant the bill touches them. This species is sociable and mostly seen in pairs or groups of up to 25 individuals, but occasionally more. Although primarily nocturnal when feeding, skimmers are also active at dawn and dusk and occasionally for brief periods during the day.

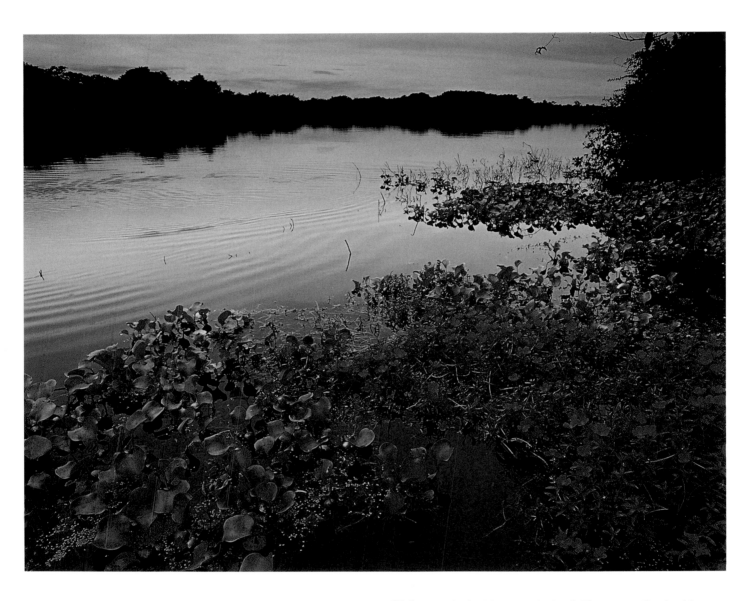

High water in the Rio Negro in April. The surrounding land is very
flat and so the wide, meandering river flows extremely slowly even
when the water level is high. Like all rivers in the Pantanal, the Rio
Negro drains into the Rio Paraguay.

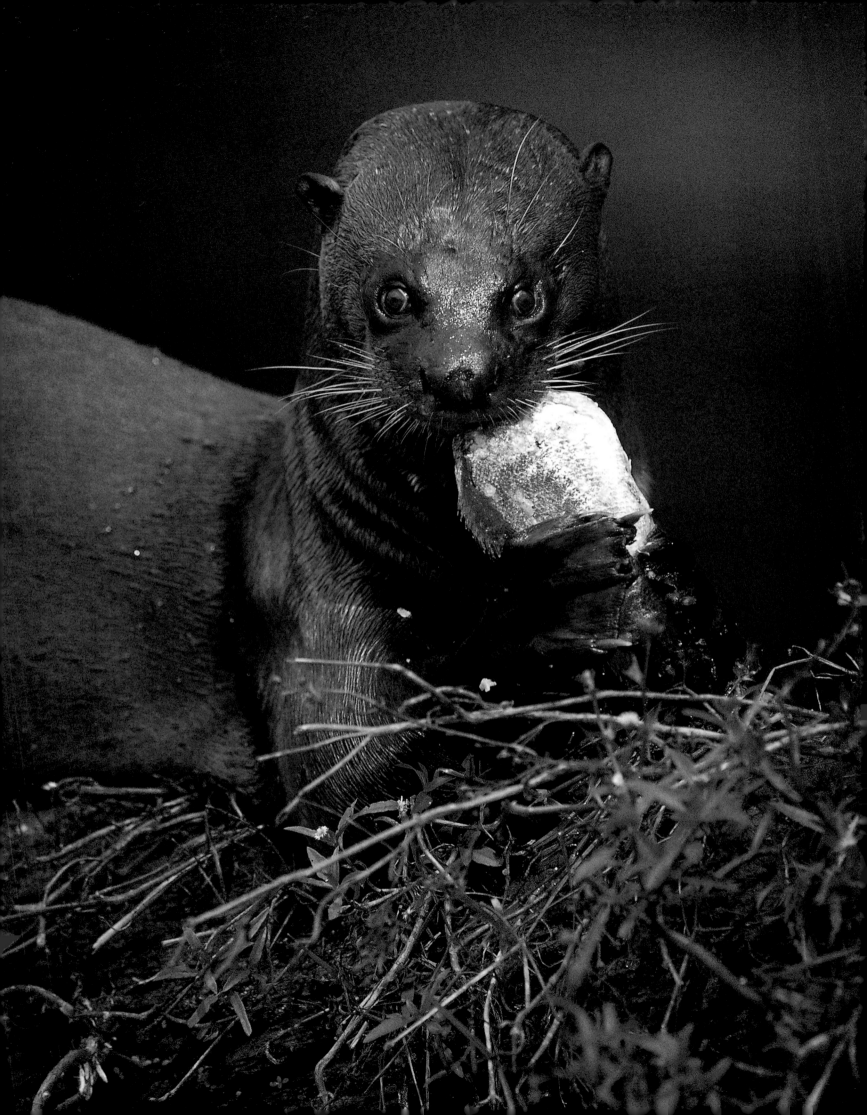

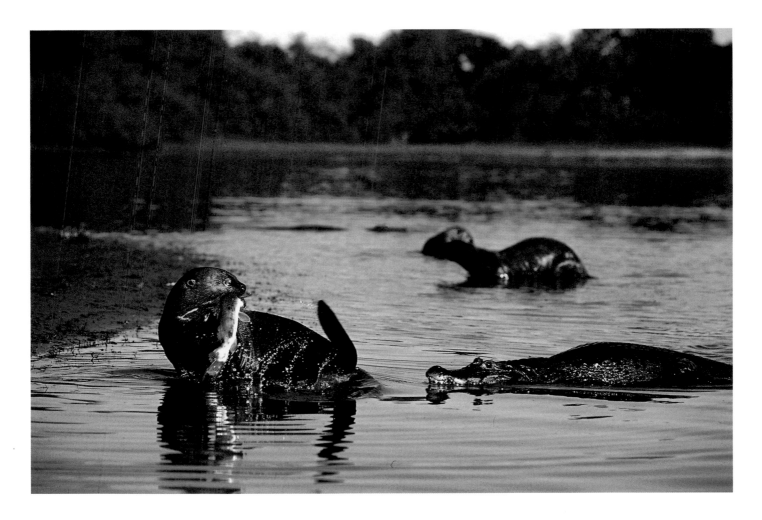

A caiman (*Caiman yacare*) in the Rio Negro approaching a giant otter from behind in an attempt to steal its freshly caught fish. Such behavior is rarely observed as otters and caimans usually avoid confrontations, especially since the caiman is unlikely to be successful in its efforts given the great speed and agility of the otter.

A giant otter (*Pteronura brasiliensis*), OPPOSITE, eating a piranha at Fazenda Rio Negro. Although this species appears to be making a comeback in many parts of its range, and is frequently observed in the rivers and lagoons of the Pantanal, especially during the dry season, it is still listed as an endangered species.

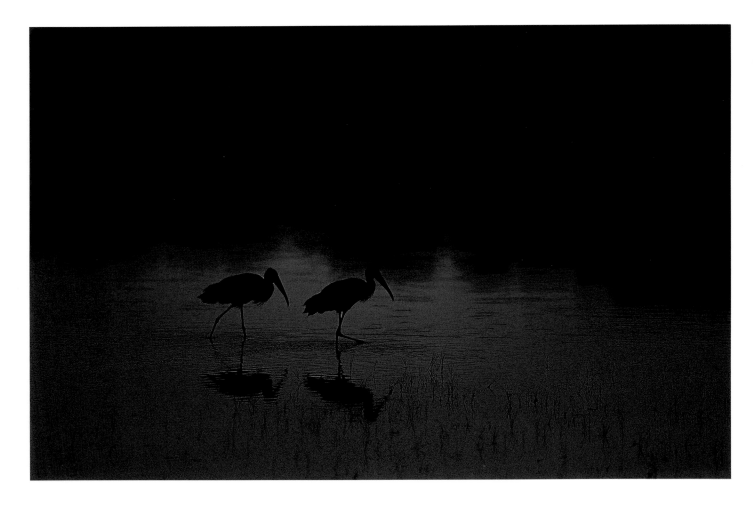

Wood storks (*Mycteria americana*) feeding in a shallow dry-season lagoon near the Rio Negro. This species is notably gregarious and almost always seen in groups ranging from a few to hundreds. Wood storks sometimes feed cooperatively, wading together in shallow water, stirring the bottom with their feet and sweeping partly opened bills back and forth. During the dry season they obtain part of their food by stealing it from other storks and waders.

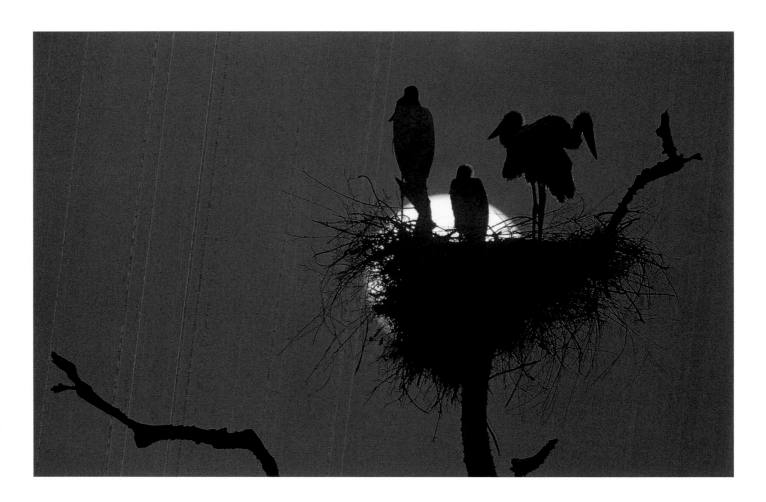

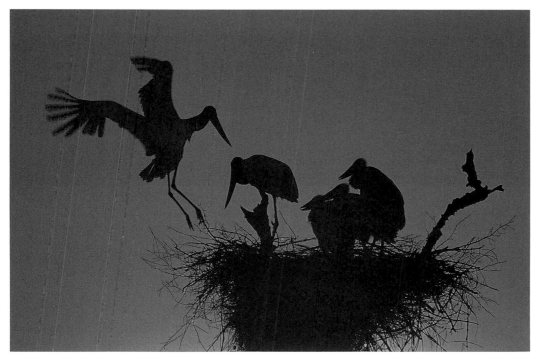

ABOVE & LEFT: A jabiru nest (*Jabiru mycteria*) in the northern Pantanal with three chicks. These huge nests are guarded authoritatively by the magnificent adult birds, the world's largest storks. This particular nest was blown down by strong winds after the chicks had left, but was subsequently rebuilt by the adults.

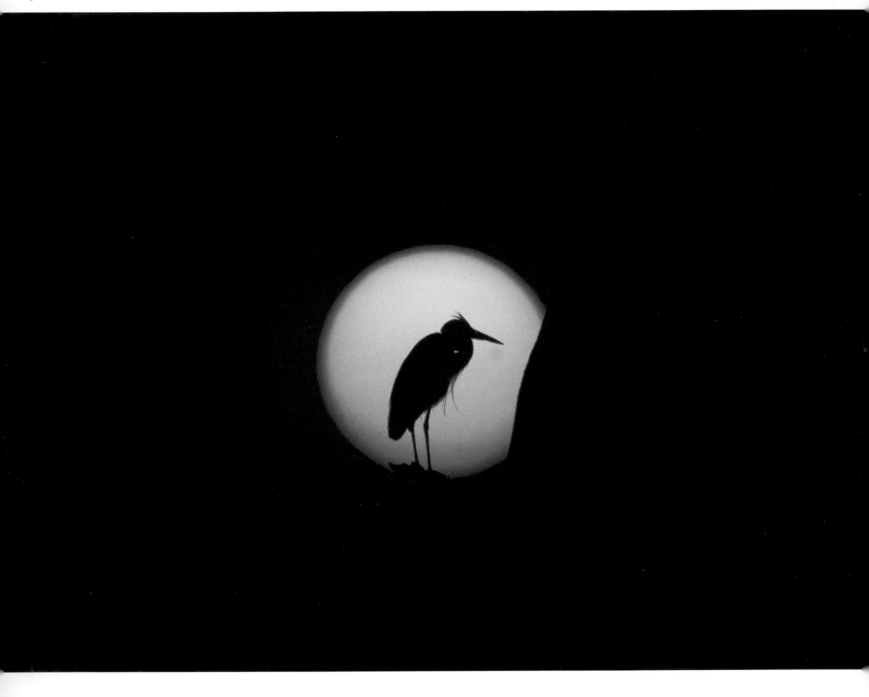

A cocoi heron (*Ardea cocoi*) roosting in a tree, Mato Grosso.
This heron is one of the many conspicuous bird species that
nest in large numbers throughout the Pantanal.

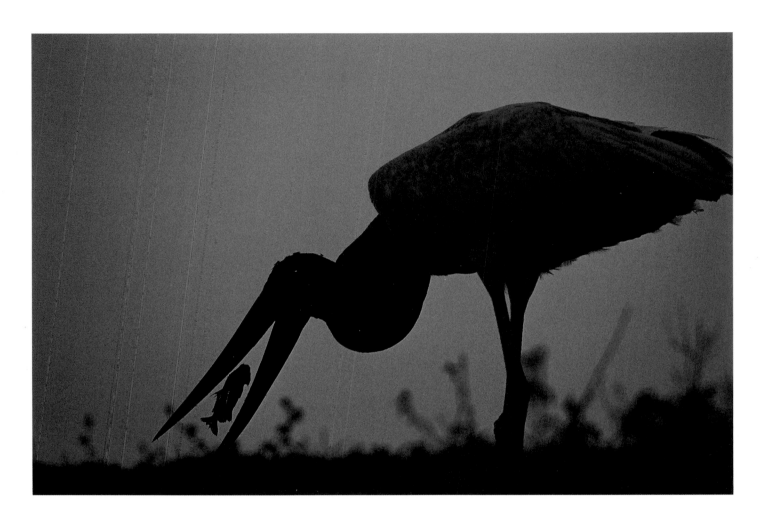

A jabiru stork (*Jabiru mycteria*) eating a piranha. This spectacular bird, rare in most of its range, is still easy to see in the Pantanal.

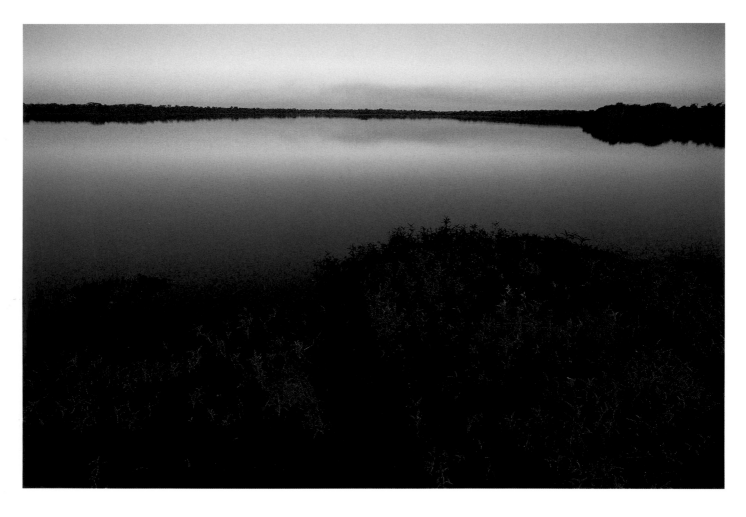

A vast freshwater lagoon or *baia* at Refúgio Ecológico Caiman.

A yellow anaconda (*Eunectes notaeus*), one of the two species of this giant snake that occur in the Pantanal. Although it does not reach the huge size of the common anaconda (*E. murinus*), female yellow anacondas can still reach 4 meters in length.

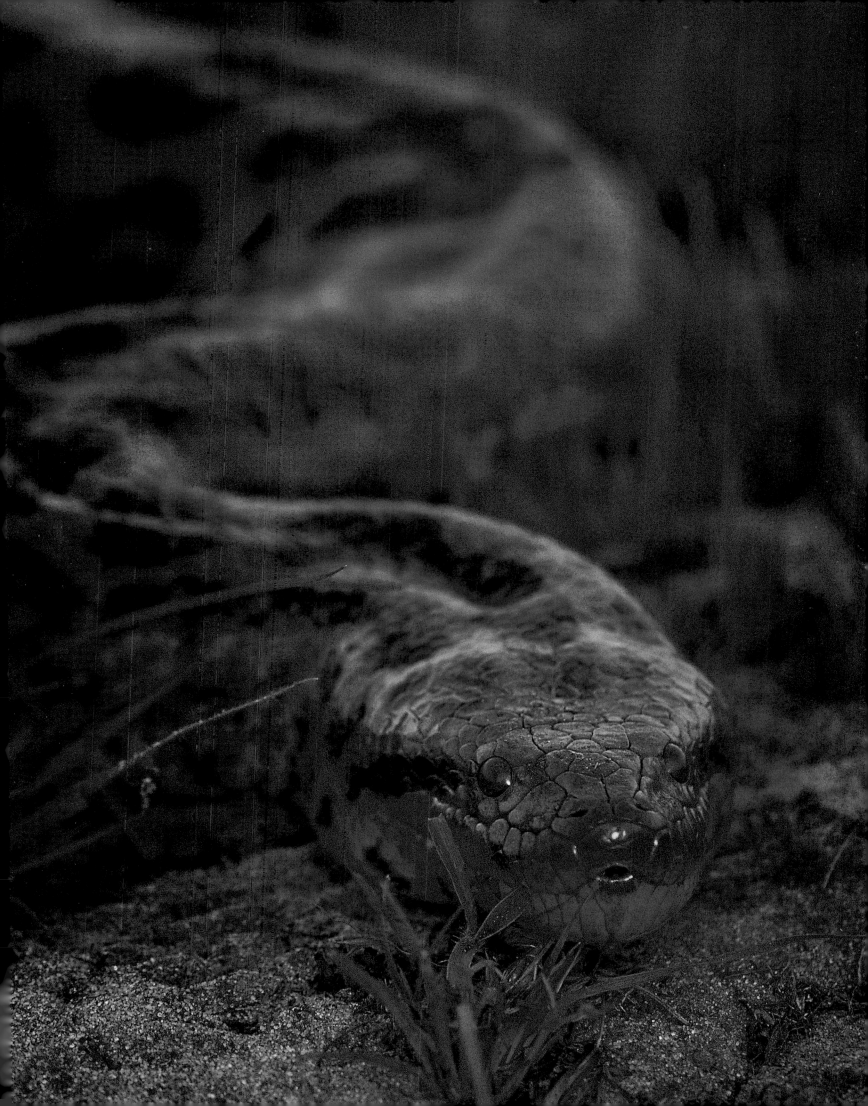

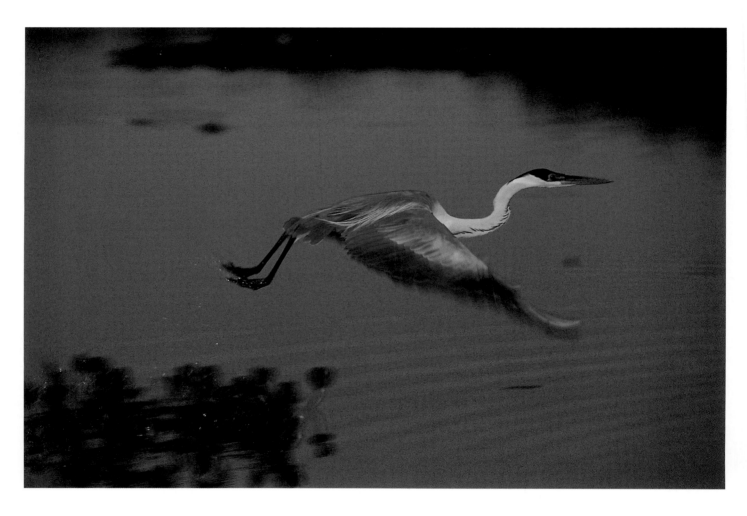

A cocoi heron (*Ardea cocoi*) along the Rio Pixaim in northern Pantanal. This species occurs all the way from Panama in the north to Chile, and is found throughout the whole of Brazil. It is a solitary bird that employs a stand-and-wait method of foraging in shallow water and occasionally wades slowy. It is somewhat wary and does not allow close approach.

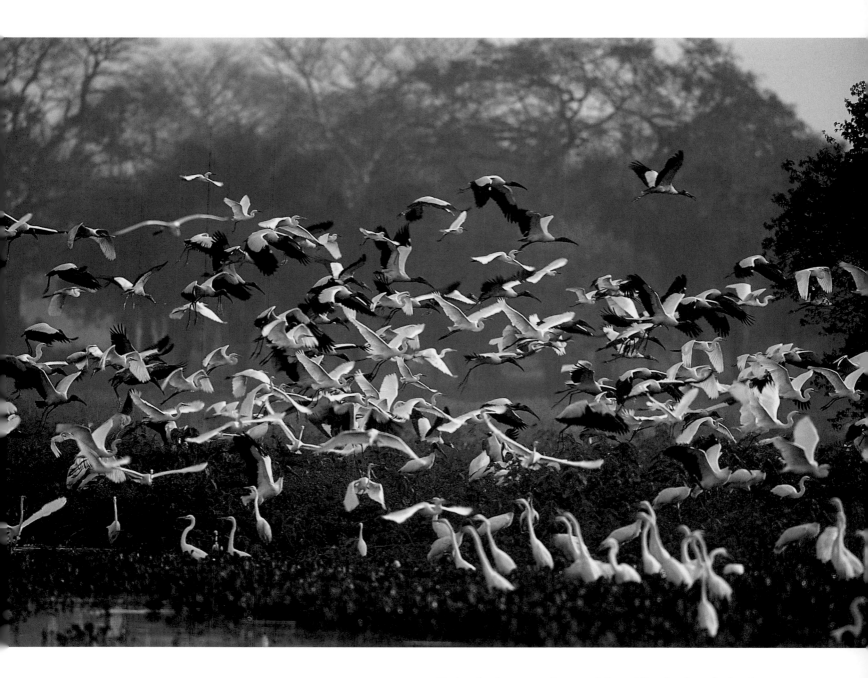

During the dry season, between July and October, large flocks of water birds gather around the shrinking lagoons of the Pantanal. This photo was taken along the Transpantaneira Highway, a popular place for seeing bird life. This 150-kilometer raised dirt road has ditches running alongside, where construction material was excavated. The resulting body of water provides a plentiful food supply for the many birds in the area.

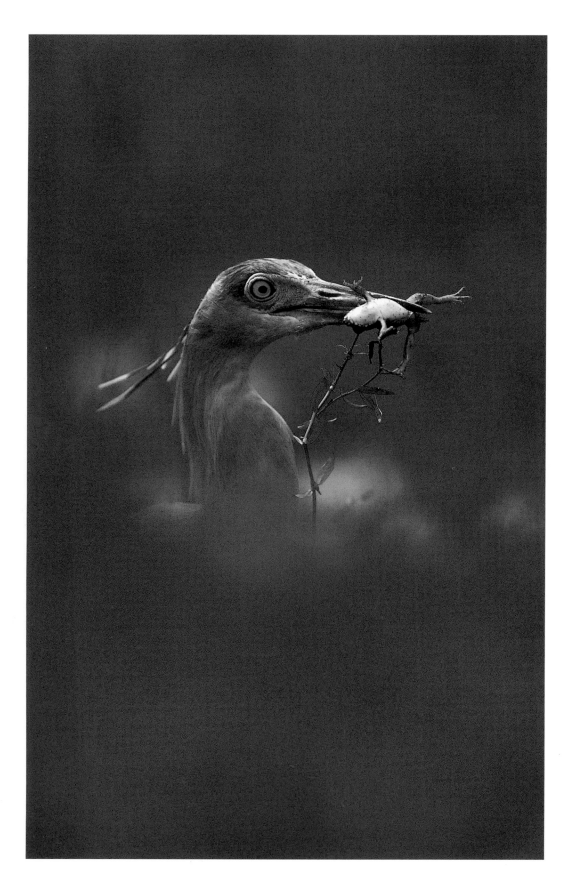

A rare whistling heron (*Syrigma sibilatrix*) catches a frog amongst the water hyacinths of the Rio Negro.

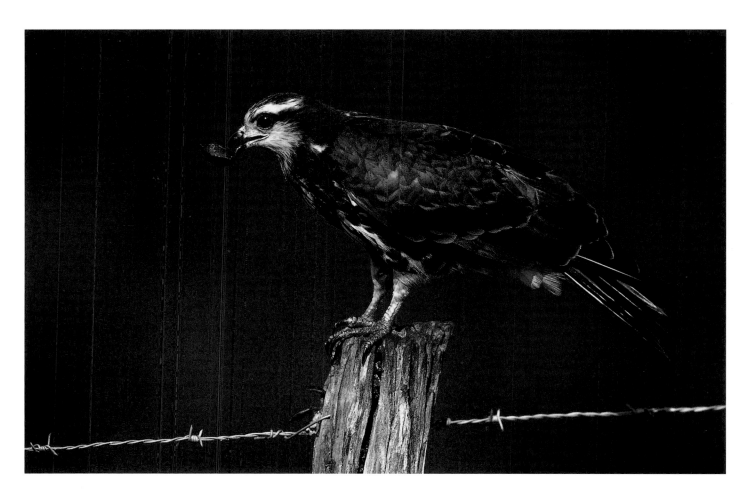

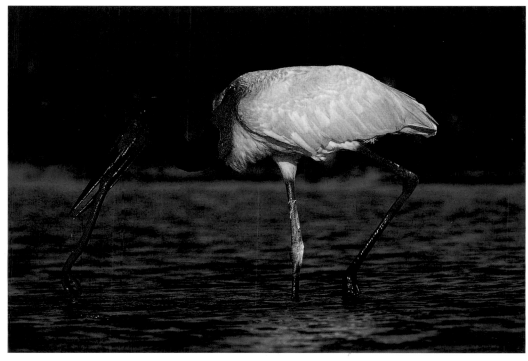

An immature snail kite (*Rostrhamus sociabilis*), ABOVE, eats part of a crustacean on a farm fence in the northern Pantanal. This species is common in wetlands all along its large range, from southern Florida to Argentina and Uruguay.

A jabiru (*Jabiru mycteria*), RIGHT, catching an eel in a small dry-season lagoon in the Nhecolândia region, Mato Grosso do Sul.

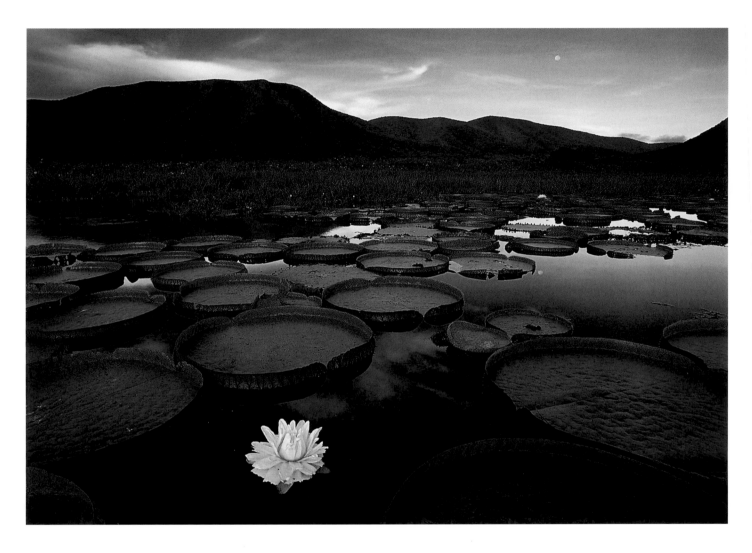

The flower of the giant Amazon water lily (*Victoria amazonica*) opens only at night. This photograph, taken in the Acurizal Reserve near the Rio Paraguay, shows the Serra do Amolar in the background, part of the western border of the Pantanal.

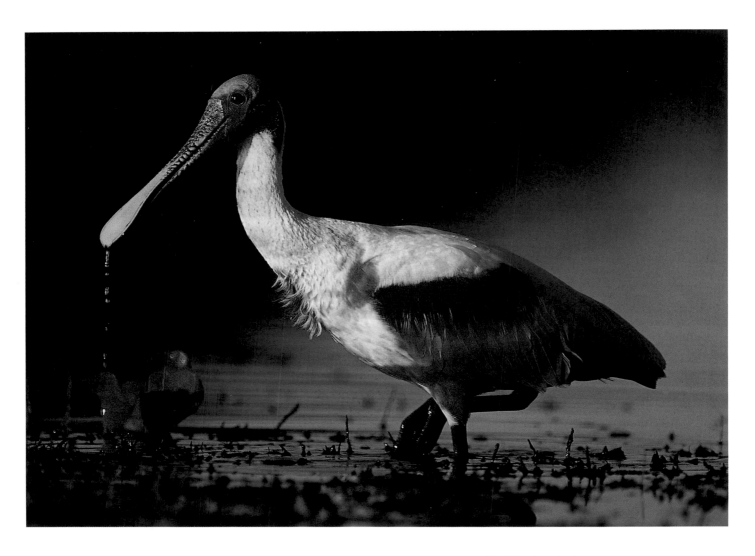

The roseate spoonbill (*Platalea ajaja*), here seen in a lagoon near the
Rio Negro, is a striking species that is found in marshes throughout
the region. Its special bill is ideal for swishing through the water in
search of small swimming prey.

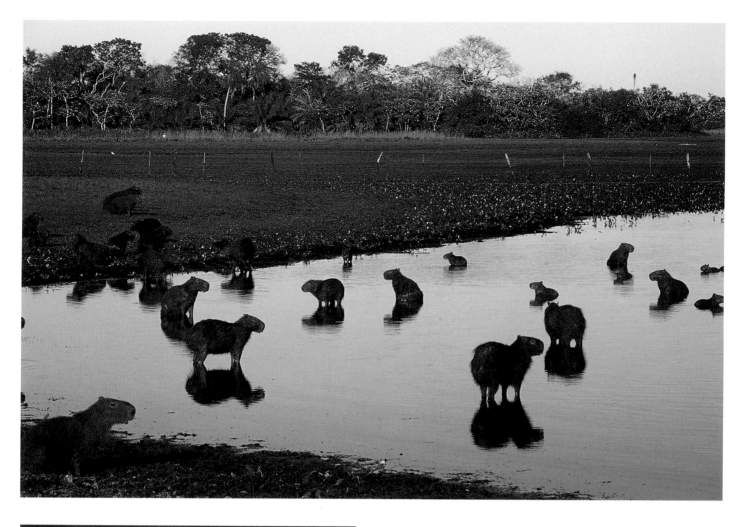

A large herd of capybaras (*Hydrochaeris hydrochaeris*), ABOVE, in a lagoon at Fazenda Pouso Alto in the Nhecolândia region of the southern Pantanal. The capybara reaches high densities in many areas and is one of the flagship species of the Pantanal.

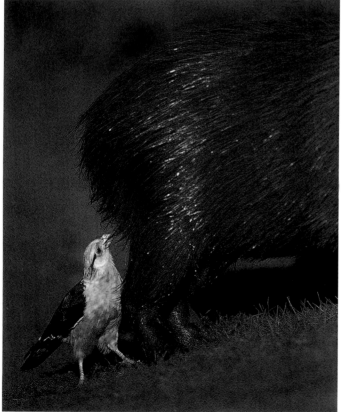

A yellow-headed caracara (*Milvago chimachima*), LEFT, picking insects from a capybara. This widespread species, that ranges from southwestern Costa Rica to northern Argentina and Uruguay, is a conspicuous bird of open country and ranchland. In addition to riding the backs of cattle and capybaras, where they watch for prey disturbed by these animals, caracaras scavenge carrion and almost any edible plant or animal matter.

Capybara (*Hydrochaeris hydrochaeris*) in a lagoon at sunrise, Fazenda Rio Negro. Though mainly diurnal, this large rodent does some feeding at night and can become more nocturnal in areas where it is hunted for food.

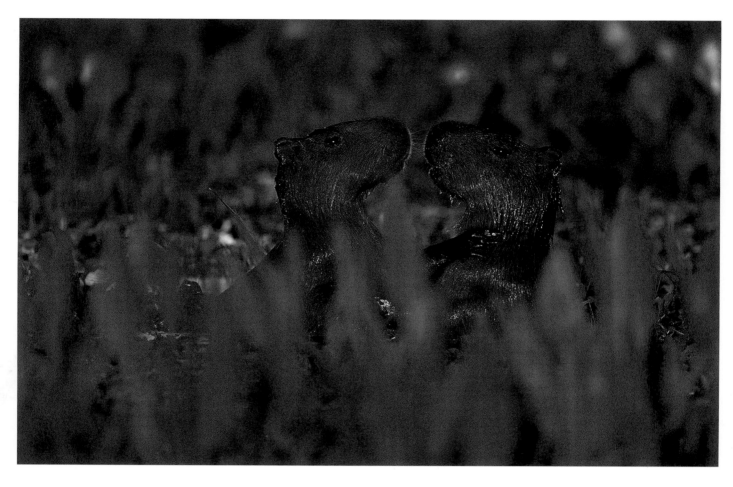

Young capybaras (*Hydrochaeris hydrochaeris*), ABOVE, at play in a swamp at Fazenda Rio Negro. The capybara is herbivorous, feeding on grass and browse, especially aquatic vegetation.

A male capybara (*Hydrochaeris hydrochaeris*), RIGHT, yawning. The capybara is the largest rodent in the world and can weigh up to 70 kg.

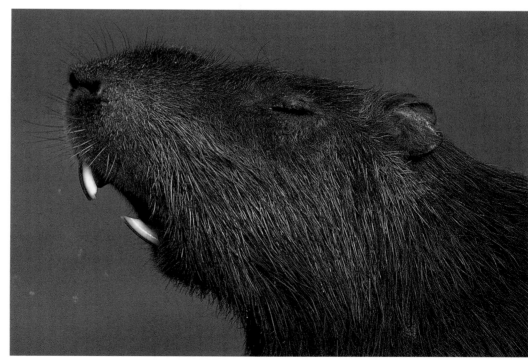

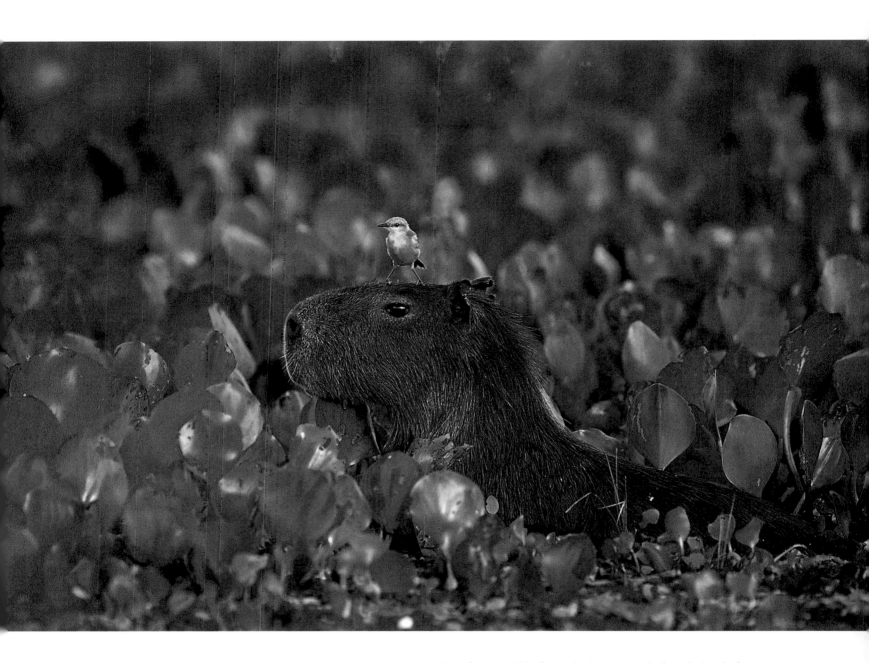

A cattle tyrant (*Machetornia rixosus*) perched on the head of a capybara (*Hydrochaeris hydrochaeris*). Many birds use capybaras as a handy perch from which to catch insects that the animals disturb as they move through the swamp.

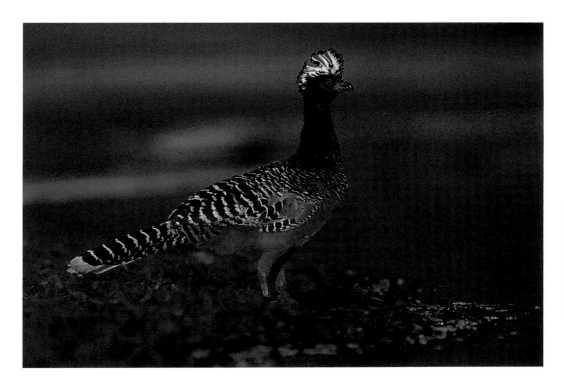

A female bare-faced curassow (*Crax fasciolata*), ABOVE.
This large pheasant-like bird can reach up to 3 kg in weight and is a
favorite target of hunters. It can still be seen at the edges of gallery
forests in some places in the Pantanal, but is rare to locally extinct
in other parts of its range.

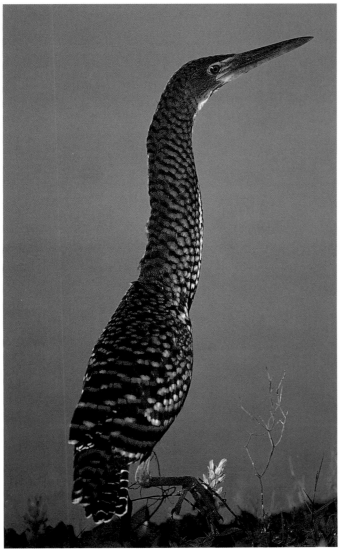

An immature rufescent tiger heron (*Tigrisoma lineatum*), LEFT,
along the Rio Negro. This strikingly beautiful species is found
throughout the Pantanal, but can be easily missed because of its
cryptic coloration.

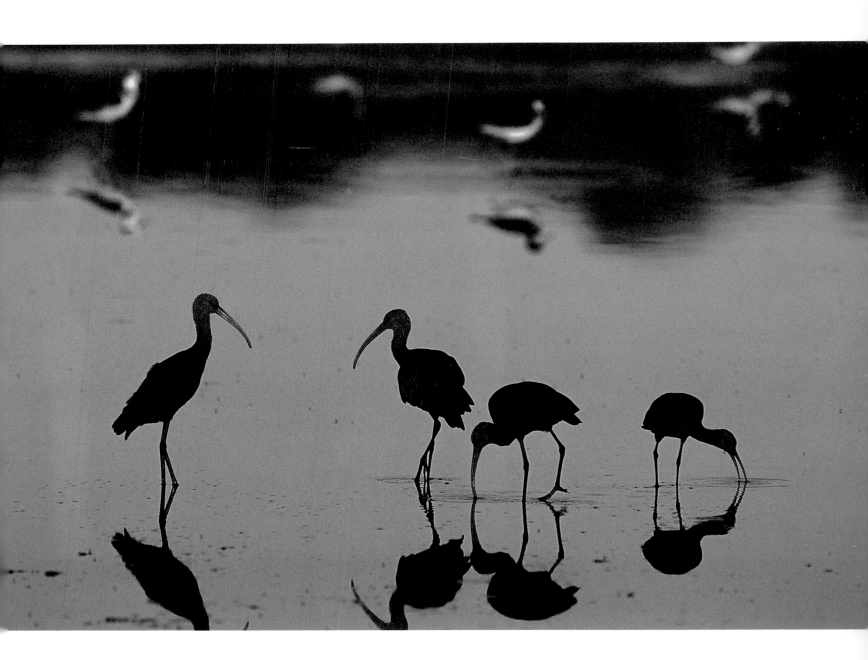

White-faced ibises (*Plegadis chihi*) feeding in a shallow lagoon at Fazenda Rio Negro.

Grasslands
Born of flood and drought

The vegetation of the Pantanal is a mosaic of many species highly influenced by neighboring biomes, by different soil types and by the water regime. Grasslands, which occupy more than 30 percent of the region,[1] are the best-represented vegetation type in the Pantanal, followed by *cerradão*, a forest type described in more detail in Chapter 4 (see p. 136). The proportion of floodplain grasslands inundated every year varies significantly, depending on river discharges and local rainfall, but at least some are permanently inundated. These areas are known locally as *brejos* and play a very important role as refuges for several vertebrate species, such as the marsh deer (*Blastocerus dichotomus*) and jaguar (*Panthera onca*), during the dry season.

Dominant grassland species

Dry grasslands without shrubs or trees are locally known as *campo limpo* (clean field), whereas grasslands with a scattering of shrubs and small trees are known as *campo sujo* (dirty field). *Campos de murundu* are open grasslands dotted with a regular pattern of raised earthmounds bearing cerrado trees and shrubs, and often termite mounds. In some places, grasslands are dominated by two plant species, *pirizeiro* (*Cyperus giganteus*) and *caeté* (*Thalia geniculata*), and from these are derived their local names *pirizal* and *caetezal*.

The transition between floodplain grasslands and other vegetation types is extremely dynamic and is determined by the degree of saturation of the soil. During dry years, marginal cerrado plant communities, such as *canjiqueral* (*Byrsonina orbigyana*) and *lixeira* (*Curatella americana*), expand into the grasslands. During the wet periods, herbs and grasses increase significantly.

A South American coati (*Nasua nasua*) feeding in a meadow in the rainy season, Nhecolândia.

108

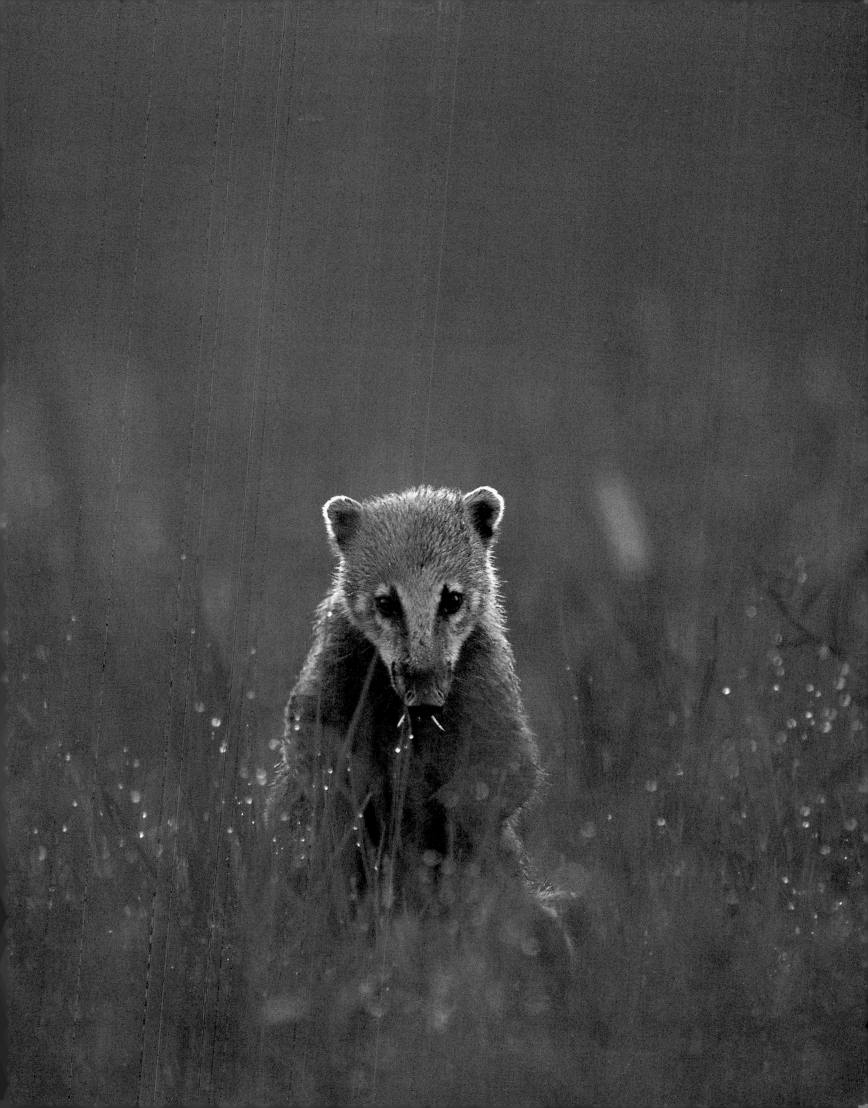

110

The distinctive shapes of carandá palm (*Copernicia alba*) rise above
the morning fog blanketing the grasslands of Refúgio Ecológico
Caiman.

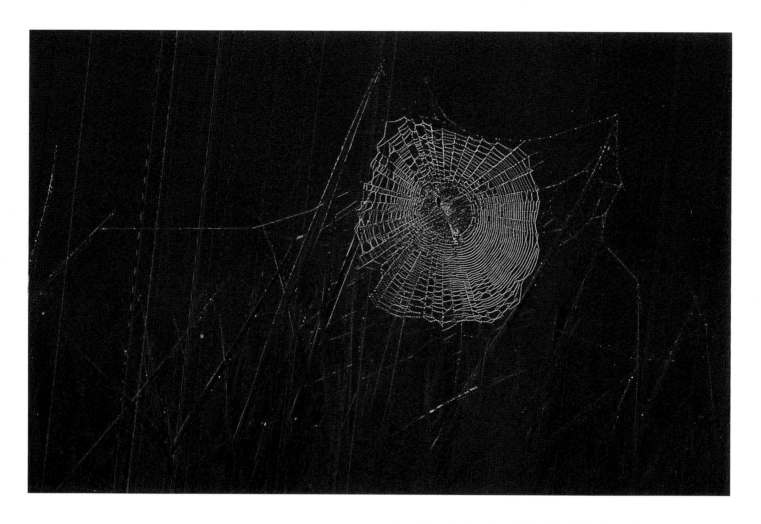

A spiderweb glistening in the dawn light, Fazenda Rio Negro, Mato Grosso do Sul.

Although commonly used, the term "grassland" oversimplifies the Pantanal situation. Local inhabitants, for example, distinguish a number of different herbal formations and have given them special names, such as *mimosal* (for areas of *Axonopus purpusii*), and *arrozal do brejo* for areas dominated by the productive wild-rice genus *Orizae*.

Another formation is the *caronal* (colonized by *Elionurus muticus*), an area situated on higher ground and often a refuge for armadillos and anteaters. The *caronal* is a burden to some farmers, who consider it unproductive and occupying land that would otherwise be suitable for cattle grazing. To this end, some farmers advocate the substitution of African *braquiara* grass (*Brachiaria humidicola*), which is a very aggressive plant that often takes over from native species.

The marsh deer

Natural grasslands are the principal food resource for the herbivorous fauna of the region, and indirectly for other animals as well. One of the most important flagship species of the Pantanal grasslands, and perhaps its most elegant creature, is the marsh deer (*cervo*; *Blastocerus dichotomus*). Indeed, one of the greatest thrills in the Pantanal is to fly low in a small plane over areas of appropriate habitat and spot marsh deer from the air. The animal's beautiful reddish fur and large size make it easily seen. On a good flight several dozen may be located, foraging in the open, either individually or in small groups.

The Pantanal is home to the largest remaining population of marsh deer, which has been estimated to number 44,000 individuals in this region, but it faces many threats in other parts of its range. It is listed as endangered in Brazil, and has already disappeared from many wetlands of the Paraná River because of hunting pressure.[2] This species shows a preference for foraging in relatively shallow water, usually at depths of less than 70 cm. It is also unusual among open-country deer in that it does not live in large breeding groups. Mating in the Pantanal coincides with the dry season, and births occur at the end of the floods, after a gestation period of roughly 270 days.

Another important and conspicuous deer species is the pampas deer (*Ozotoceros bezoarticus*). It favors open habitats, principally the central areas of the Pantanal where grasslands and savannah dominate, foraging in sparsely covered fields and hiding in those that are more densely vegetated.

Carnivores of the grasslands

Carnivores are also an important part of the open habitats. The crab-eating fox (*Cerdocyon thous*) uses open fields during nightly walks in search of bird nests and small mammals, and these in turn survive on grass and other seeds.

Some species are evident only in drier seasons. For example, during the long droughts that took place in the southern Pantanal between 1963 and 1973, maned wolves (*Chrysocyon brachyurus*), characterized by their long spindly legs and large ears, were often seen hunting in the tall grass. Today, maned wolves have almost disappeared from central areas of the Pantanal due to more extensive floods, which have pushed them back to higher lands.

Armadillos and anteaters

Grasslands on the Pantanal floodplain are also home to four armadillo species and the giant anteater (*Myrmecophaga tridactyla*). These all live on the ground and are active both day and night. The giant anteater is the largest in the world and has an estimated Pantanal population of about 5,000 individuals.[3] With its sharp talons and long sticky tongue, it is well equipped to feed on its favorite meal — ants and termites — ripping open their nests and mounds with its powerful front claws. This creature can often be seen foraging on the vast grasslands and open savannahs, carrying its young on its back. When in danger, the giant anteater can

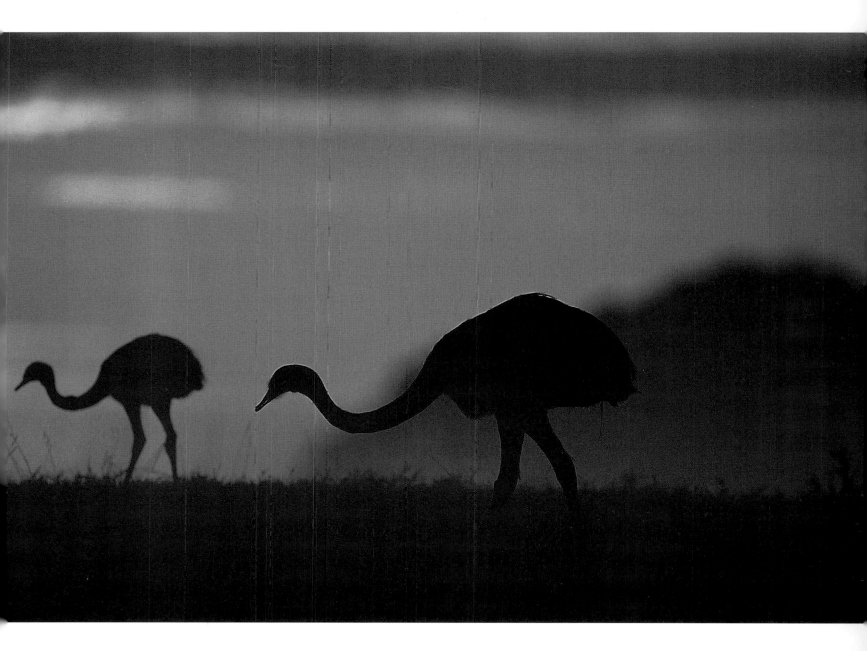

Greater rheas (*Rhea americana*) in the early morning, Fazenda Rio Negro. At up to 1.5 m in height, this is South America's largest bird. A relative of the ostrich and emu, it can be seen on the drier grasslands around the margins of the Pantanal.

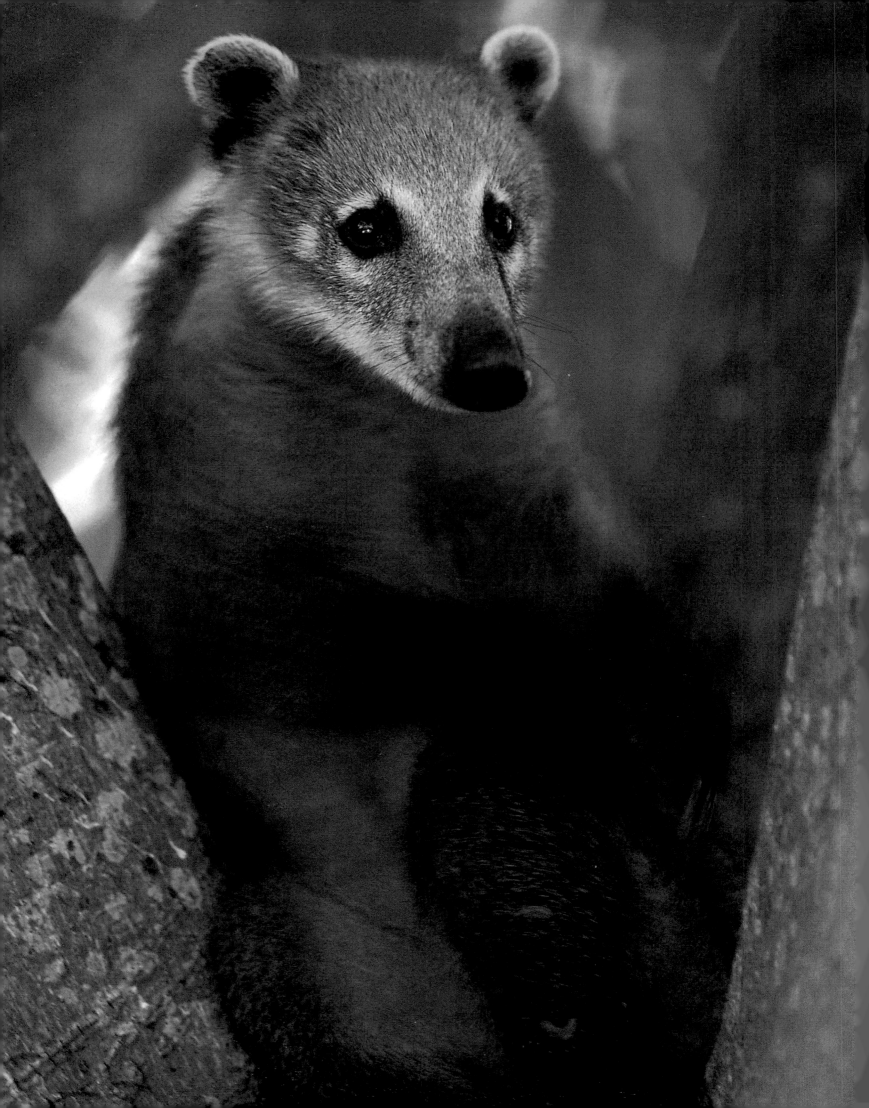

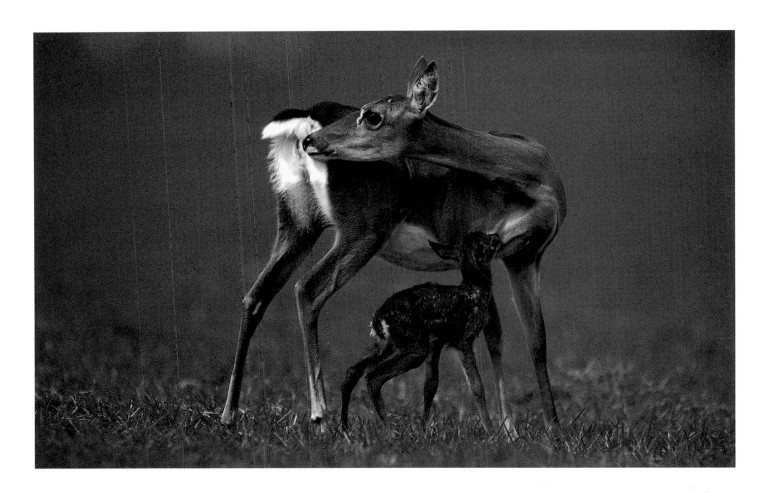

The pampas deer (*Ozotoceros bezoarticus*) is a frequent sight on the grasslands of the Pantanal. Large concentrations can often be seen grazing on *vazantes*, grass-covered floodplains, during the dry season. Both the female and fawn, ABOVE, and the male, RIGHT, were photographed in December, during the wet season at Fazenda Pouso Alto.

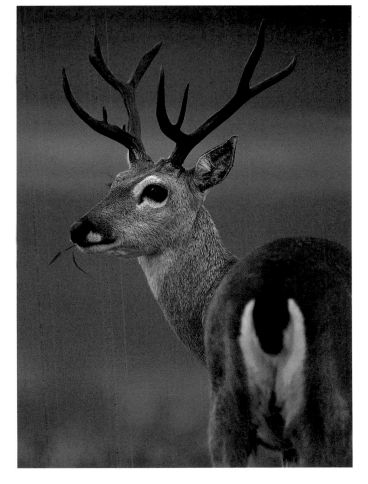

A South American coati (*Nasua nasua*), OPPOSITE, at Fazenda Pouso Alto. This wide-ranging species is omnivorous, feeding on fruits, invertebrates and small vertebrates, and is at home both on the grasslands and in the surrounding trees.

115

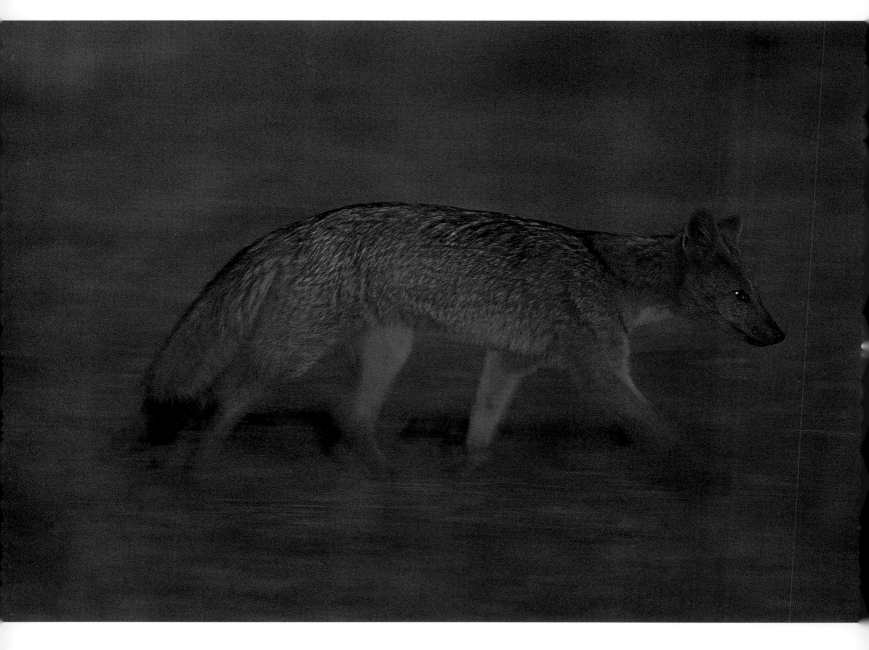

A crab-eating fox (*Cerdocyon thous*) in the Nhecolândia region.
This nocturnal species is regularly seen at dawn and dusk, especially
in open grasslands and savannah.

"gallop" quite rapidly, surprising for what appears to be an ungainly animal, but if cornered it will use its powerful claws for defense. Indeed, it is so strong that there are instances recorded of where it has actually caught a jaguar in its death embrace. On the other hand, one of the most delightful sights in the Pantanal is that of a baby giant anteater — a perfect little replica of its parent — riding piggy-back on its mother.

Coatis

A time of abundance for water creatures, the season of flood offers small fish a route through the grass fields to more suitable places in which to grow. Other creatures — for example, the South American coati (*Nasua nasua*) — use the seasonal windfall to dig for prey at the edge of receding waters. A long-nosed and inquisitive relative of raccoons, the coati feeds on invertebrates and fruits, foraging in trees and on the ground. It is common to observe a group of up to 20 coatis — with their curly-tipped tails erect — running in the open grassland to cross from one *capão* (forest) to another. There is also a species of raccoon in the region, the elusive crab-eating *Procyon cancrivorous*, a more graceful version of its northern cousin.

Peccaries

Two species of peccary are also likely to be encountered in and around the forests of the Pantanal. The collared peccary (*Tayassu tajacu*) is usually seen in small family groups. The larger and intimidating white-lipped peccary (*Tayassu pecari*), which threatens intruders with a metallic clacking of its teeth, can sometimes be seen in herds of several hundred animals cutting a swath through the forests and grasslands.

A valuable resource under threat

The grassland is the most valuable resource for the *Pantaneiro* — the traditional human inhabitant of the Pantanal. Indeed, the entire development of ranching in the region was based on this gift from nature, which has allowed a vast economy to grow over the last two centuries. About 95 percent of Pantanal lands are privately owned and over 80 percent are used as extensively-managed ranches. Such low density cattle-ranching has permitted considerable coexistence with the native fauna but, as outlined in the Introduction on page 15, this scenario has been slowly changing over the past 25 years. In some areas, higher ground that is not seasonally inundated has been converted to pasture and this has resulted in over 500,000 ha of deforestation — with loss of wildlife habitat and river sedimentation the inevitable result.

As impressive as today's grasslands look, they may have been dramatically different before the introduction of cattle. Over 200 years, cattle have re-shaped the Pantanal landscape, making it difficult to distinguish natural from man-induced savannah.[4] When cattle are removed from an area, and natural restoration takes place, the difference becomes very apparent. As native perennial and tall grasses take over from smaller annual species, the chances of survival for all creatures depending on this environment improve dramatically. From a conservation perspective, ranching practices that thrive on organic production methods, together with conservation of remaining natural forests, are essential elements of an integrated model for environmental, social and economic development that will maintain harmony between the traditional *Pantaneiro* way of life and the rich biodiversity of the region's grasslands.

GUILHERME MOURÃO, MÔNICA BARCELLOS HARRIS, REINALDO LOURIVAL, RUSSELL A. MITTERMEIER, CRISTINA G. MITTERMEIER

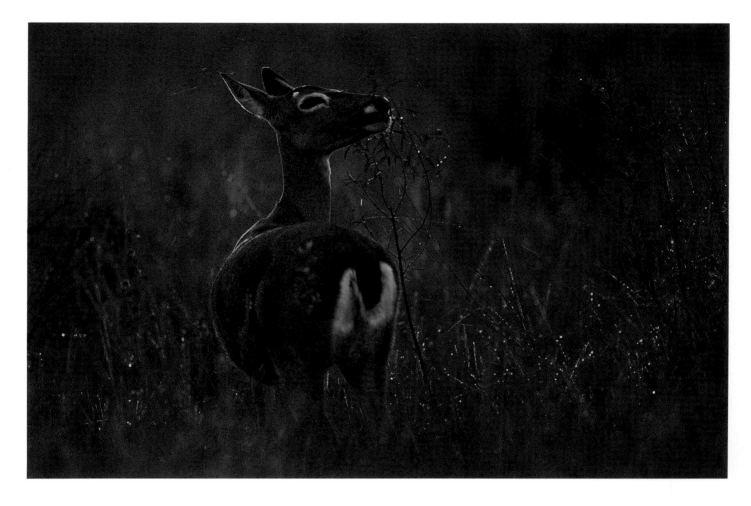

The pampas deer (*Ozotoceros bezoarticus*), seen here feeding on
flowers during the dry season, can only be found in a few areas of
its former range.

Morning fog covers natural grasslands in April, Fazenda Rio Negro. Much of the native grasslands of the Pantanal have been modified by introduced grasses, such as the African *Brachiaria* sp. These modified grasslands now cover approximately 40 million hectares of savannah due to the ability of the African species to thrive in poor soils.

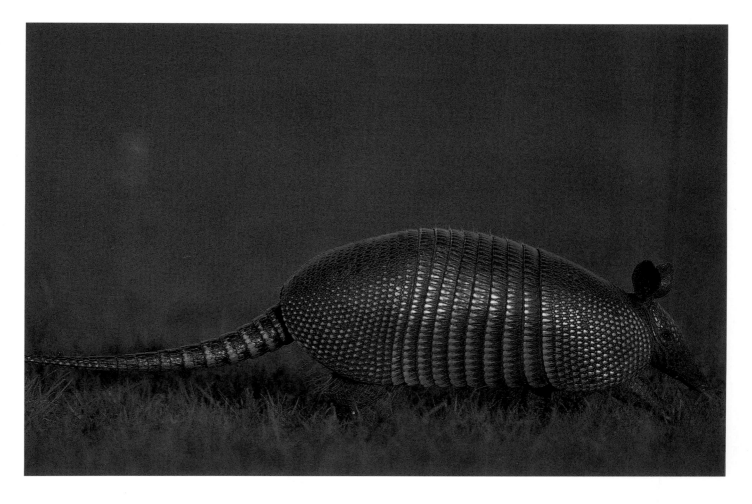

Nine-banded armadillo (*Dasypus novemcinctus*), Fazenda Pouso
Alto. These nocturnal creatures have poor eyesight but a keen sense
of smell, allowing them to find food both in the soil and in forest
litter. They are known for digging sizable burrows, from 1.5 to 3 m
long, that often join to a central den.

The smaller of the two peccary species (the other being the white-
lipped peccary), collared peccaries (*Tayassu tajacu*), OPPOSITE, occur
in small groups.

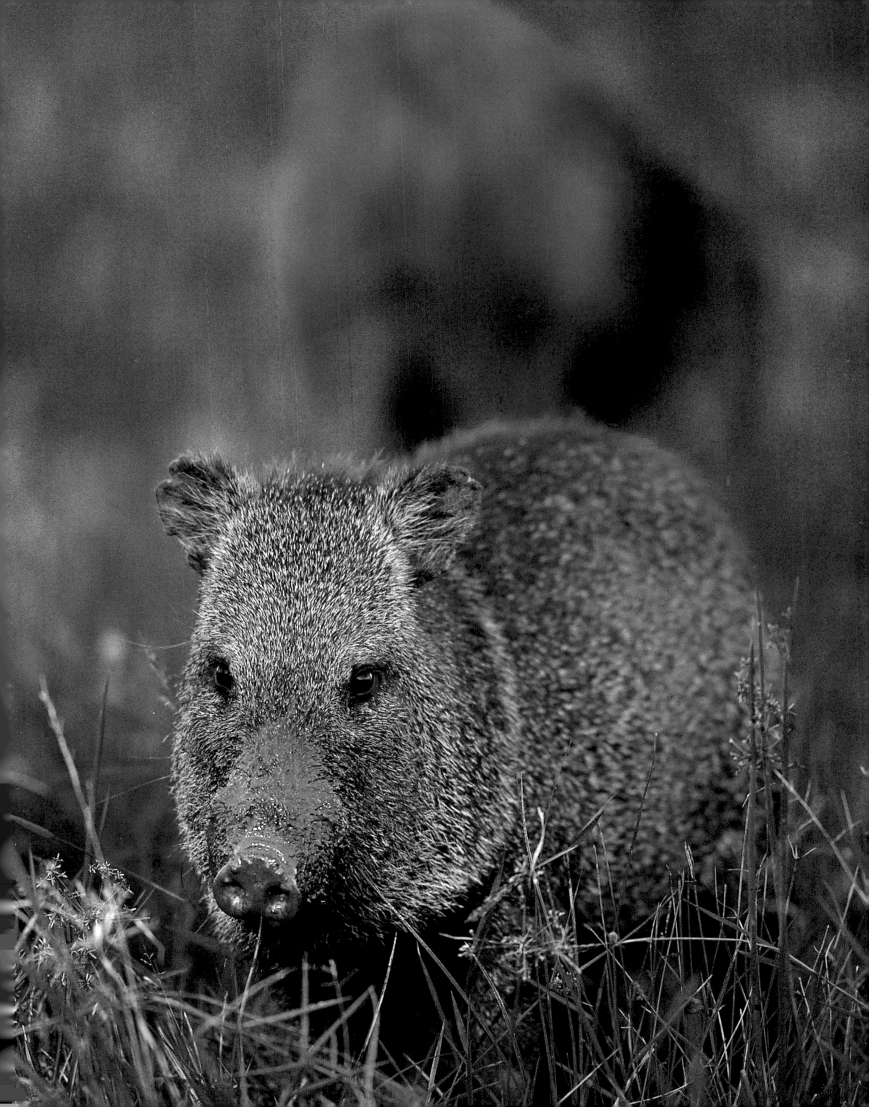

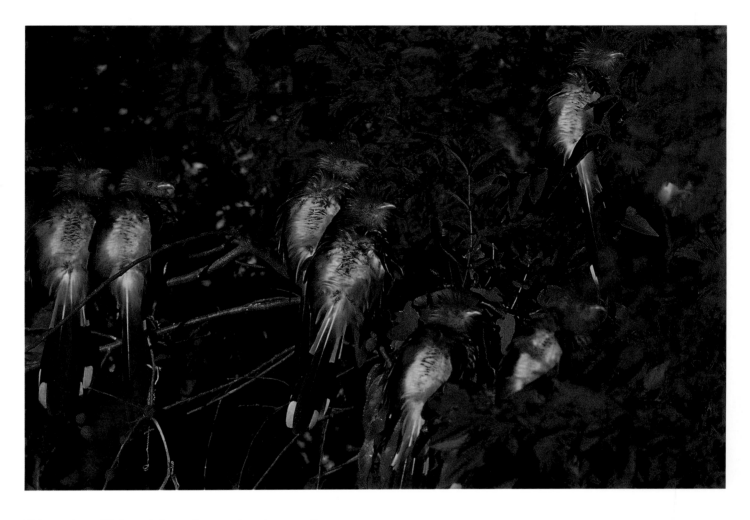

Guira cuckoos (*Guira guira*) are often seen in pairs or small groups in brushy savannah or gardens. These cuckoos are competitive communal nesters; the group will work together to incubate eggs and feed chicks, but will also toss the eggs of rivals out of the nest or hide them to prevent hatching.

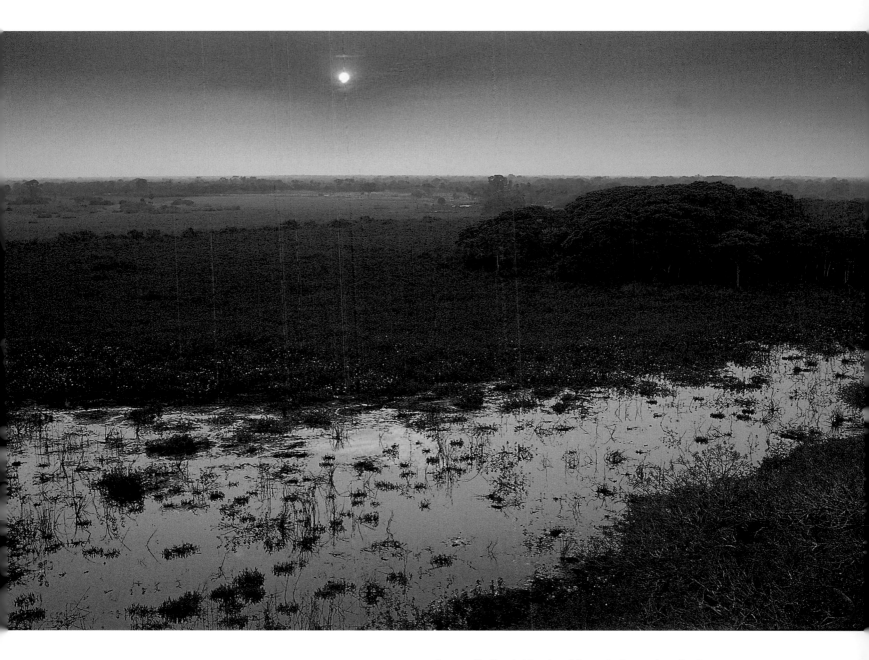

Seasonally flooded land and forest in September, the dry season, northern Pantanal. Only a small elevation above the floodplain is needed to allow trees to become established, creating 'forest islands' during the wet season.

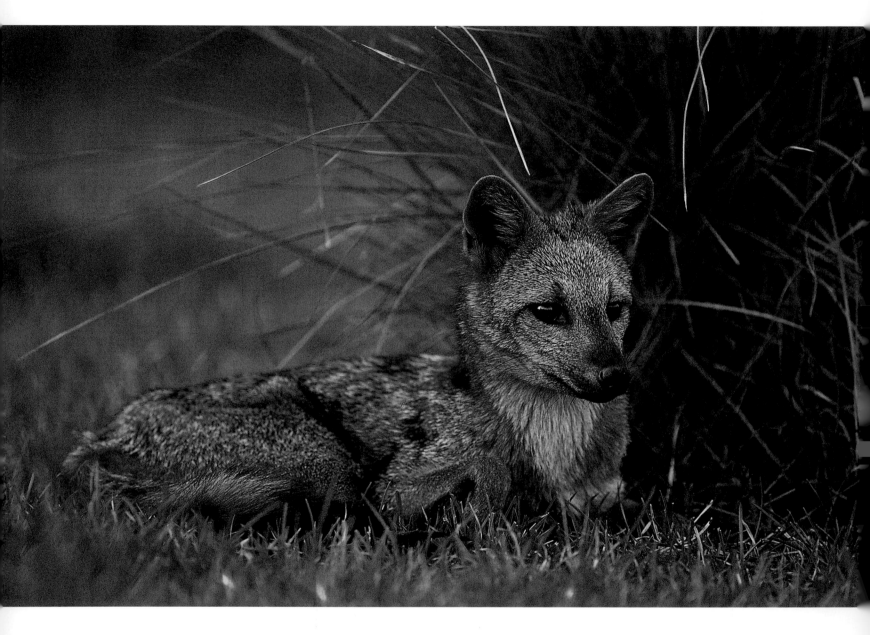

A crab-eating fox (*Cerdocyon thous*), Fazenda Pouso Alto, Nhecolândia region in December. This widespread species lives in pairs and feeds on mice, frogs, insects and fruit. During the rainy season it adds crabs to its diet, hence the common name.

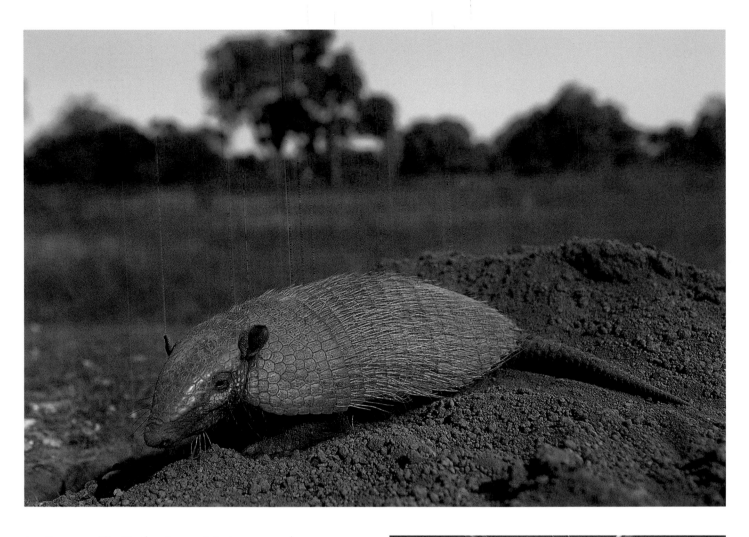

A yellow armadillo (*Euphractus sexcintus*), ABOVE, at the entrance to its burrow. This medium-sized armadillo species can reach a total length of half a meter, and feeds on a wide variety of plant foods, ants and other insects, and small vertebrates.

A troupial (*Icterus croconotus*), RIGHT, at Refúgio Ecológico Caiman in June. Legendary for its singing, individuals living in regular contact with people can even learn to imitate passages of music.

125

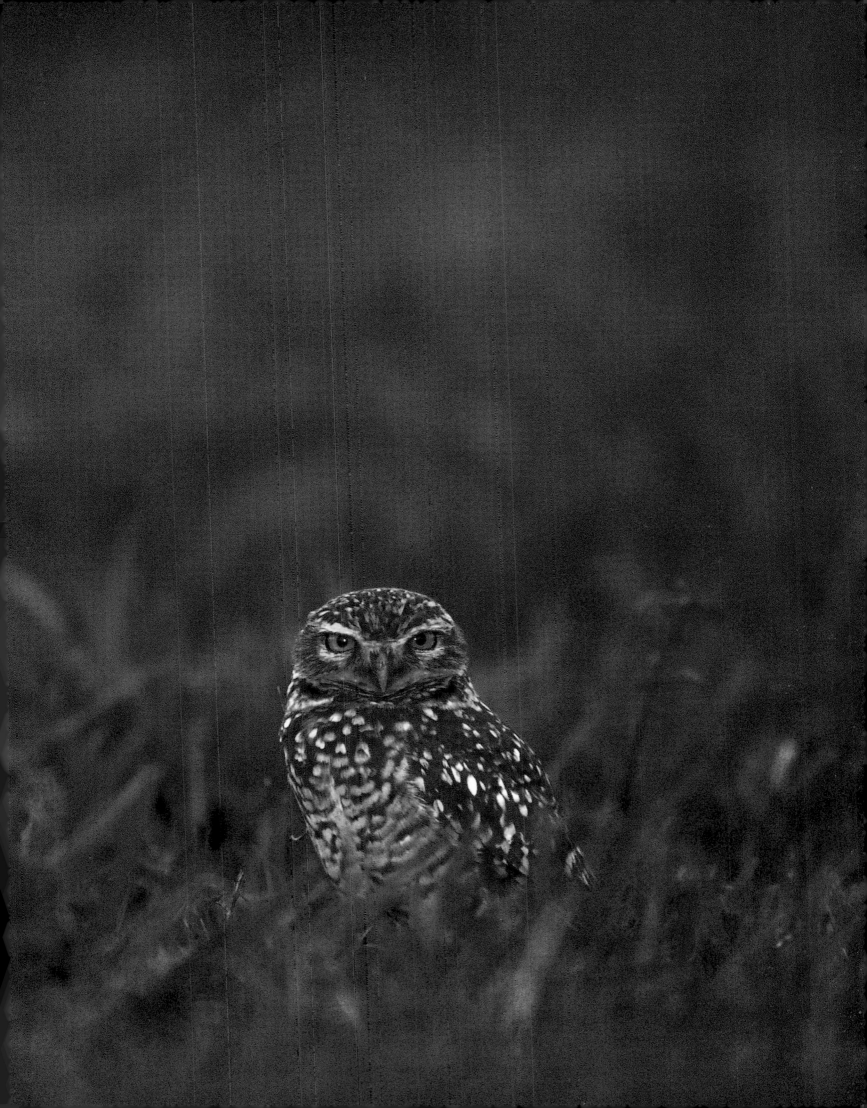

The white-lipped peccary (*Tayassu pecari*) is the larger of the two peccary species in the Pantanal. It travels in large herds that can reach 100 or more individuals and has a fearsome reputation for aggression toward people. Though this may be overstated, their large, sharp teeth can inflict damage and, if charged, a hasty retreat up a tree is recommended.

PREVIOUS PAGES: A male burrowing owl (*Athene cunicularia*) alongside its burrow. This small owl is active during the day and can be seen in open grasslands throughout the Pantanal.

A giant anteater (*Myrmecophaga tridactyla*) feeding on ants, Fazenda Pouso Alto. This threatened animal can still be seen in the Pantanal, especially in protected areas. Highly specialized feeders, anteaters use their strong front claws to open up ant and termite colonies, and also for protection when attacked.

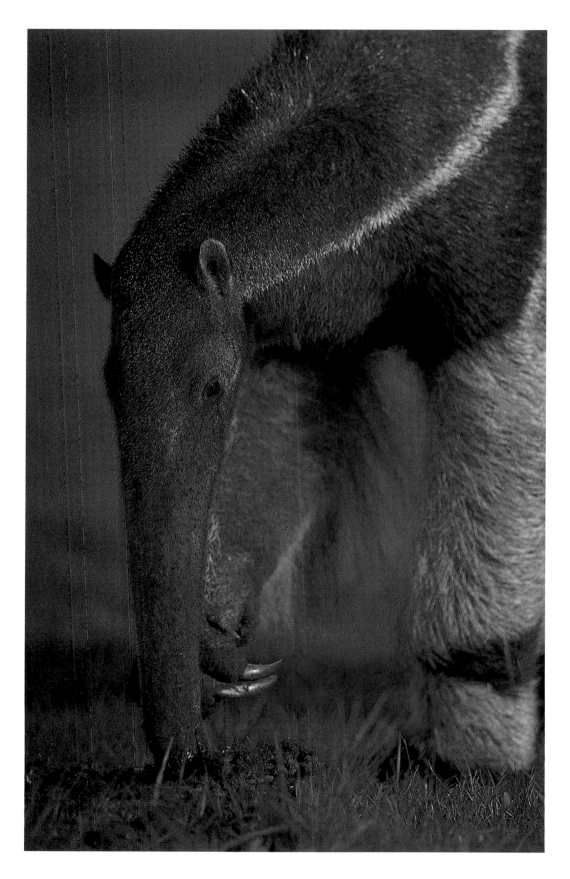

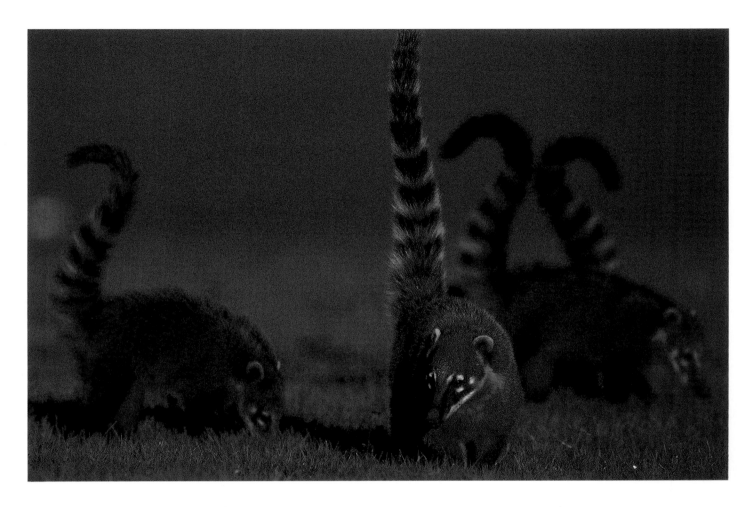

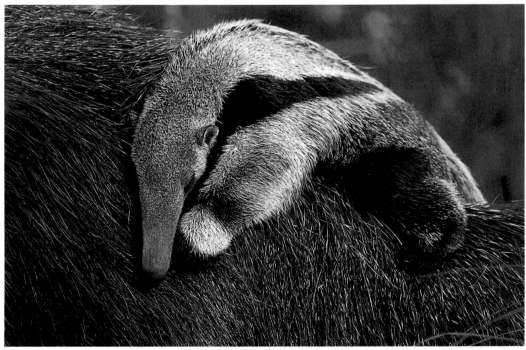

South American coati (*Nasua nasua*), ABOVE, feeding on a dry season grass-covered floodplain, or *vazante*, southern Pantanal. Female coati and juveniles travel in groups, while the males are usually solitary.

A baby giant anteater (*Myrmecophasa tridactyla*) riding on its mother's back, see also OPPOSITE.

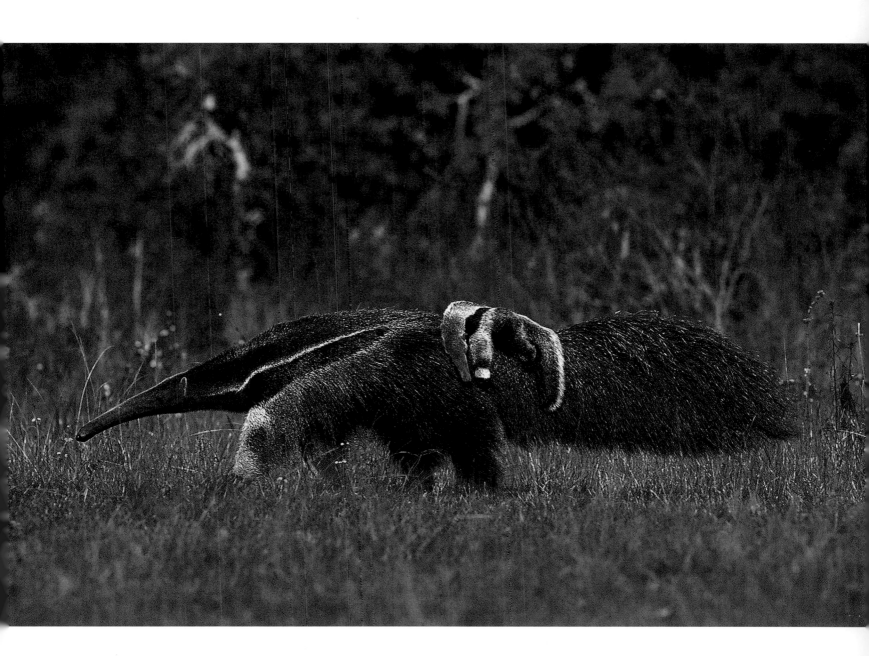

A giant anteater (*Myrmecophasa tridactyla*), known in the Pantanal as "tamandua-bandeira" or "flag-anteater" because of its long bushy tail and striking pattern. This female is carrying a baby on her back, see also in close-up OPPOSITE. Anteaters bear only one offspring at a time and are very attentive mothers. It is only when the juvenile reaches about half the adult's size, of around 1.8 m, that the two part company.

Forests of the Pantanal

Refuges in a flooded land

When one flies over the Pantanal for the first time, it is easy to understand why scientists have always referred to this region as a "mosaic" or a "complex" of different types of vegetation. Although dominated by vast and impressive grasslands, the Pantanal harbors a number of different forest types as well, each with its own set of tree species. Four major types can be distinguished here: riverine forests, palm forests, mesophitic forests and *cerradão*.

Riverine forests

When a river flows through the Pantanal for a long period of time, several geomorphological units are formed in association with it, particularly side dikes or levee-banks built up by sediments deposited during periodic flooding. These levee-banks constitute a special environment enjoying favorable water conditions. They receive an additional water supply on a seasonal basis and, at the same time, are well drained because they are raised above the surrounding floodplain and the adjacent river itself.

During flood periods, the rivers carry different propagules (seeds, fruits, branches, and even complete trees), many of which originate in the forests of the upper basin in Amazonia or in the Cerrado. Rivers thus generate the environmental conditions suitable for the development of riverine forests and then act as the main source of propagules for the species which grow there. In the Pantanal, riverine forests cover only 2.4 percent of the region,[1] but they are widespread, since nearly all rivers and streams are fringed by such growth.

When riverine forests are narrow strips along small rivers and streams and are flanked by grasslands, they are referred to as "gallery" forests because tree crowns form a gallery over the watercourse. However, when they border wider rivers, these forests are often called matas ciliares (literally, "eyelash forests") because they fringe both banks like eyelashes.[2]

Riverine forests have canopy trees 20–30 m tall, with some emergent trees reaching over 30 m in height. Species composition varies a lot according to topography, drainage and soil characteristics, but trees such as *ingá* (*Inga vera*), *ingá-bravo* (*Pterocarpus michelii*), *chifre-de-veado* (*Sweetia fruticosa*), *figueira mata-pau* (*Ficus dendrocida*), *bambu* (*Guadua paniculata*)

A male black howler monkey (*Alouatta caraya*) yawning. It is difficult to believe that these small, generally quiet animals can generate one of the most imposing sounds of the Pantanal forest. Amplified by a cup-shaped, bony hyoid apparatus in the throat, the roar of a male howler monkey can be heard several kilometers away in the forest, and even further over water.

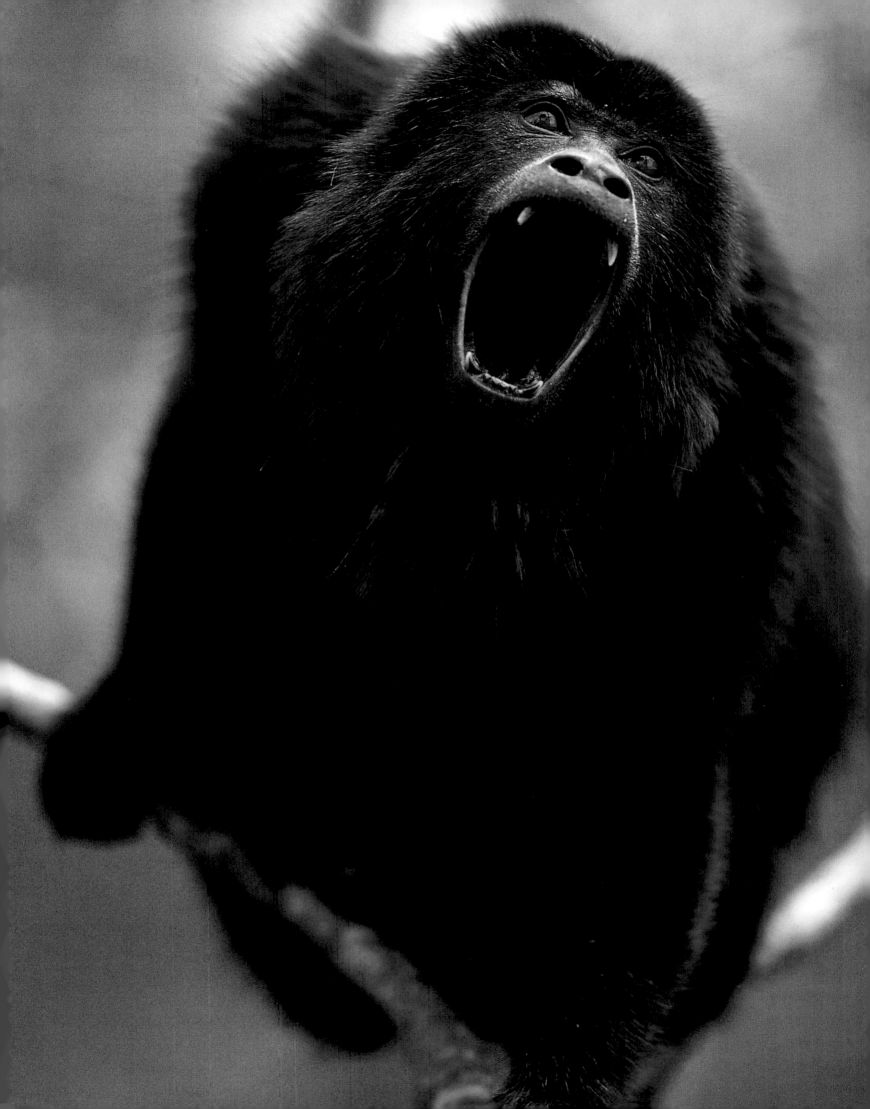

and *novateiro* (*Triplaris americana*) are regularly found in these forests. Riverine forests also represent floristic intrusions from Amazonia and/or the Atlantic forest into the Pantanal and are key habitats for some of the region's most interesting species of birds, including macaws, parrots, guans, curassows and toucans, as well as two types of monkey, the howler and the tufted capuchin.

Palm woodlands

The second type of forest is found in areas with high concentrations of certain palm species and is usually referred to as palm woodland or palm forests by botanists, although local people give them different names according to the dominant species present. There are *buritizais* whose dominant species is the spectacular lollipop-shaped *buriti* palm (*Mauritia flexuosa*), *babaçuais* dominated by the *bacaçu* palm (*Orbygnya phalerata*), and *carandazais* dominated by the carandá wax palm (*Copernicia alba*). *Buritizais* are usually associated with marshes and small watercourses, whereas *babaçuais* and *carandazais* require well-drained soils.[3] It seems that *babaçuais* constitute a secondary vegetation type derived from the alteration of semideciduous forests or were introduced by ancient indigenous populations that moved into the Pantanal.

Dry forests

The other two main forest types of the Pantanal are on higher ground. Although most of the Pantanal is a floodplain, there are some patches of slightly elevated ground that are not subjected to inundation. The large ones are called *cordilheiras* while the small ones are referred to as *capões* (singular *capão* from *caa* = forest, *pon* = round, in the Tupi Indian language). These terrains are relics of climatic conditions completely different from the current one and are true natural laboratories for understanding the complex and intriguing paleoecological history of the Pantanal.[4] Since these elevations experience severe drought during six months of the year, rather than evergreen forest, they are covered by either dry seasonal, or mesophitic, forest (where trees lose a large portion of their leaves during the dry season) or *cerradão*.

Mesophitic seasonal forests can be deciduous or semi-deciduous and are associated with nutrient-rich soils. The plant species belong to ancient forests that were probably continuous, or almost continuous, across Central and South America during drier and cooler periods in the Tertiary and Quaternary (from 65 million years ago to recent times), but are now represented by three main regions: the arboreal *Caatingas* of northeastern Brazil; the *Missiones* forests of Corumbá-Porto Suarez, extending into Paraguay, Missiones in Argentina, and the Brazilian state of Santa Catarina; and the *Piedmont* forests of Bolívia and northern Argentina.[5]

Mesophitic forests cover only 4 percent of the Brazilian Pantanal.[6] The taller trees produce a canopy 15–25 m in height, with a few emergent individuals. Species such as *aroeira* (*Myracroduon urundeuva*), *gonçalo* (*Astronium fraxinifolium*), *aroeirinha* (*Lithraea molleoides*), *coronilho* (*Schinopsis brasiliensis*), *cedro* (*Cedrella fissilis*), and the broad–crowned *ximbiuva* (*Enterolobium contortisiliquum*) are conspicuous in this type of forest. In some mesophitic forests, the understorey is dominated completely by *acuri* palm (*Attalea phalerata*), forming the so-called *acurizais*.[7] Sometimes this palm is so abundant that it produces a shade so deep it prevents development of other vegetation. In other forest patches, the understorey is dominated by a dense, almost impenetrable ground layer of *bromélias* (*Bromelia balansae*) which sometimes reaches 2 m in height.

Cerradão

Cerradão (Portuguese for big Cerrado) is the tree component of the vegetation that covers most of the central Brazilian plateau (the Cerrado). It is an almost closed woodland with crown cover of 50 to 90 percent, made up of trees usually 8–12 m in height but sometimes

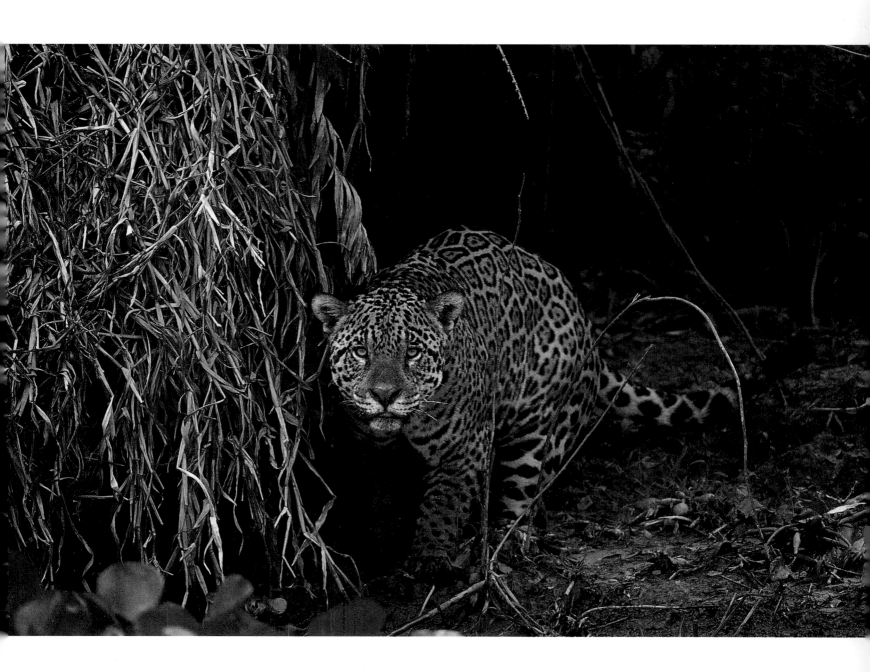

A Pantanal jaguar (*Panthera onca palustris*) on the banks of the Rio Cuiabá. The Pantanal subspecies of this wide-ranging cat is by far the largest, and males can reach weights of 130 kg.

PREVIOUS PAGES: Toco toucan (*Ramphastos toco*), Fazenda São José near the Rio Aquidauana.

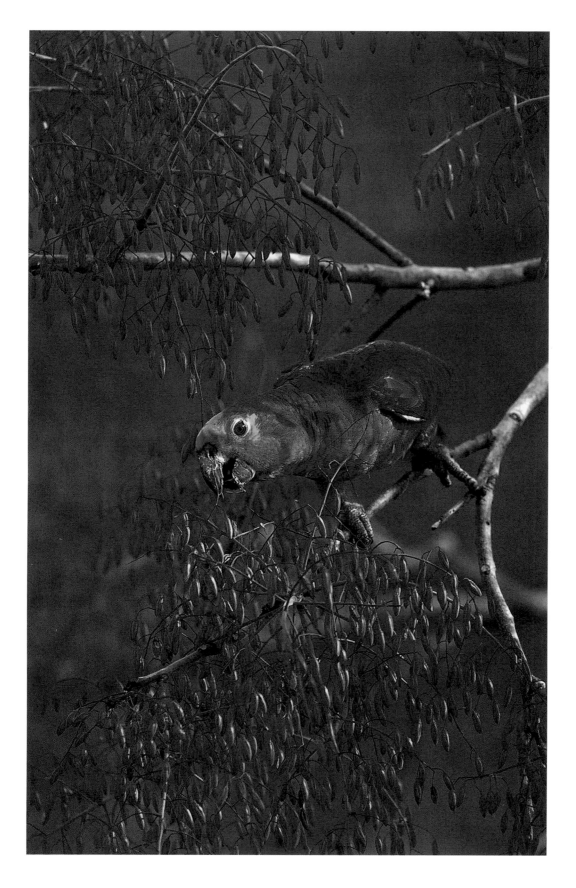

A turquoise-fronted parrot
(*Amazona aestiva*) feeds on
seeds, Poconé region, northern
Pantanal.

taller and casting considerable shade so that the ground layer is much reduced.[8] *Cerradão* covers 22.1 percent of the Brazilian Pantanal.[9] Here most of the *cerradão* falls into the category of "mesotrophic facies *cerradão*", a very distinctive vegetation type associated with soils of intermediate fertility, particularly in terms of calcium and magnesium.[10] This type of *cerradão* is readily recognized by the presence of several indicator species such as *timbó* (*Magonia pubescens*), *carvoeiro* (*Callisthene fasciculate*), *mulher-pobre* (*Dilodendron bipinniatum*) and *capitão* (*Terminalia argentea*).

Animals of the forests

The forests of the Pantanal are home to a lot of the region's most interesting animal species, many of which move out into the grasslands and wetlands to seek food, but retain the trees as their ultimate refuge. These include creatures like the brilliantly-colored macaws and parrots, the imposing Pantanal jaguar, the puma, the huge Brazilian tapir — largest of South America's land animals — the giant anteater and its smaller relative the southern *tamandua*, the two species of peccary, the coatis, and a handful of monkey species.

Jaguar

The forests and grasslands are also home to the famous Pantanal jaguar (*Panthera onca palustris*), the largest cat of the Americas and, unusually among the big cats, a good swimmer. Reaching up to 130 kg, jaguars prey on a wide variety of animals, in trees, water and on the ground, including fish, peccaries, capybaras, tapirs and marsh deer. They keep the food chain in check by controlling other prey populations, but are also victims of their bad reputation, and have long been hunted in the Pantanal because of their perceived threat to people and cattle. Famous hunters came here to experience the thrill of killing jaguars ambushed by dogs. A huge, heavy, metal-tipped spear, known as a *zagdaya*, was skillfully used by old-time *Pantaneiros* to kill the big cats. Hunting was officially banned in Brazil in 1967 but illegal jaguar-hunting expeditions still occur in the Pantanal even today, slowing down the recovery of the species after years of persecution.

Hyacinth macaw

Although one sees many different animals on a trip to the Pantanal, some of the most memorable and most sought-after species are those of the forests. One of the great prizes of the region is the stunning hyacinth macaw (*Anodorhynchus hyacinthinus*). At around 93 cm it is the largest member of the parrot family by length, and at 1.5 kg it is only exceeded in weight by the bizarre nocturnal flightless *kakapo* of New Zealand.

Fortunately this macaw is often one of the first species encountered during a visit and the deep blue-colored bird with its large head, heavy beak, and raucous voice has become quite accustomed to humans, especially in the *fazendas* that are now specializing in tourism. For visitors it is a never-ending delight to see these macaws in small patches of forest, jockeying for position or feeding on the nuts that make up a large part of their diet. One is also likely to see a number of other members of the parrot family during a visit, including at least three other macaw species: the red-and-green macaw (*Ara chloroptera*); the golden-collared macaw (*Propyrrhura auricollis*); and the blue-winged macaw (*Propyrrhura maracana*). The forests here are home to a total of 19 members of the parrot and macaw family.

More secretive species

In the Pantanal, there is often a good chance of seeing several secretive species that are extremely difficult to view elsewhere in South America. Once such notable and impressive animal is the Brazilian tapir (*Tapirus terrestris*). The largest land mammal on the continent, it reaches 1.1 m high at the shoulder and can weigh up to 250 kg. Although widespread in

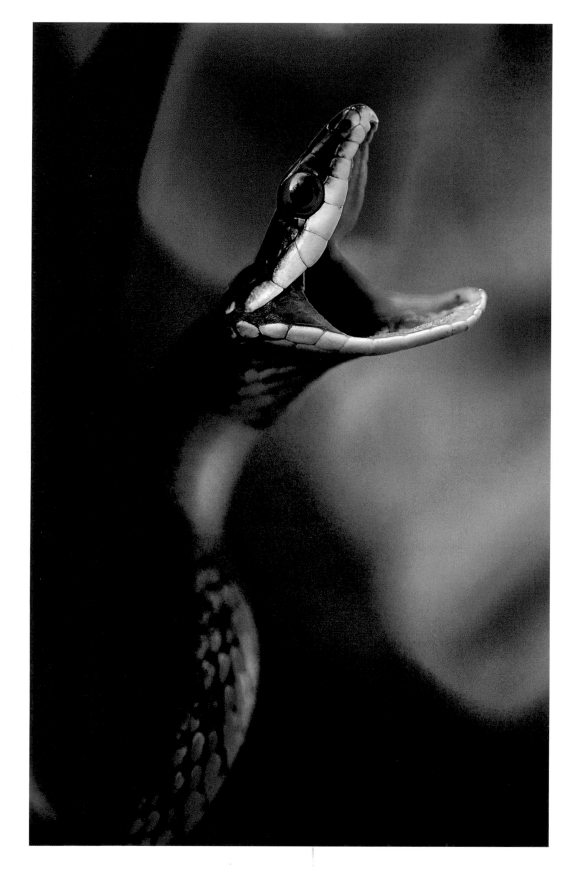

A parrot snake (*Leptophis ahaetulla*) in the Acurizal Reserve, northern Pantanal. These diurnal hunters are found in trees and shrubs, where they feed on frogs, lizards, birds and birds' eggs.

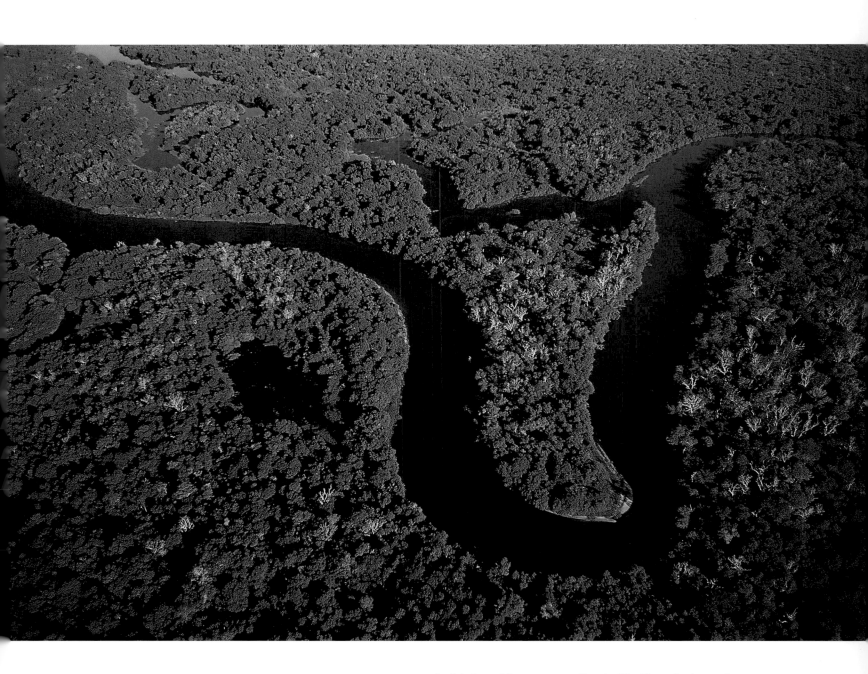

Aerial view of forest surrounding the Rio Negro in the southern
Pantanal.

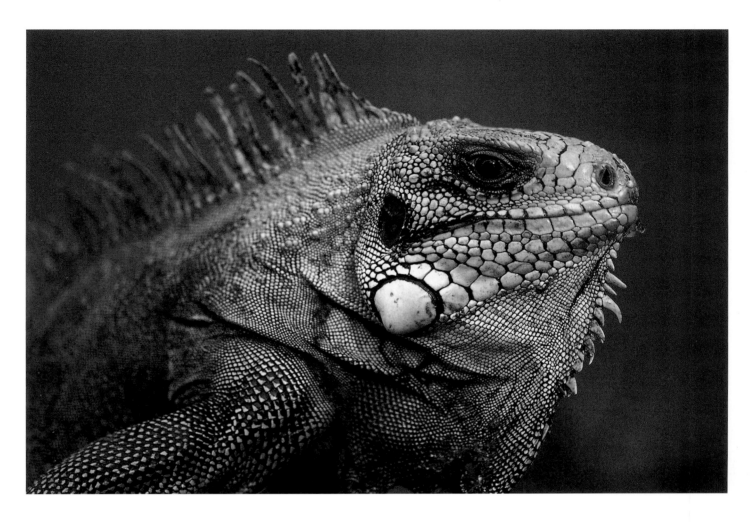

At up to 1.8 m in length, the green iguana (*Iguana iguana*) is a large arboreal reptile. Abundant through much of the Neotropical region (South and Central America and the Caribbean), it is also common in the Pantanal.

Amazonia, it is very difficult to see there because of the dense rain forest, but in the Pantanal it can often be observed in the early morning or at dusk at the forest edge.

The big cats, the jaguar and the puma (*Puma concolor*), though much more difficult to see in the wild than most other large mammals, are more likely to be observed in this region than anywhere else. With more effective protection, big cat populations are rebounding from the negative effects of hunting and sightings are on the increase.

Although also seen on the grasslands, like many Pantanal species the coati (*Nasua nasua*), and its near relative the crab-eating raccoon (*Procyon cancrivorous*), spend much of their time in the forests and are commonly sighted here.

Less conspicuous than its cose relative the giant anteater, the southern tamandua (*Tamandua tetradactyla*), also feeds on ants, termites and other insects, but, unlike the giant anteater, is at home both in the Pantanal's trees, where it makes good use of its prehensile tail, and on the ground.

Monkeys

Last but not least are the monkeys. Although only two species — the black howler monkey (*Alouatta caraya*) and the tufted capuchin monkey (*Cebus apella*) — are found in the forests of the Pantanal proper, there are two others with very restricted Pantanal distributions — the black-tailed marmoset (*Mico melanura*) and the night monkey (*Aotus azarae*) — living along the forest edges. Despite the small representation of species, the monkeys of the Pantanal are an integral part of the experience of this region. One of the iconic sounds of the Pantanal forest is the earth-shaking roar of the howler monkey. Considering its size (its body length is only 50 cm), one can scarcely believe that such an overwhelming noise can be produced.

A natural laboratory

Because of its extraordinary diversity of ecosystems with different biogeographic affinities, the Pantanal can be described as a large melting pot in which species that have originated in other regions come together. This has arisen through the expansion and retraction of the different vegetation types within the Pantanal, caused by both regional geomorphological changes and global climatic fluctuations during the last 2 million years. Thus, the Pantanal is in many ways a natural laboratory for any study on the evolutionary processes that shaped the biodiversity of tropical regions. Its conservation for these purposes alone is of utmost importance.

José Maria Cardoso da Silva, Russell A. Mittermeier, Cristina G. Mittermeier, Mônica Barcellos Harris

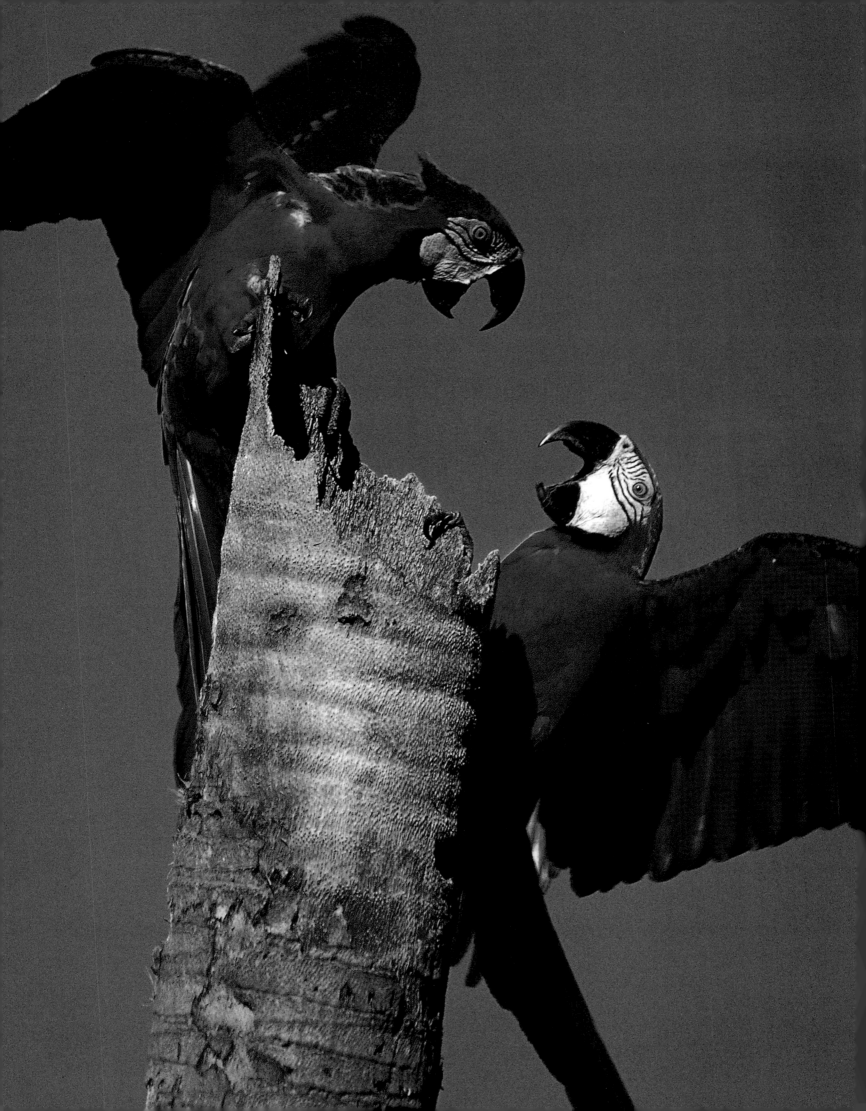

145

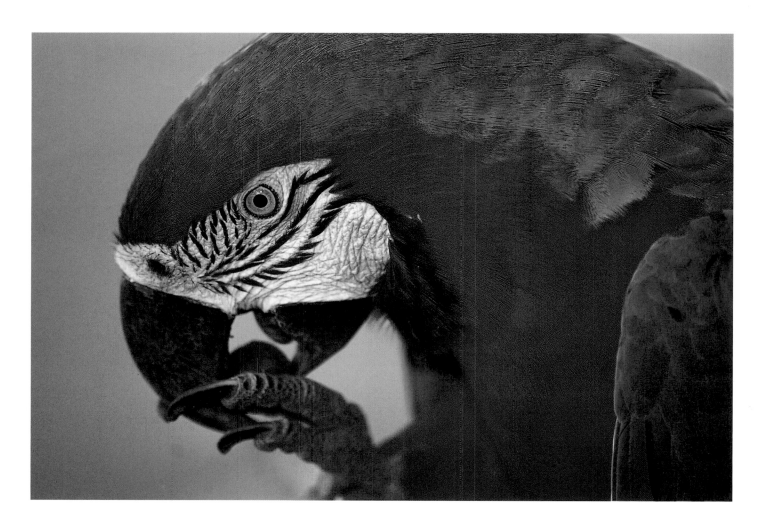

Blue-and-yellow macaws (*Ara ararauna*) are just one of the many brilliantly-colored parrot species of the Pantanal. The pair LEFT are wild birds at Fazenda Pouso Alto, Nhecolândia region, while the macaw eating a nut ABOVE was captured for the pet trade and then released at Fazenda São José near the Rio Aquidauana.

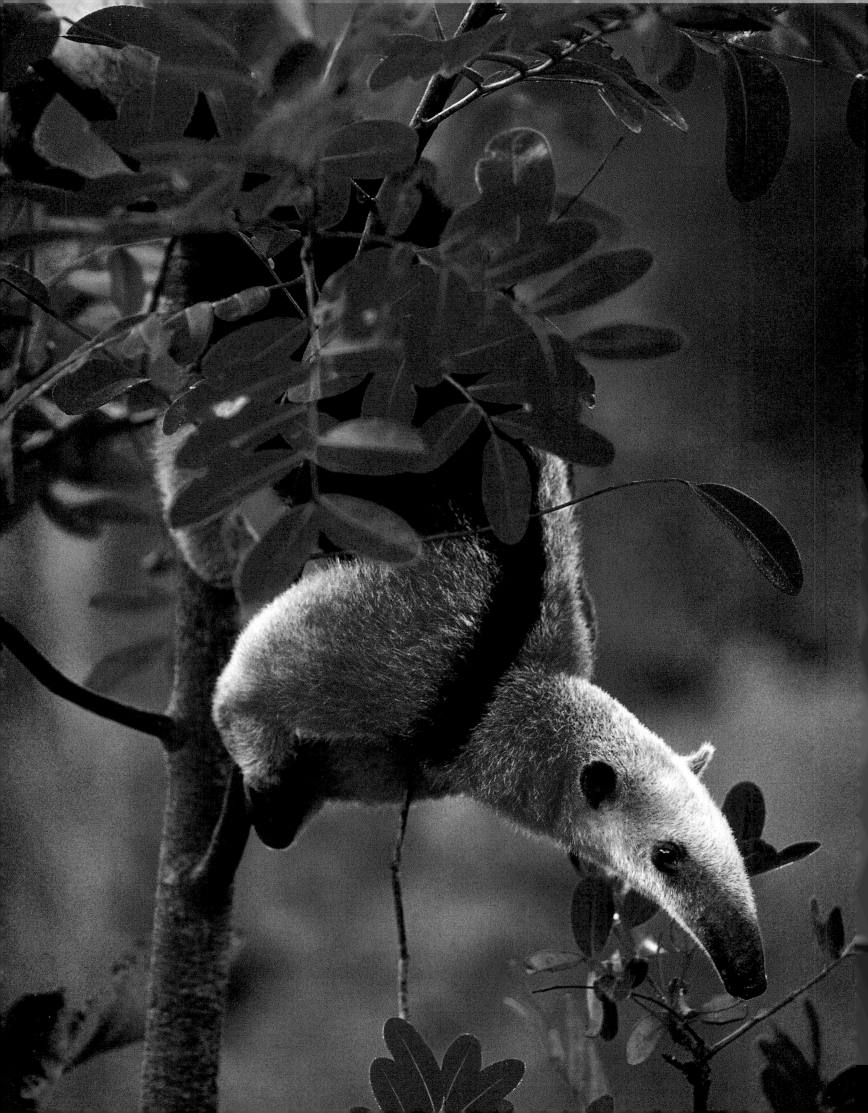

A red brocket deer (*Mazama americana*), RIGHT, at Fazenda São José near Rio Aquidauana. In contrast to the pampas deer and the marsh deer, this is a forest species.

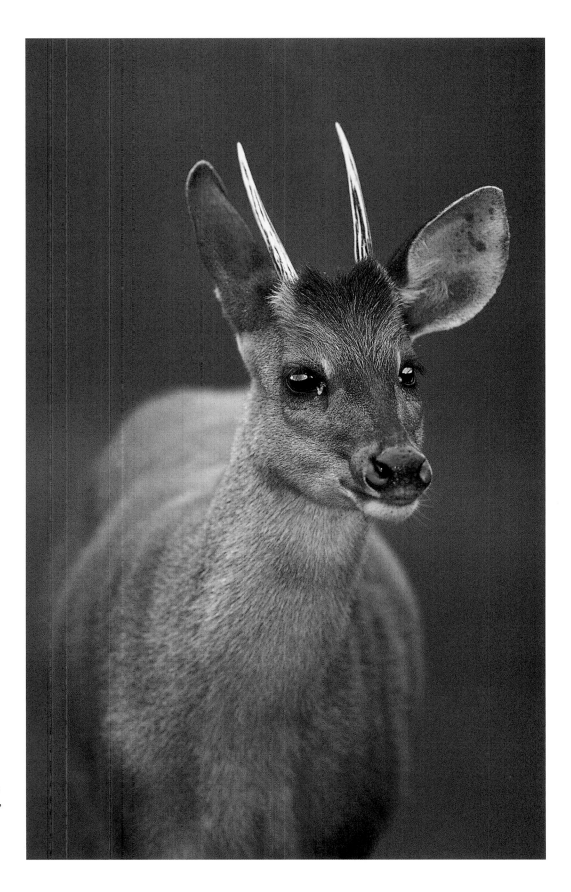

The southern tamandua (*Tamandua tetradactyla*), OPPOSITE, though not as conspicuous as its giant relative (see pages 129–131), is widespread in the forested areas of the Pantanal. It feeds on ants, termites and bees and forages both on the ground and in the canopy.

149

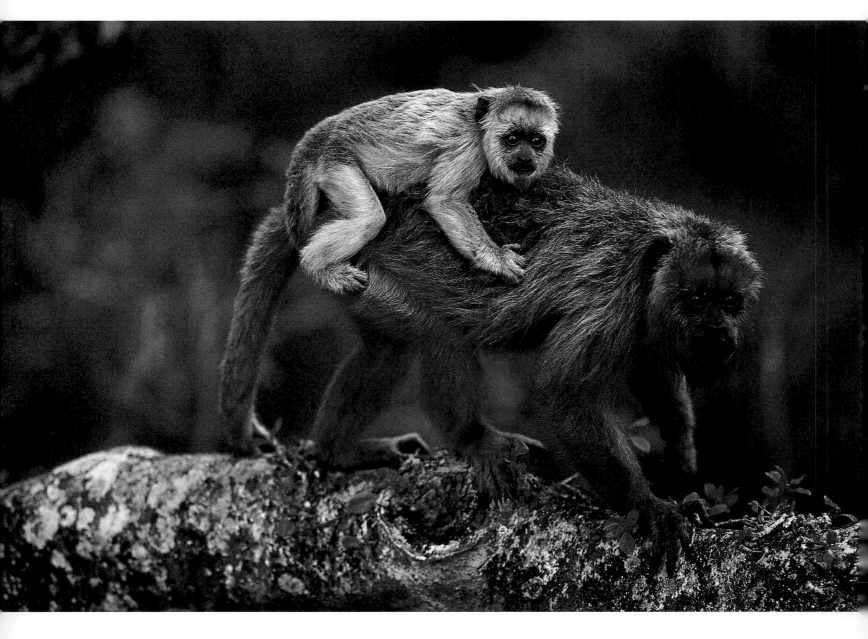

A female black howler monkey (*Alouatta caraya*) with infant,
climbing a tree in the northern Pantanal. This species is described as
sexually dichromatic; the males are a different color to the females.
Compare this yellowish female and infant with the solid black male
on page 133 and top right.

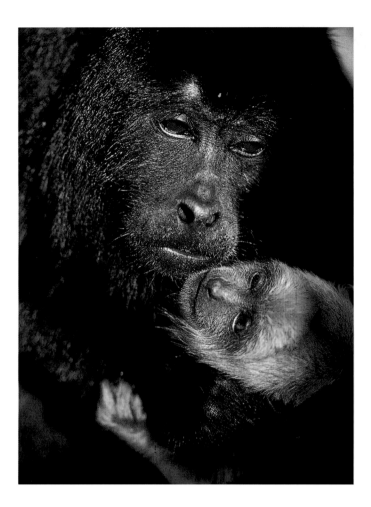

A male black howler monkey (*Alouatta caraya*) holding a baby. All infants begin life with the yellowish coloration of the mother, but males begin to turn black in the first year of life. Although most howler monkey species occur in tropical rain forest, the black howler monkey is found in a wide variety of habitats, including gallery forests in the Pantanal.

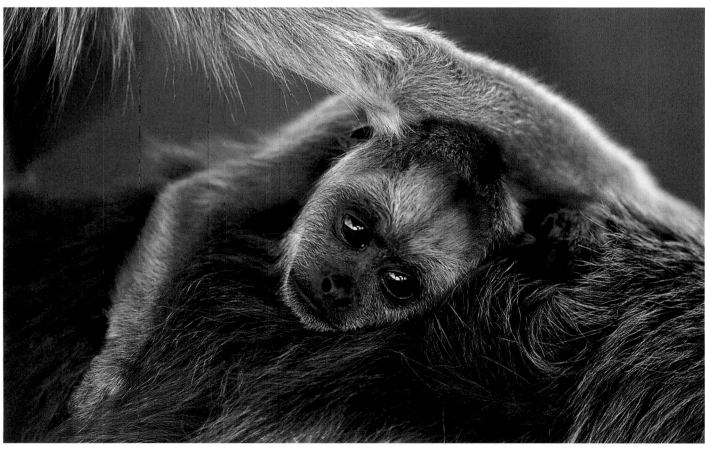

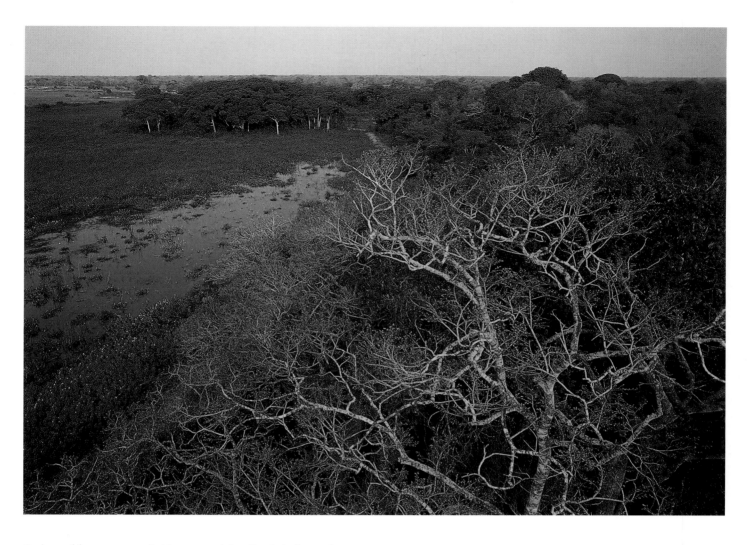

Pockets of forest surrounded by seasonal floodlands in September, during the dry season, Poconé region, northern Pantanal.

Toco toucan (*Ramphastos toco*) in flight. Although primarily fruit eaters (the toucan, OPPOSITE, is eating papaya fruit), toucans will occasionally eat animals, including the nestlings of other birds.

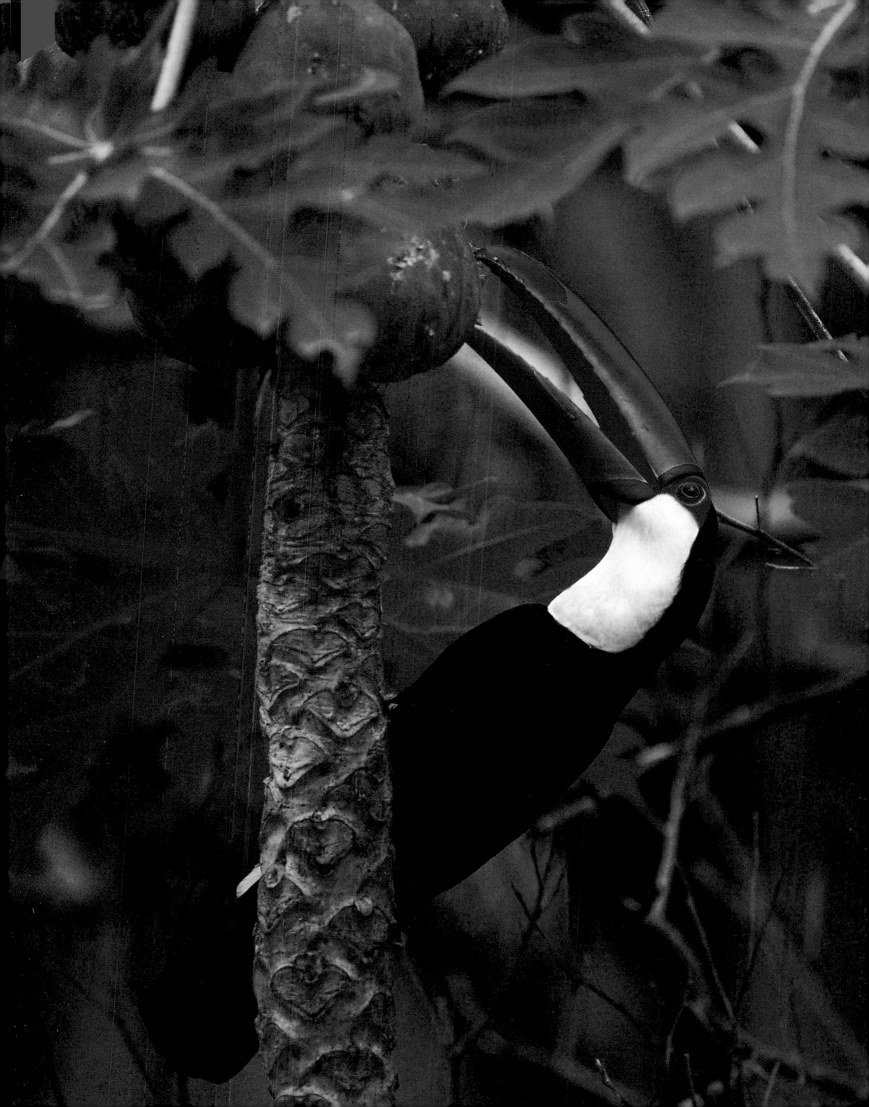

154

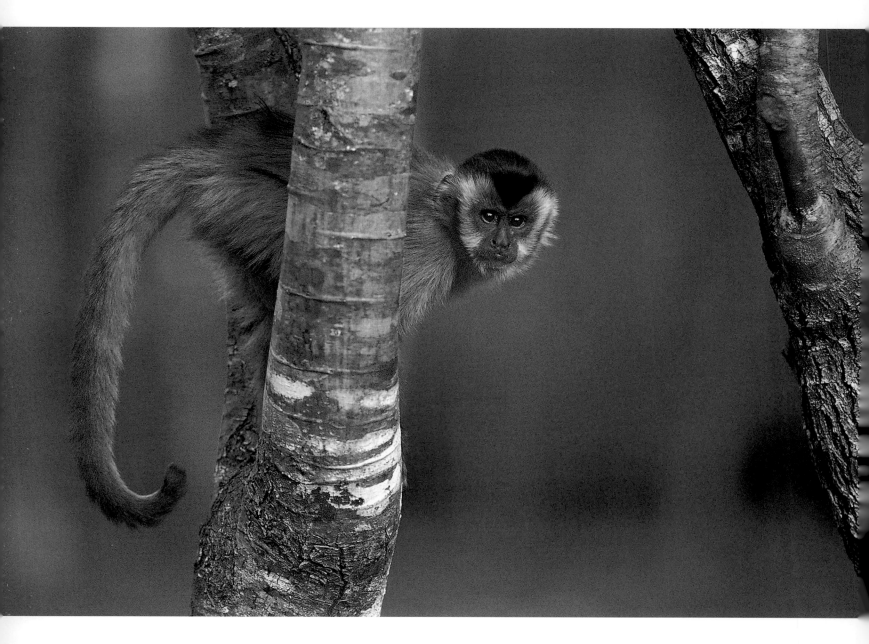

A tufted capuchin monkey (*Cebus apella*) near Poconé, northern
Pantanal. These highly active and gregarious animals are one of
the few monkey species occurring in the region.

A southern tamandua
(*Tamandua tetradactyla*) takes
refuge in a tree in the northern
Pantanal.

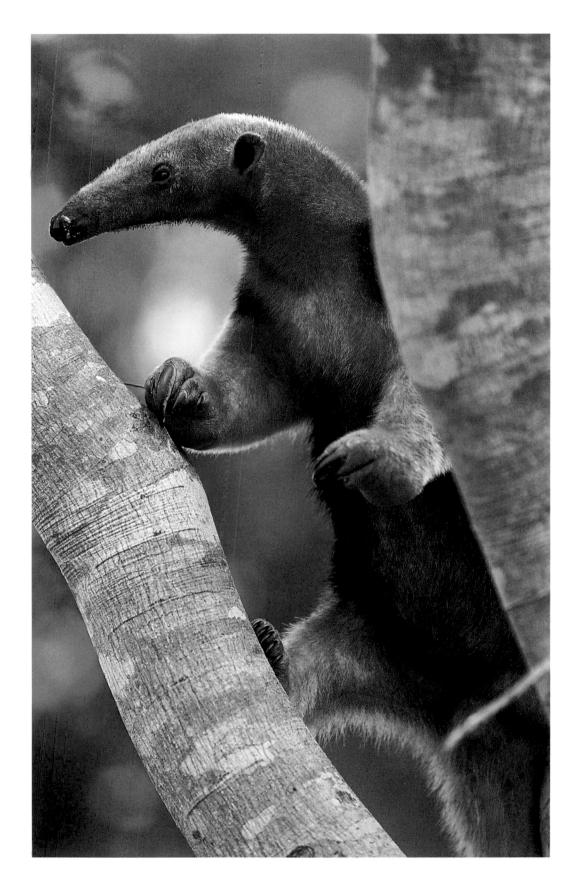

155

Caiman
Celebrating a comeback

One of the most enduring memories of any trip to the Pantanal is one's first encounter with a large concentration of Pantanal caimans (*Caiman yacare*). Although crocodilians are difficult to see and often quite secretive in most parts of the world, the caimans of the Pantanal are omnipresent during daylight hours and can be observed in large to sometimes enormous numbers — usually in the dozens, sometimes in the hundreds, and, at the peak of the dry season, occasionally in the thousands. With densities which can reach 150 individuals per sq km,[1] concentrations of this species are surely among the greatest wildlife spectacles on earth, yet few casual observers realize that the caiman was at great risk as recently as a decade ago. What visitors see now is the result of great efforts by conservationists and local people to make it possible for this and many other Pantanal species to make dramatic comebacks. In this chapter, we discuss the history of hunting in the Pantanal and the factors that made it possible for species like the caiman, the jaguar and the giant otter to recover their populations and hopefully to survive over the long term.

Hunting traditions

Hunting has long been a tradition in the Pantanal. Since time immemorial, people have taken advantage of this very productive ecosystem to hunt game animals of various kinds. The tribes that once lived here carved figures of animals and painted scenes on the walls of sandstone caves — for example, on the red cliffs of the Serra de Maracajú, in Coxim Municipality, eastern Mato Grosso do Sul — to mark their paths when searching for food and shelter. River-dwelling people left behind broken ceramics, and sometimes these contained remnants of food that give us clues as to what they hunted.

Hunting in this region may have been so intense that some biologists believe it could have caused the post-Pleistocene extinction of the giant ground sloths that once roamed these plains. Archeological discoveries pointing to this have been found inside limestone caves in the Bonito area, near the Bodoquena National Park.

Conversely, the extreme seasonal weather patterns in the Pantanal may have acted as natural controls for hunting activities by influencing yearly movements of game species in the floodplain and thus affecting hunting strategies. Target species dispersed and hid during the floods, giving them the chance to reproduce and revive their populations before the next hunting season.

The legacy of commercial hunting

In the early 20th century, new pressures emerged as hunting became a commercial activity in the Pantanal, with the skin trade becoming an important part of Brazil's regional economy. Harvesting data gathered by a commercial association in Corumbá show that species such as caiman, capybara, peccary and deer were heavily hunted from 1901 until 1967, when

A Pantanal caiman (*Caiman yacare*) in a small river, northern Pantanal. Caimans use the river to help maintain their body temperature. In cooler temperatures they stay in the water and as the day warms up they move onto the land to bask in the sun.

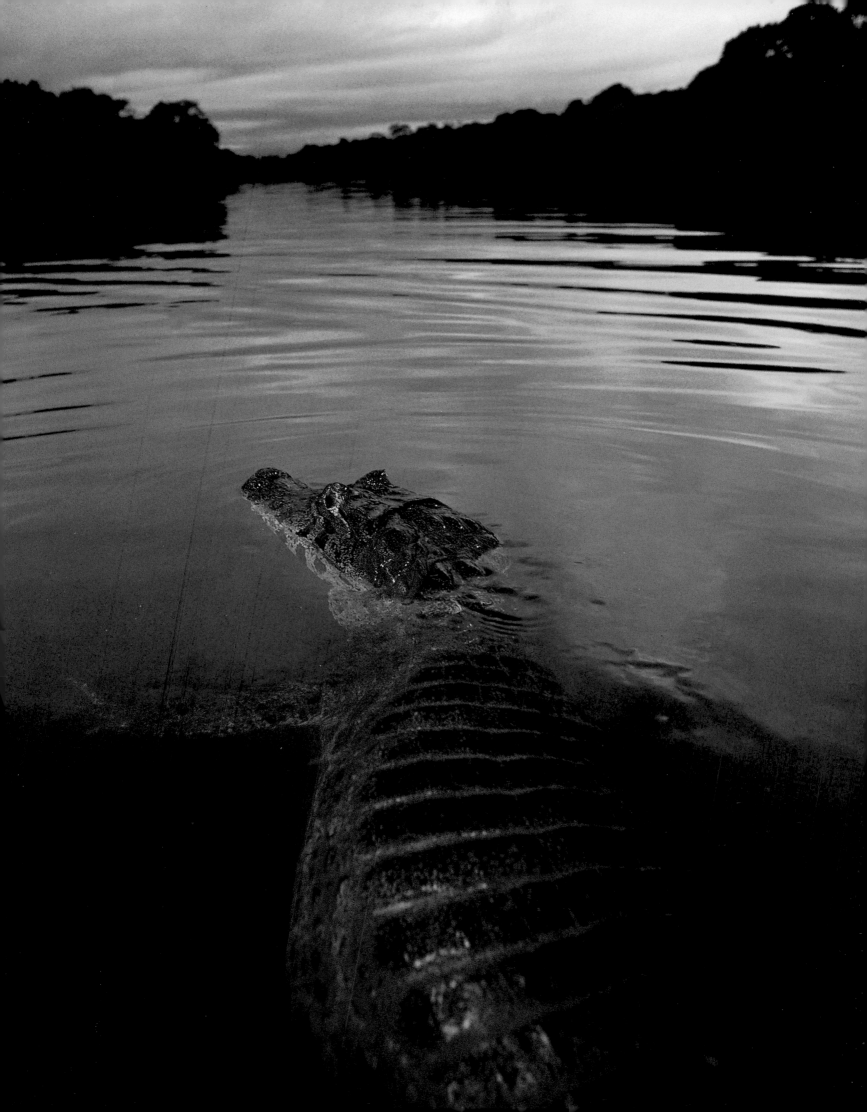

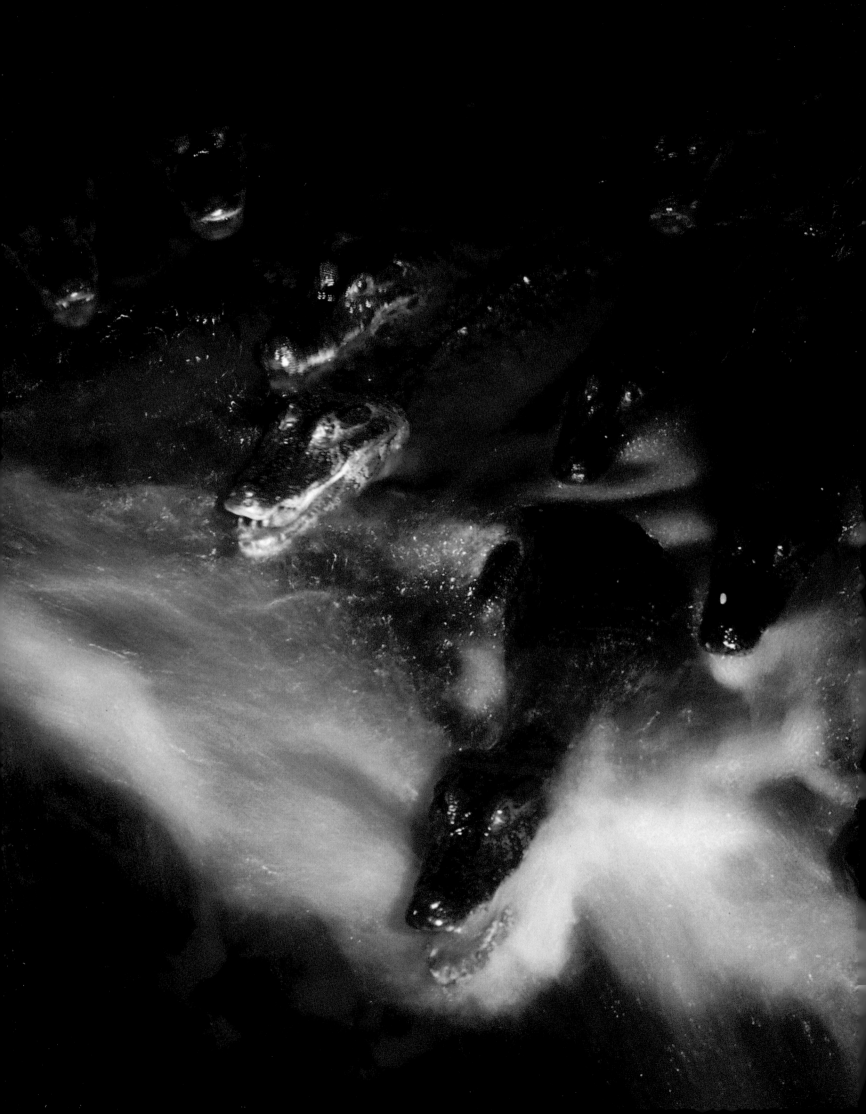

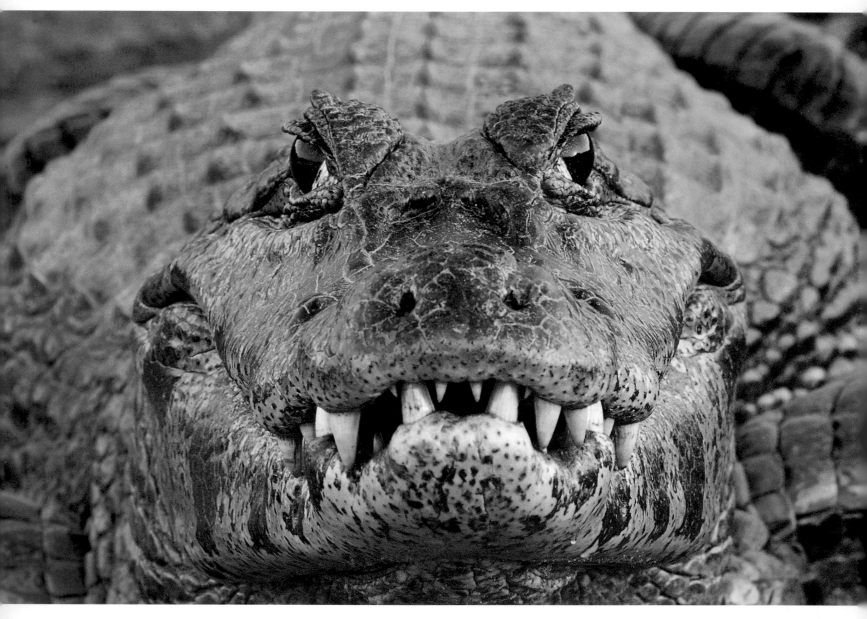

Close up of the head of an adult Pantanal caiman (*Caiman yacare*). The Pantanal species is a rather small crocodilian compared to the Australian saltwater crocodile or the American alligator. It reaches no more than 2.5 to 3 m in length, with males weighing up to 58 kg and females approximately half this.

PREVIOUS PAGES: Rather than chasing down their prey, these Pantanal caimans (*Caiman yacare*) are waiting in the current for fish or other animals to flow into their open jaws. Caimans come together in large numbers only infrequently. Here, at Refúgio Ecológico Caiman, it is because of the large quantity of food available in this creek flowing out of a lagoon. The only other time they gather together is during the dry season, when they crowd around ever-diminishing pools of water.

commercial harvesting was officially prohibited by Brazilian law. Unfortunately hunting didn't end with the ban, but continued throughout the remainder of the 20th century, with animals being smuggled into Paraguay and Bolivia to be legally exported from those countries.

Conflicts between farmers and *coureiros* (poachers) — especially those in search of caimans — became common and local people were often afraid to leave their own homes because of the threat posed by the illegal hunters. An army of forest guards was put in place and many people were killed on both sides during the ensuing conflict. Colonel G. Rabelo, Corumbá's current Secretary for the Environment and Tourism (2004), was still in school when he was shot by poachers during a skirmish at the Brazil-Bolivia border. As a result, he partially lost the movement of an arm.[2]

The caiman comeback

From 1962 to 1973, caiman populations in the Pantanal experienced a double whammy, with a severe drought and intense hunting pressure. The result was a dramatic reduction in caiman stocks. Although detailed data are not available, anecdotal information from the early 1970s suggest that densities dropped to a low of 10 to 20 caimans per sq km,[3] or 15 times lower than the highest densities observed today. It is reported by local people that carcasses littered the ground, and many more caimans could be seen starving in the dry fields. Specialists became concerned that the species would be exterminated entirely from the region.

Legal intervention

The situation described above became so severe that the plight of the Pantanal caiman provided one of the principal motivations behind passage of the 1967 law banning all commercial hunting of wildlife in Brazil. However, despite the commercial hunting ban and vigorous enforcement attempts, caimans continued to be subjected to intense harvest pressure during the 1980s — to the point that the species was reported as one of the most heavily exploited crocodilians in the world.[4] Estimates indicate that in that decade approximately one million caimans were harvested annually in the Pantanal.[5]

International influences

In recent years, changes in international legislation, especially the implementation of CITES (the Convention on International Trade in Endangered Species of Wild Fauna and Flora), and a worldwide drop in the market price of skins resulted in much-reduced incidence of poaching. Since the early 1990s, illegal caiman hunting in Brazil has been all but eliminated, due both to increased enforcement capabilities and to growing conservation efforts by research institutions like EMBRAPA (Empresa Brasileira de Pesquida Agropecuária, the Brazilian Agricultural Research Corporation), state universities and conservation NGOs. At the same time, water levels in the Rio Paraguay have remained high since 1974, facilitating a comeback. In a harvest-free environment and under a high water-level regime that has lasted 30 years, caimans are thriving once again in conditions that favor the survival of young, the acceleration of individual growth rates, and maximum overall reproductive success. Today, we are certain that adult caiman numbers in the entire Pantanal exceed 3.5 million. These are certainly among the largest concentrations of crocodilians anywhere on earth, and visitors to the region, however short their stay, can now be assured of seeing the Pantanal's most celebrated reptile.

Other species under threat

Spotted cats were another group targeted by hunters in Brazil. The skins of these beautiful creatures have always been highly prized by the fashion industry, and that, combined with the fact that some species were considered pests by ranchers, meant that jaguars, pumas, and ocelots quickly became high-value targets of the skin trade.

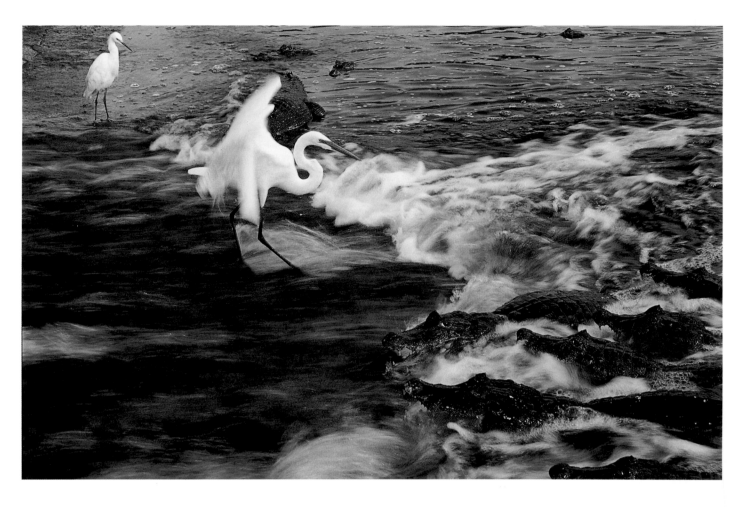

A great egret (*Ardea alba*) fishing in a stream near Pantanal caimans (*Caiman yacare*), Refúgio Ecológico Caiman.

Caimans (*Caiman yacare*) near Porto Joffre, northern Pantanal, concentrating around shrinking lagoons at the end of the dry season. When water is in very short supply, this species can reach amazingly high densities.

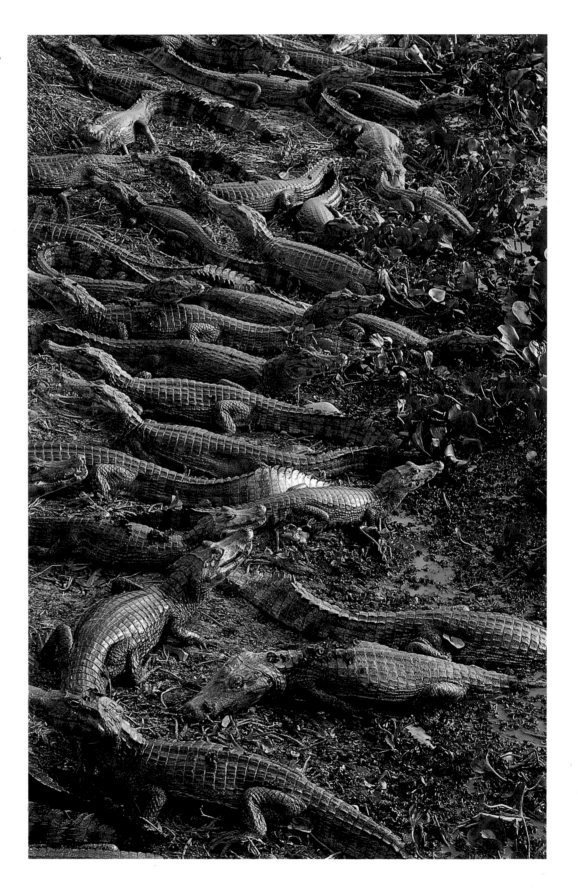

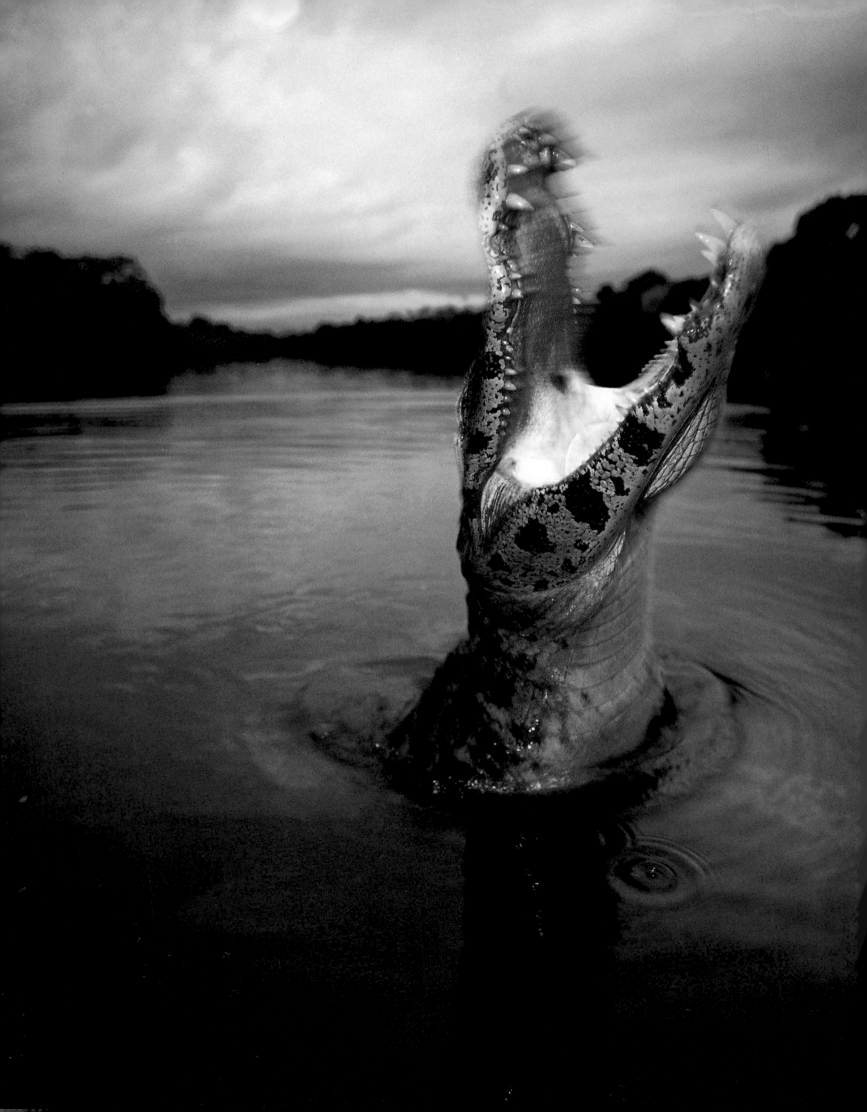

Jaguars in the firing line

Aside from the obvious commercial interest in their fur, jaguars in particular have great significance in sport hunting, being one of the most sought-after trophies by hunters from around the world. And the fact that the Pantanal jaguar (*Panthera onca palustris*), which can reach 130 kg, is by far the largest of the jaguars and the third largest big cat on earth, made it an even more appealing target. Indeed, former American President Theodore Roosevelt wrote a book about his jaguar-hunting exploits with his Brazilian host and founder of Brazil's Indian Agency (FUNAI), Marechal Candido Mariano da Silva Rondon.

Another legend in this risky sport was Sasha Siemel, the "Tigerman" of Brazil who became a living icon as a *zagaiero* (hunter of this very specialized prey) and was credited with having killed over 270 jaguars in his career.[6] Having experimented with several weapons, including rifle, bayonet, spear and bow, Siemel came to prefer the combination of bow and spear over the rifle, as the following passage indicates: "It is only logical and natural that I should. The spear is a primitive weapon, so is the bow. While I would not want to say that hunting big cats with a rifle cannot be plenty dangerous and exciting under all circumstances, particularly so in our Mato Grosso jungles, where vision is extremely limited, it seems to me that the bow complements the spear. If I now had any use for a shield besides, I should be perfectly equipped."[7]

Fortunately, although the jaguar is still seen by many as a threat to cattle and other livestock, conservationists and local communities in some areas are coming up with solutions that involve both economic compensation for losses and tax breaks for positive conservation agendas. As outlined in the Introduction, Conservation International has supported the Jaguar Conservation Fund Pilot Project that financially compensates farmers and local communities for losses in cattle, and also assists socially by providing medical and dental treatment to occupants of carnivore-friendly ranches. Thus, while the secretive jaguar is always difficult to observe, numbers appear now to be on an upswing. Certainly, one stands a better chance of actually spotting one in the Pantanal than virtually anywhere else in the animal's vast range.

The giant river otter

Another important flagship species of the Pantanal that was heavily impacted by the skin trade is the giant river otter (*Pteronura brasiliensis*). As narrated by Jorge Schweizer, a Pantanal *fazendeiro* (ranch-owner) who recounts his long relationship with this magnificent species in a book entitled *Ariranhas no Pantanal*,[8] these animals were killed by the hundreds for their pelts, with an average of 1,500 otters being slaughtered every year between 1937 and 1966.[9]

In his book, Schweizer recalls how populations of *ariranhas* had dwindled by 1965 and how the survivors were hardly ever seen during the daylight hours. Although many animals are able to modify their activity patterns to avoid hunting pressure, this isn't the case for giant otters, which hunt during the day and are an easy target for poachers.

Fortunately, thanks to increased protection and innovative conservation programs, also fashion consumers' resistance, giant otters are now also becoming more abundant, and are relatively easy to see in several parts of the region.

Ecotourism's impact

Furthermore, it must also be acknowledged that the recovery of all the above once heavily-hunted animals is fast becoming an engine for the rapidly-growing ecotourism industry. Their survival is an important income generator for the Pantanal's traditional *fazendas*, who are turning to this alternative operation in increasing numbers. All of this bodes well for species like the caiman, the jaguar and the giant otter, whose future once hung in the balance but whose comebacks in recent years have been among the most dramatic anywhere in the world.

Reinaldo Lourival, Cristina G. Mittermeier, Marcos Coutinho, Russell A. Mittermeier

A caiman (*Caiman yacare*) explodes from the waters of a small river in the northern Pantanal. This dramatic action can occasionally be observed when caimans fight over a large fish. In this particular case the behavior was triggered by baiting the caiman with fish to demonstrate its ability to jump high out of the water.

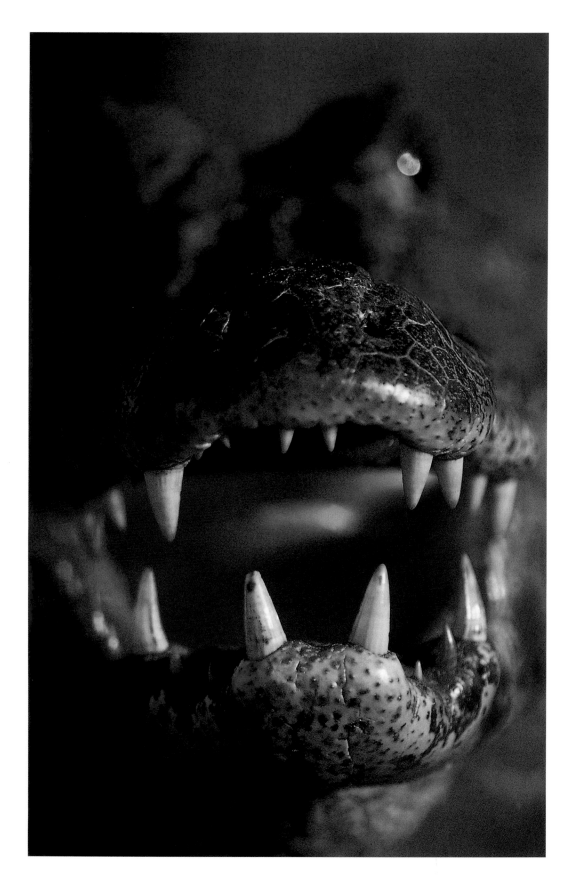

Despite its fierce appearance, the Pantanal caiman (*Caiman yacare*) is not dangerous to humans.

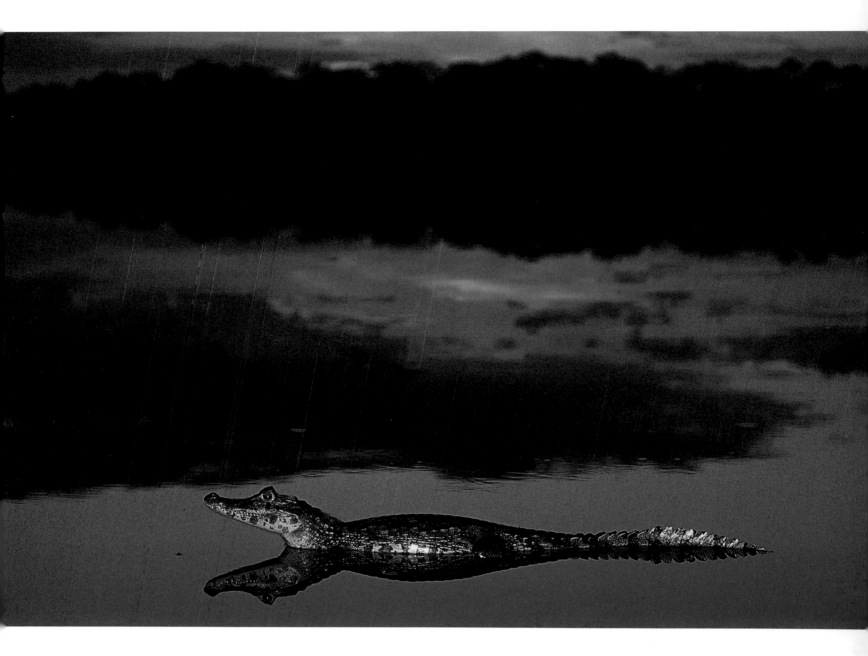

A caiman in one of the *salinas* of Fazenda Rio Negro. Caimans are able to use these brackish habitats in addition to their usual freshwater haunts.

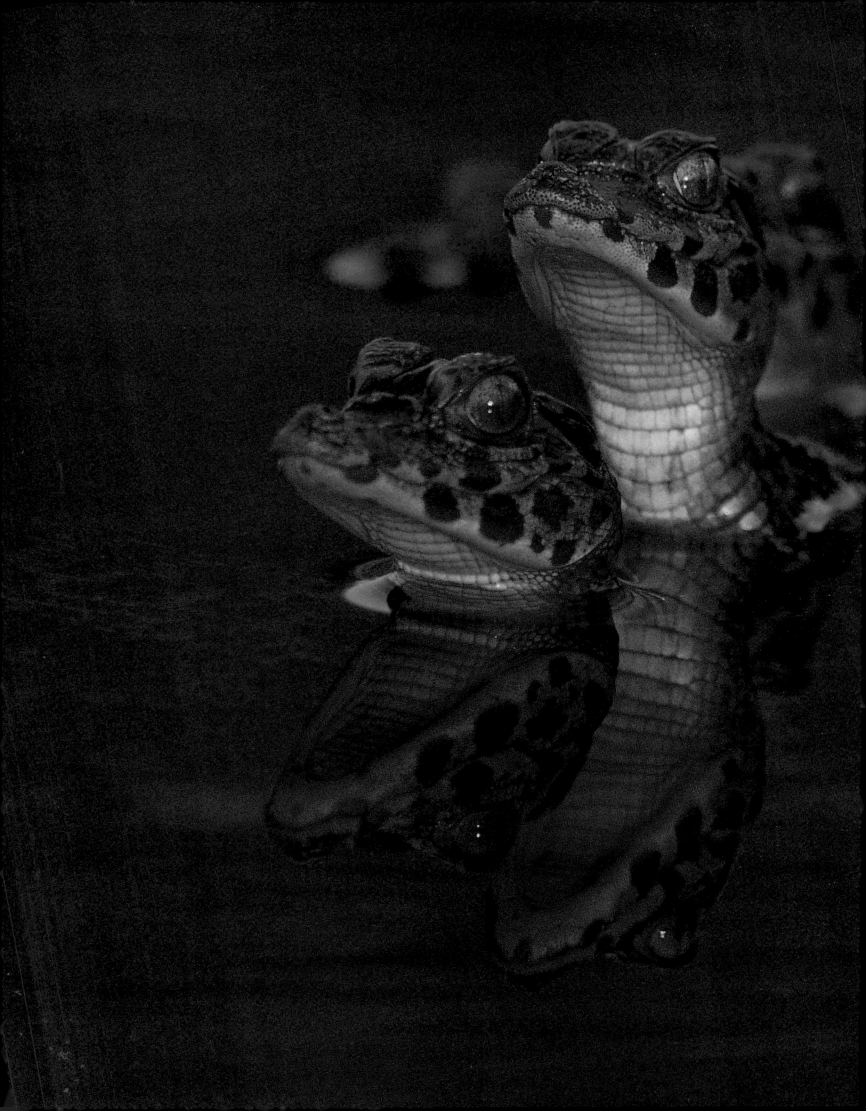

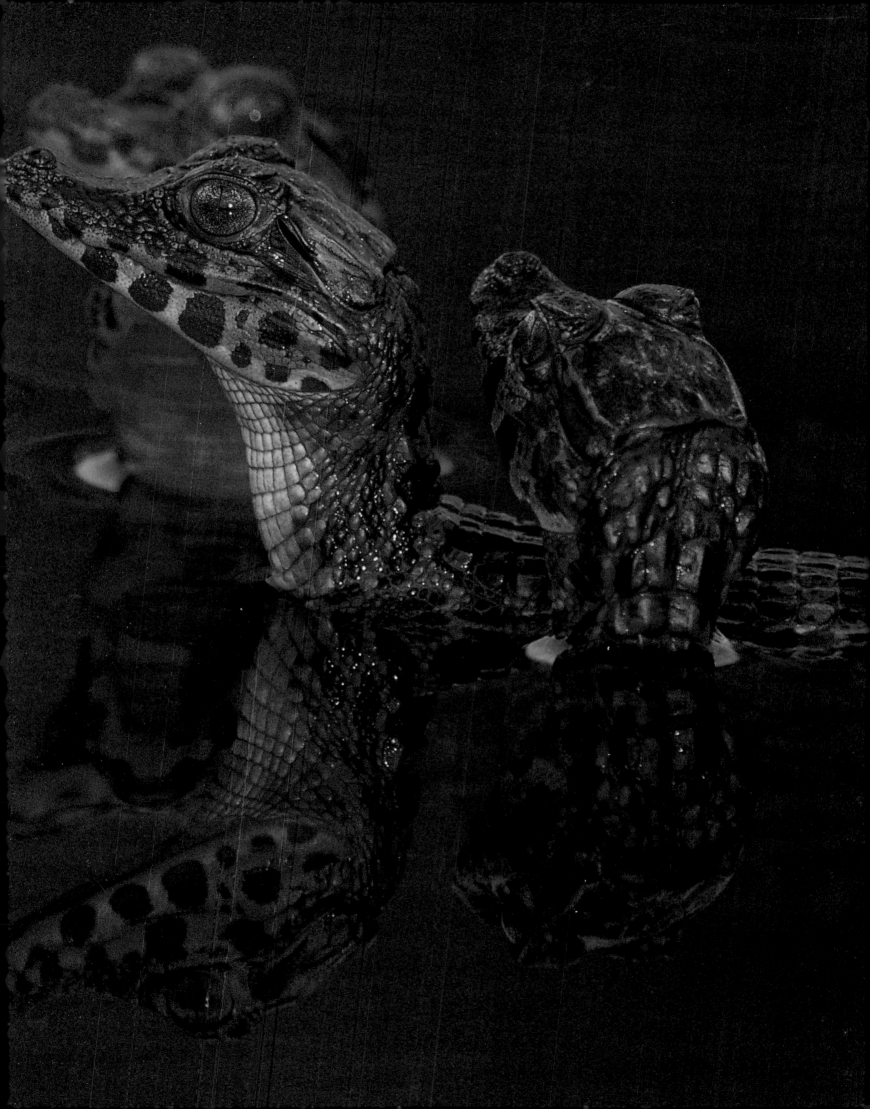

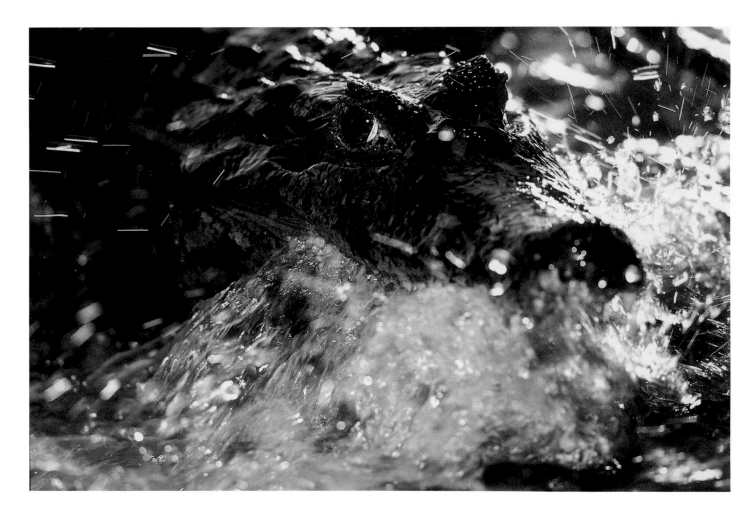

A caiman (*Caiman yacare*) in a strong current, Refúgio Ecológico Caiman. Although millions of caimans were killed for their skins during the peak period of the trade, their numbers have recovered well and they now appear to be one of the least threatened of all crocodilian species.

PREVIOUS PAGES: Although not in the picture, their mother is guarding these young caimans (*Caiman yacare*), along with more of their siblings, in a shallow lagoon at Fazenda Rio Negro. Caimans are among the few reptile species that exhibit a degree of parental care.

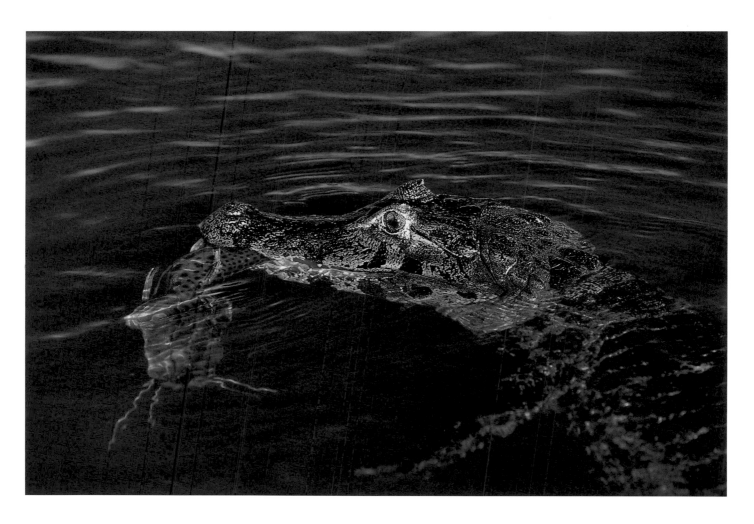

Caiman (*Caiman yacare*) swimming with a recently-captured catfish in its mouth, Poconé region, northern Pantanal.

Close up of the eye of a caiman (*Caiman yacare*).

The Authors

RUSSELL A. MITTERMEIER is President of Conservation International (CI), a position he has held since 1989. A primatologist and herpetologist by training, he has traveled widely in 100 countries, and conducted field work in more than 20 — much of his field work has focused on Amazonia (particularly Brazil and Suriname), the Atlantic forest region of Brazil and Madagascar. In addition to his work at Conservation International, he has served as Chairman of the IUCN/ SSC Primate Specialist Group since 1977, has been an Adjunct Professor at the State University of New York since 1978, and President of the Margot Marsh Biodiversity Foundation since 1996. He has published more than 400 scientific and popular articles and 12 books, including the recent trilogy *Megadiversity*, *Hotspots* and *Wilderness*, and, most recently, *Wildlife Spectacles*. Among the awards he has received are the San Diego Zoological Society's Gold Medal (1988), the Order of the Golden Ark of the Netherlands (1995), the Cincinnati Zoo Wildlife Conservation Award (1997), the Brazilian Muriqui Prize (1997), the Grand Sash and Order of the Yellow Star of the Republic of Suriname (1998), and the Order of the Southern Cross of the Brazilian Government (1998). In December 1998 he was also selected by *Time* magazine as one of its Ecoheroes for the Planet. Mittermeier is fluent in Portuguese, Spanish, German, French and Sranan Tongo (the Creole language of Suriname) in addition to English. He graduated from Dartmouth College (Summa Cum Laude, Phi Beta Kappa) in 1971, and received his Ph.D. in Biological Anthropology from Harvard University in 1977.

CRISTINA G. MITTERMEIER is one of the leaders of an emerging group of conservation photographers. Originally from Mexico, Mittermeier started her career as a marine biologist and has a degree in biochemical engineering from the Monterrey Institute of Technology and Advanced Studies. She has co-authored several scientific papers about biodiversity loss and conservation, but in recent years has expanded her focus to photography, with an emphasis on the documentation of endangered species and disappearing human cultures. Her work has been featured in several books, including *Hotspots* (1999) and *Wilderness* (2002), as well as numerous magazines in the United States, Mexico and Brazil, including *National Geographic* and *Nature's Best*.

GUSTAVO A. B. DA FONSECA is the Executive Vice President of Conservation International, and also Professor of Zoology at the Federal University of Minas Gerais (UFMG), Brazil. He was the first director of the Center for Applied Biodiversity Science, today a major international facility for conservation research. He led the design and became the director of the first graduate program in conservation biology in Brazil at the UFMG. In addition, he has authored over 100 scientific publications and dozens of popular articles, and serves on the board of several conservation NGOs. Among the awards he has received are the 1989 Oliver Austin Prize from the University of Florida, the 1989 Rodolpho von Ihering award from the Brazilian Society of Zoology, and the the Order of the Golden Ark of the Netherlands (2001).

REINALDO F. F. LOURIVAL, has worked in the Pantanal for the last 18 years. He started CI's Pantanal program 12 years ago and was its Senior Director up to 2003, when he started the Ph.D. program at the University of Queensland, Australia. Working with CI, he fostered the establishment of several public and private protected areas in the region (more than 150,000 hectares), and was also responsible for the implementation of the Rio Negro Conservation Ranch and Ecotourism product among other projects. With a Master degree in Ecology and Conservation, he worked as Mammal Curator of the Rio de Janeiro Zoo for two years, and as Associate Researcher of the Kayapó Project in the Amazon for one year. In partnership with several Brazilian and international organizations he coordinated two scientific expeditions to the headwaters of the Pantanal and developed the first national Ecotourism planning program with more than 800 trained trainers over 23 Brazilian states. Lately Reinaldo is focusing on his Ph.D. project on Conservation Planning for dynamic landscapes such as the Pantanal.

MÔNICA F. BARCELLOS HARRIS is the Director of the Pantanal Program at Conservation International Brazil. She grew up in the Pantanal, descending from early settlers in the region. Mônica attended college at Reading University in England, where she received her Bachelor of Science degree in Applied Zoology in 1996. She later pursued her Master's in Aquatic Resource Management from King's College of London. She started her work at CI as a consultant in 1999 on a joint effort with The Nature Conservancy and World Wildlife Fund to investigate stakeholders and economics of the Pantanal in preparation for establishing new

regional conservation priorities and strategies. In 2000 she joined CI staff full-time, initially coordinating the Cerrado-Pantanal Biodiversity Corridor program financed by USAID, later undertaking additional projects in the Pantanal program with support from the USAID Mission in Brazil, GEF, Funbio, Anheuser-Busch and others. Currently, she leads a multidisciplinary team of eight technicians working on four Biodiversity Corridor Programs in the Pantanal in partnership with over 25 local organizations. Mônica also oversees a rapidly expanding ecotourism and research center — the Fazenda Rio Negro, Conservation International's private protected area in the Pantanal.

JOSÉ MARIA CARDOSO DA SILVA is the Vice-President for Science of Conservation International Brazil. Before to join CI, he was a professor at the Federal University of Pernambuco (UFPE) and a visiting researcher at Museu Paraense Emílio Goeldi (MPEG). He graduated from Federal University of Pará in 1986, and received his Ph.D. in Zoology from University of Copenhagen in 1995. He has studied birds in all major Brazilian biomes and has published around 70 articles on ecology, conservation, systematics and biogeography of Neotropical birds, as well as editing four scientific books. He has received awards from the Brazilian Ornithological Society (1994), Brazilian Science and Technology National Council (1996), and from the Environment Program of USAID (2003).

PETER A. SELIGMANN, CEO and Chairman of the Board of Conservation International, is one of the most dynamic leaders of the global conservation movement. Since co-founding CI in 1987, he has grown the organization to become one of the most influential environmental groups in the world, with more than 800 professionals working in over 40 countries worldwide. A strong advocate of building partnerships, Seligmann has forged ground-breaking partnership projects between the environmental community and other sectors, including government and industry. Under his leadership, CI has pioneered conservation tools that are economically sound, scientifically based and culturally sensitive. Seligmann holds a Master's degree from Yale University's School of Forestry and Environmental Science.

Endnotes

Introduction

1 Por, F. D. 1995. *The Pantanal of Mato Grosso (Brazil)*. Kluwer Academic Publishers, The Netherlands.

2 Prance, G.T. and G. Schaller. 1982. "Preliminary observations on woody vegetation types on the Pantanal of Mato Grosso, Brazil". *Brittonia* 34: 228–251.

3 Bertelli, A. de P. 1988. *O Pantanal—Mar dos Xaraies*. Edições Sicilano, São Paulo.

4 Mittermeier, R. A., I. de Gusmão Câmara, M.T. Jorge Padua and J. Blanck. 1990. "Conservation in the Pantanal of Brazil". *Oryx* 24 (2): 103–12.

5 Adámoli, J. 1981. "O Pantanal e suas relações fitogeográficas com os cerrados. Discussão sobre o conceito de 'Complexo do Pantanal'". In: Anais do XXXII Congresso Nacional de Botânica. *Congresso Nacional de Botânica* 32: 109–119.

6 Hamilton, S.K. 2002. "Human Impacts on hydrology in the Pantanal wetland of South America". *Water Science and Technology* 45: 35–44.

7 Mittermeier, R. A., I. de Gusmão Câmara, M. T. Jorge Padua and J. Blanck. 1990. Op. cit.

8 Ravazzani, C., H. Wiederkehr Filho, J. P. Fagnani and S. Da Costa. 1990. *Pantanal*. Editora Brasil Natureza, Paraná.

9 Hamilton, S.K. 2002. Op. cit.

10 Magnanini, A. 1986. *Pantanal*. Edições Siciliano, São Paulo.

11 Assine, M. L. and P. C. Soares. 2004. "Quaternary of the Pantanal, west-central Brazil". *Quaternary International* 114(1): 23–34.

12 Seidl, A. F., J. S. V. Silva and A. S. Moraes. 2001. "Cattle ranching and deforestation in the Brazilian Pantanal". *Ecological Economics* 36: 413–425.

13 Silva, M. P., R. Mauro, G. Mourão and M. Coutinho. 2000. "Distribuição e quantificação de classes de vegetação do Pantanal através de levantamento aéreo". *Revta Brasil. Bot.* 23 (2): 143–152.

14 Brown Jr, K. S. 1986. "Zoogeografia da região do Pantanal Mato-grossense". In Brook, A. (ed.) *Anais do I Simpósio sobre Recursos Naturai e Socioeconômicos do Pantanal*. EMBRAPA-CPAP, Documento 5, Corumbá: 29–42.

15 Pott, A. and V. J. Pott. 1994, 2000. *Plantas do Pantanal*. Embrapa, Brasília.

16 Willink, P. W., B. Chernoff, L. E. Alonso, J. R. Montambault and R. Lourival (eds). 2000. *A Biological Assessment of the Aquatic Ecosystems of the Pantanal, Mato Grosso do Sul, Brasil*. RAP *Bulletin of Biological Assessment* 18. Conservation International, Washington, DC.

17 Fonseca, F. A. B., G. Hermann and Y. R. Leite. 1999. "Macrogeography of Brazilian mammals". In: J. Eisenberg and K. H. Redford (eds), *Mammals of the Neotropics, Volume 3*. University of Chicago Press, Chicago: 549–563.

18 PCBAP. 1997. "Aspectos ecológicos dos vertebrados terrestres e semiaquáticos no Pantanal". In: PCBAP. *Plano de Conservação da Bacia do Alto Paraguai, Diagnóstico dos Meios Físico e Biótico—Meio Biótico, Volume II, Tomo III*. Empresa Brasiliera de Pesquisa Agropecuária, Projeto Pantanal, Programa Nacional de Meio Ambiente, Brasília: 197–433.

19 Willink, P. W., B. Chernoff, L. E. Alonso, J. R. Montambault, and R. Lourival (eds). 2000. Op. cit.

20 Tubelis, D. P and W. M. Tomas. 2003. "Bird Species of the Wetland, Brazil". *Ararajuba* 11: 5–37.

21 Willink, P. W., B. Chernoff, L. E. Alonso, J. R. Montambault, and R. Lourival (eds). 2000. Op. cit.

22 Silva, M. P., R. Mauro, G. Mourão and M. Coutinho. 2000. Op. cit.

23 Prance, G.T. and G. Schaller. 1982. Op. cit.

24 Ravazzani, C., H. Wiederkehr Filho, J. P. Fagnani and S. Da Costa. 1990. Op. cit.

25 Ibid.

26 Súarez, Y. R., M. Petreri Jr and A. Catella. 2004. "Factors regulating diversity and abundance of fish communities in Pantanal lagoons, Brazil".

Fisheries Management and Ecology 11: 45–50.

27 Lourival, R. F. F. and G. A. B. Fonseca. 1997. "Análise de sustentabilidade do modelo de caça tradicional, no Pantanal da Nhecolândia, Corumbá, MS". Em: *Manejo e Conservação de Vida Silvestre no Brasil.* (Eds C. Valladares-Pádua and R.E. Bodmer): 123–172.

28 Mourão, G., M. Coutinho, R. Mauro, Z. Campos, W. Tomas and W. Magnusson. 2000. "Aerial surveys of caiman, marsh deer and pampas deer in the Pantanal wetland of Brazil." *Biological Conservation* 92: 175–83.

29 Gaski, A. L. and G. Hemley. 1988. "The ups and downs of the crocodilian skin trade". *Traffic* 8(1): 5–16.

30 Mittermeier, R. A., I. de Gusmão Câmara, M. T. Jorge Padua and J. Blanck. 1990. Op. cit.

31 Silva, M. P., R. Mauro, G. Mourão and M. Coutinho. 1999. "Conversion of Forests and Woodlands to Cultivated Pastures in the Wetland of Brazil". *Ecotropicos* 12(2): 101–108.

32 Lourival, R. F. F. and G. A. B. Fonseca. 1997. Op. cit.

33 Ibid.

34 Resende, E. K. 2004. "*Migratory Fishes of the Paraguay—Paraná Basin Excluding the Upper Paraná Basin*". In: Migratory Fishes of South America. Biology, Fisheries and Conservation Status. World Fisheries Trust/World Bank/IDRC.

35 Catella, A. C. and M. Petrere Jr. 1996. "Feeding patterns in a fish community of Baía da Onça, a floodplain lake of the Aquidauana River, Pantanal, Brazil". *Fisheries Management and Ecology*, v.3: 229–237.

36 Resende, E. K. 2004. Op. cit.

37 Girard, P. 2002. *Efeito Cumulstivo das barragens no Pantanal.* Instituto Centro Vida, Rios Vidos.

38 Lourival, R. F. F, C. J. da Silva, D. F. Calheiros, M. A. Bezerra, L. M. R. Borges, Z. Campos, A. C. Catella, G. A. D. Damasceno, E. L. Hardoim, S. K. Hamilton, F. de Arruda Machado, G. M. Mourão, F. K. Nascimento, F. M. de Barros Nogueira, M. D. Oliveira, A. Pott, M. Silva, V. Pinto-Silva, C. Strussmann, A. M. Takeda, and W. M. Thomas. 1999. Os impactos da Hidrovia Paraguai/Paraná sobre a biodiversidade do Pantanal—Uma discussão multidisciplinar". Em: *II Simpósio de Recursos naturais e Sócio-econômicos do Pantanal—Manejo e Conservação.* Corumbá: EMBRAPA.

The Pantaneiro: People of the Pantanal

1 Peixoto, J. L. S. 2003. *A ocupação dos povos indígenas pré-coloniais nos grandes lagos do Pantanal Sul-mato-grossense.* Porto Alegre: Pontifícia Universidade Católica do Rio Grande do Sul.

2 Peixoto, J. L. S. and M. A. O. Bezerra. 2004. "Os povos ceramistas que ocuparam a planície aluvial antes da conquista européia, Pantanal." In: *4. Simpósio Sobre Recursos Naturals e Socio-econômicos do Pantanal—Sustentabilidade Regional, 2004, Corumbá.* Corumbá: EMBRAPA (CD-Rom.)

Wetlands: Life at the water's edge

1 Pott, A. and V. J. Pott. 2000. *Plantas Aquáticas do Pantanal.* EMBRAPA, Pantanal.

2 Prado, C. P. A., M. Uetanabaro and F. S. Santos. 1996. "Aspectos relacionados à reprodução e variações sazonais da anurofauna do Pantanal

do Mirand/Abobral, Corumbá, MS". In: *Anais do III Congresso de Ecologia do Brasil:* 176.

3 Catella, A. C. 2003. *A pesca no Pantanal Sul: situação atual e perspectivas.* EMBRAPA, Pantanal.

4 Junk, W. J. and C. da Silva. 1999. "O Conceito do Pulso de Inundação e Suas Implicações para o Pantanal de Mato Grosso." In: *Anais do 2º Simpósio Sobre Recursos Naturais e Sócio-Econômicos do Pantanal: Manejo e Conservação.* Corumbá: EMBRAPA: 17–28.

5 Mourão, G., M. Coutinho, R. Mauro, Z. Campos, W. Tomas and W. Magnusson. 2000. "Aerial surveys of caiman, marsh deer and pampas deer in the Pantanal wetland of Brazil." *Biological Conservation* 92: 175–83.

6 Médri, I. M. and G. Mourão. 2004. "A fauna do Pantanal." *Ação Ambiental*, 4(26): 14–17.

7 Mourão, G. and L. Carvalho. 2001. "Cannibalism among Giant Otters (*Pteronura brasiliensis*)." *Mammalia* 65(2): 225–27.

8 Mittermeier, R. A., I. G. Camara, M. T. J. Pádua and J. Blanck. 1990. "Conservation in the Pantanal of Brazil." *Oryx* 2(24): 103–12.

Grasslands: Born of flood and drought

1 Silva, M., R. Mauro, G. Mourão and M. Coutinho. 2000."Distribuição e quantificação de classes de vegetação do Pantanal através de levantamento aéreo". Revta. Brasil. *Bot.* 23 (2): 143–52.

2 Mourão, G., M. Coutinho, R. Mauro, Z. Campo, W. Tomás and W. Magnusson. 2000. "Aerial surveys of caiman, marsh deer and pampas deer in the Pantanal Wetland of Brazil." *Biological Conservation* 92 (2): 175–83.

3 Coutinho, M., Z. Campos, G. Mourão and R. Mauro. 1997. "Aspectos Ecológicos dos vertebrados terrestres e semi aquáticos no Pantanal". *Plano de Conservação da Bacia do Alto Paraguai (Pantanal): Diagnóstico dos meios físicos e bióticos* 2, tomo 3, Cap. 2: 183–322

4 Prance, G. T. and G. B. Schaller. 1982. "Preliminary study of some vegetation types of the Pantanal, Mato Grosso, Brazil". *Brittonia* 34: 228–51.

Forests of the Pantanal: Refuges in a flooded land

1 Silva, M. P., R. Mauro, G. Mourão and M. Coutinho. 2000. "Distribuição e quantificação de classes de vegetação do Pantanal através de levantamento aéreo." *Rev. bras. Bot.* 23: 143–152.

2 Oliveira-Filho, A. T. and J. A. Ratter. 2002. "Vegetation physiognomies and woody flora of the Cerrado Biome." In: P. S. Oliveira and R. M. Marquis (eds). *The Cerrados of Brazil: Ecology and Natural History of a Neotropical Savanna.* Columbia University Press, New York: 91–120.

3 Silva, M. P. et al. Op cit.

4 Ratter, J. A., A. Pott, V. J. Pott, C. N. Cunha and M. Haridasan. 1988. "Observations on woody vegetation types in the Pantanal and at Corumbá, Brazil." *Notes Roy. Bot. Gard. Edinb.* 45: 503–525.

5 Pennington, R. T., D. E. Prado and C. A. Pendry. 2000. "Neotropical seasonally dry forests and Quaternary vegetation changes." *Journal of Biogeography.* 27:261–273.

6 Silva,. M. P. et al. Op cit.

7 Ibid.

8 Oliveira-Filho, A. T. and J. A. Ratter. Op cit.

9 Silva, M. P. et al. Op cit.

10 Ratter, J. A. et al. Op cit.

Caiman: Celebrating a comeback

1 Mourão, G., M. Coutinho, R. Mauro, Z. Campos, W. Tomas and W. Magnusson. 2000. "Aerial surveys of caiman, marsh deer and pampas deer in the Pantanal wetland of Brazil." *Biological Conservation* 92: 175–83.

2 Brazaitis, P., G. H. Rebelo et al. 1998. "Distribution of *Caiman crocodilus crocodilus* and *Caiman yacare* populations in Brazil." *Amphibia-Reptilia* 19 (2): 193–201.

3 Ibid.

4 Coutinho, M. E. 2000. "Population ecology and the conservation and management of Caiman yacare in the Pantanal, Brazil." Ph.D. thesis, Dept. of Zoology and Entomology. Brisbane, University of Queensland: 272.

5 Jenkins, M. and S. Broad (eds). 1994. *International trade in reptile skins. A review of the main consumer markets, 1983–1991.* Traffic International Report, Cambridge, United Kingdom.

6 Huntington, C. 2002. *The Tigerman.* Online at: http://www.stickbow.com/FEATURES/HISTORY/tiger_man.CFM

7 Ibid.

8 Schweizer, J. 1992. *Ariranhas no Pantanal. Ecologia e comportamento da Pteronura brasiliensis.* Editora Brasil Natureza (EDIBRAN), Curitiba, Brazil.

9 Lourival, R. F. F. and G. A. B. da Fonseca. 1998. "Analise de sustentabilidade do modelo de Caça Tradicional, no Pantanal da Nhecolândia, Corumbá, MS." *Manejo de Fauna na America Latina.* R. E. Bodmer and P. C. V. Brasília (Eds.), Instituto Mamirauá: 123–172.

Further references

Lourival, R. F. F., M. B. Harris and J. R. Montambaud. 2000. "Introduction to the Pantanal". In: *Biological Assessment of the Aquatic Ecosystems of the Pantanal, Mato Grosso do Sul, Brazil.*" University of Chicago Press, Chicago.

Costa, M. De F. 1999. Historia de um Pais Inexistente. O Pantanal entre os Seculos XXVI e XXIII. Editora Kosmos, Rio de Janeiro.

Hamilton, S. K., S. J. Sippel and J. M. Melack. 1996. "Inundation patterns in the Pantanal wetland of South America determined from passive microwave remote sensing". *Arch. Hydrobiol.* 137 (1): 1–23.

Wendel de Magalhães, N. 1992. *Conheça O Pantanal.* Terragraph, S/C, São Paulo.

WWF (World Wildlife Fund For Nature). In prep. WWF Ecoregion—Species Database for Pantanal. Washington, DC. www.worldwildlife.org/science.

Index

Page numbers in italics indicate a photograph